A Note from the Chairman

The NACF was founded in 1903 to assist the museums and galleries of Britain to buy works of art they could not otherwise afford, and at the same time to stem the flow of masterpieces from these shores. The threats to our collections become greater every year.

Over 300 galleries and museums have been helped by the NACF to acquire some of their greatest treasures and works of art of national and local importance. The NACF is concerned not only with paintings and sculpture but with drawings, furniture, silver, jewellery, ceramics, fine needlework, even musical instruments of beauty and ingenuity. Public museums and galleries throughout Britain benefit, as also do National Trust Houses.

The NACF is an independent charity, receives no money from Government, and relies entirely on subscriptions, donations and legacies.

The Fund offers its members many privileges, private views of exhibitions, visits to country houses and foreign tours, concessionary entry to many museums, and this attractive Annual Review. But the main aim and satisfaction of membership remains that of helping to build up the country's public art collections and to preserve works of art for enjoyment by ourselves and future generations.

If you are not a member, I hope very much that you will join us.

Normanby.

Phillips

FINE ART AUCTIONEERS & VALUERS SINCE 1796.

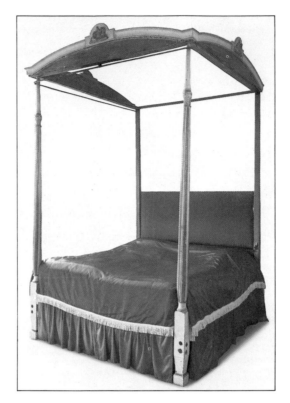

KING GEORGE III AND ALICE IN WONDERLAND SLEPT HERE

This elegant four-poster bed was made to a Hepplewhite design, circa 1780. It carries the armorial bearings of the most eccentric of the Hanoverians. Removed from Cuffnalls, Hants – the home of a sometime Secretary of the Treasury which was often visited by the King – it came into possession of Mr and Mrs Liddell, whose little daughter Alice inspired Lewis Carroll's immortal masterpiece.

At Phillips 1983 sale of Upton House in Gloucestershire – attended by its owner, Alice's great grand-daughter – the bed alone fetched the princely sum of £16,000.

Phillips enjoy a growing reputation for their auctions of country houses, very often in collaboration with local Estate Agents. Our team now numbers over 100 shrewd-eyed specialists. Our network of 14 salerooms, larger than any other auction house in the country, allows us to recommend the most favourable market for all antiques and works of art. We are delighted to send anyone who is interested our illustrated bi-monthly previews of sales.

If you would like to know more about Phillips services to sellers and buyers (which includes prompt valuations for tax, probate and insurance purposes), please telephone Paul Viney on 01-629 6602. He will be delighted to help you.

7 Blenheim Street, New Bond Street, London W1Y 0AS. Tel: 01-629 6602.

LONDON · NEW YORK · GENEVA
Fourteen salerooms throughout the United Kingdom.
Members of the Society of Fine Art Auctioneers.

Contents

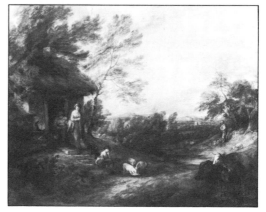

ARTEMIS GROUP

Old Master and Modern
Paintings Drawings and Prints
Antiquities and Sculpture

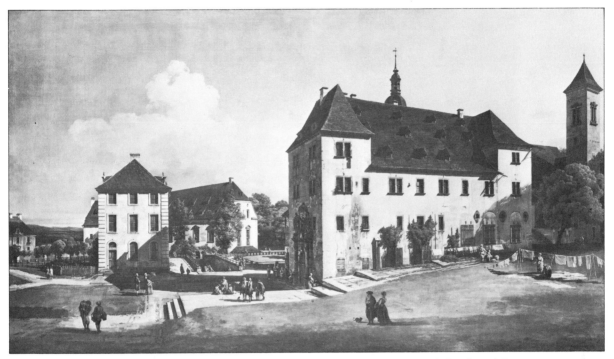

Bernardo Bellotto 1721-1780 *The Courtyard of Königstein Castle from the South* 1756-8
One of a pair of paintings by Bellotto purchased by Manchester City Art Gallery with the aid of the
National Art-Collections Fund.

The sale by private treaty of these paintings was negotiated by

David Carritt Limited,
15 Duke Street St. James's, London SW1Y 6DB

Telephone 01-930 8733

The Royal Bank of Scotland is pleased to reproduce one of the great works of art held in Scotland.

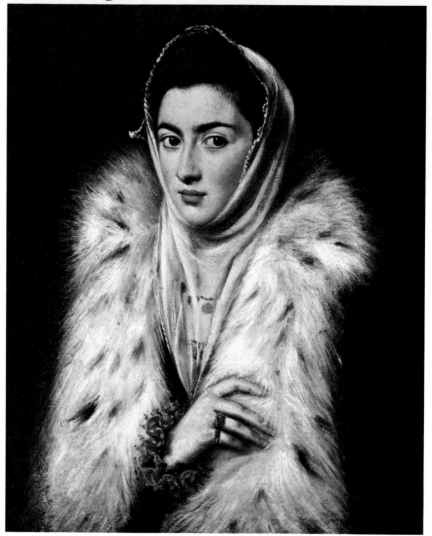

'Lady in a Fur Wrap' by El Greco (1541-1614). 62.5 by 49.9 cm.
(Glasgow Museums and Art Galleries, Stirling Maxwell Collection, Pollok House)

For further information about the Royal Bank and its services please contact:
W H Davidson in Edinburgh (031-556 8555) or any one of our many Branches throughout Scotland.
J S D C Firth in London (01-621 1234) or any one of our 9 London offices.
Or one of our offices in New York, Houston, San Francisco, Los Angeles, Chicago and Hong Kong.

The Royal Bank of Scotland

The Royal Bank of Scotland plc. Registered Office: 42 St. Andrew Square, Edinburgh EH2 2YE. Registered in Scotland Number 46419.

For the discerning collector

The Quality Antiques Publication . . .

Portrait of Josephine Bowes who with her husband John founded the Bowes Museum, County Durham, in 1869 to exhibit their marvellous collection of paintings and works of art.

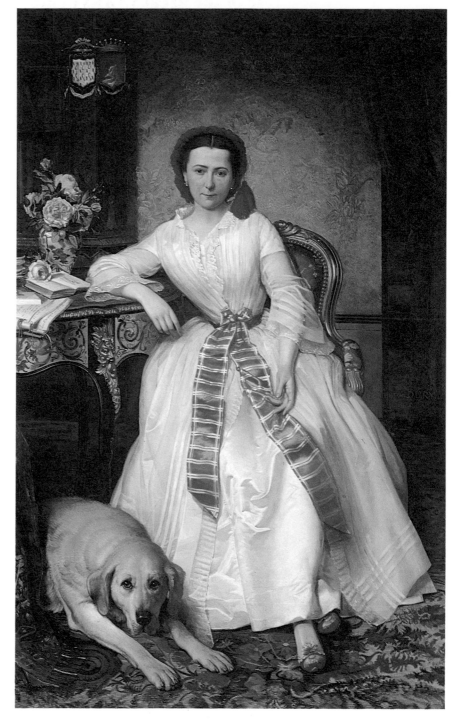

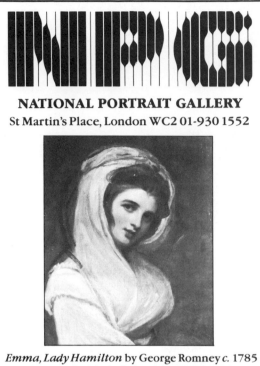
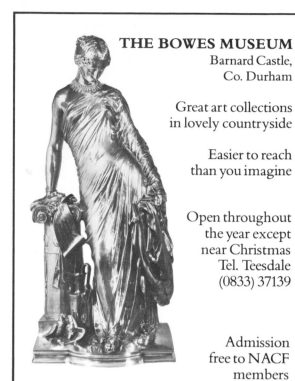

ROY MILES
Fine Paintings

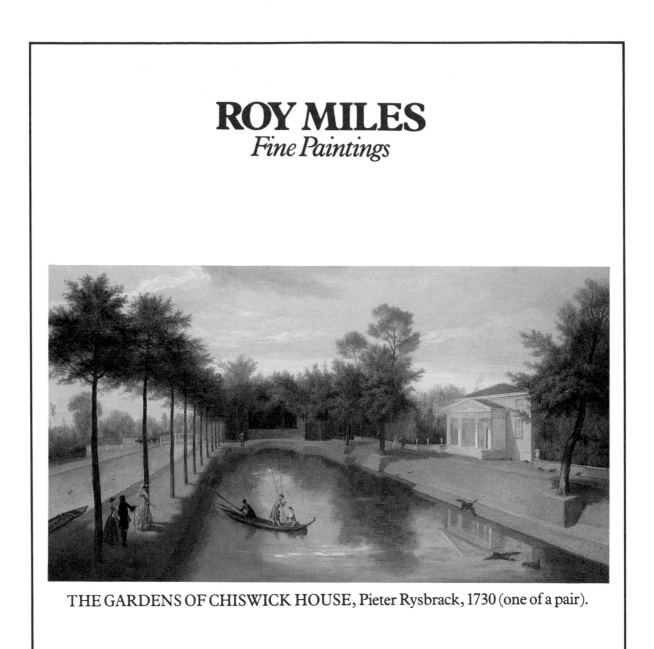

THE GARDENS OF CHISWICK HOUSE, Pieter Rysbrack, 1730 (one of a pair).

Roy Miles Fine Paintings Limited,

3 Trevor Square, London SW7
Telephone 01-581 2590

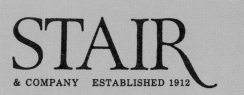

STAIR

& COMPANY ESTABLISHED 1912

In our London gallery:

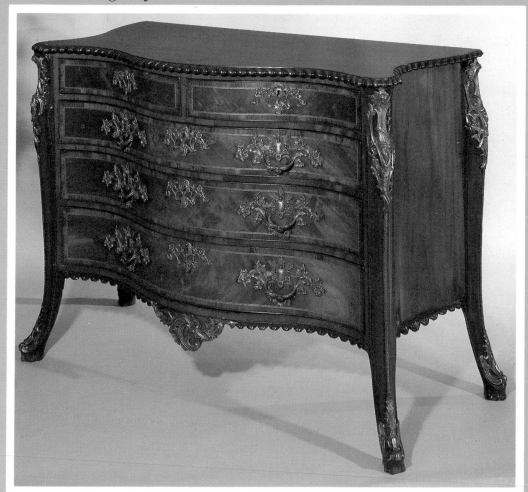

*A highly important mid-eighteenth century serpentine commode of mahogany, the heavily gadrooned top
crossbanded in kingwood with boxwood and ebony stringing. Two short and three long drawers veneered in flame
mahogany, standing on splayed feet. The finely chased ormolu handles, escutcheons, corner mounts and sabots are
recorded in an eighteenth century design book in the Victoria & Albert Museum Archives.*

Size: 56" wide 27" deep 41" high

STAIR & COMPANY LTD., 120 MOUNT STREET, LONDON W1Y 5HB. TELEPHONE: (01) 499 1784
STAIR & COMPANY INC., 59 EAST 57th STREET, NEW YORK, N.Y. 10022, USA

An important pair of French Mother of Pearl
and Ormolu Vases.

Circa 1800

height 9" 23 cms
width 6½" 16½ cms
depth 4¼" 11 cms

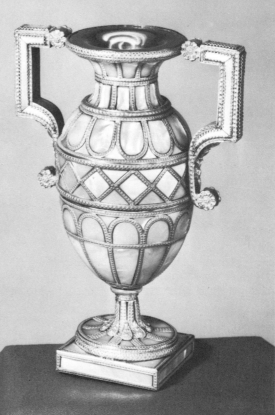
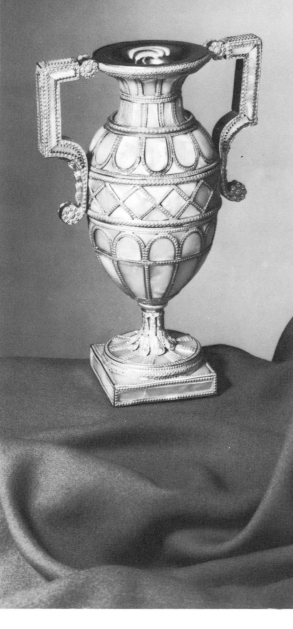

JEREMY LTD

255 King's Road,
Chelsea,
London, S.W.3.

Cables: Jeremique, London, S.W.3.
Tel: 01-352 0644/3127/3128
Members of the British Antique
Dealers' Association

SIMON REDBURN
Fine Antique Furniture and Works of Art

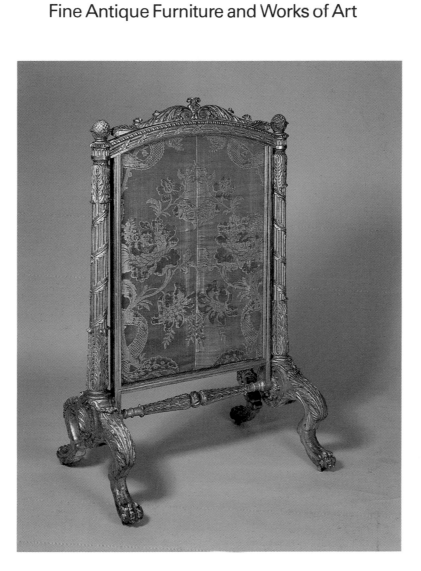

One of an important pair of 19th century English carved giltwood cheval screens supplied by Morel and Hughes to the Duke of Northumberland in 1823 for the saloon at Northumberland House, The Strand.

Height 115½ cms Width 70 cms

CORRESPONDENCE ONLY TO:

79 PARK MANSIONS 333 EAST 43rd STREET
KNIGHTSBRIDGE APPT. 921
LONDON SW1 NEW YORK, NY 10017

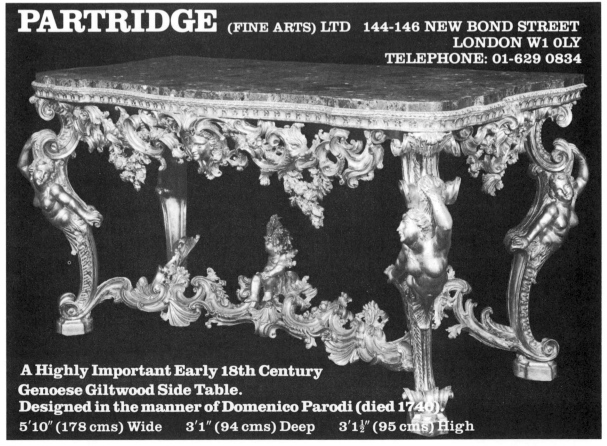
16

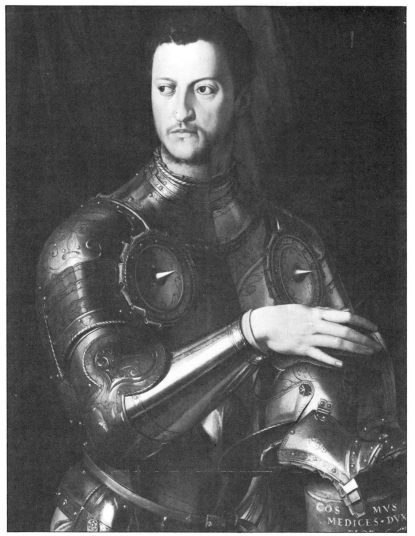

Richard Philp

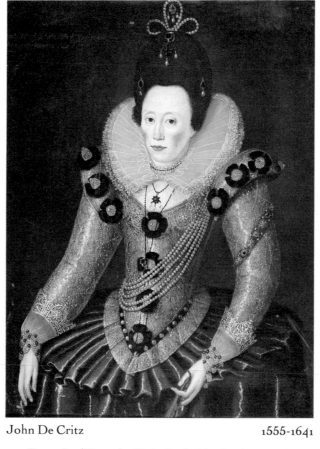

Early Painting, Sculpture and Furniture
59 Ledbury Road · London W11 2AA Tel: 01-727 7915

John De Critz 1555-1641

Portrait of Dorothy Dale, Lady North circa 1605.
Provenance: the Lords North at Wroxton Abbey.
Literature L. Cust, 'Marcus Gheeaerts',
Walpole Society III 1914, p.38.
Roy Strong, 'The English Icon' p.265.

oil on canvas 39″ x 30″

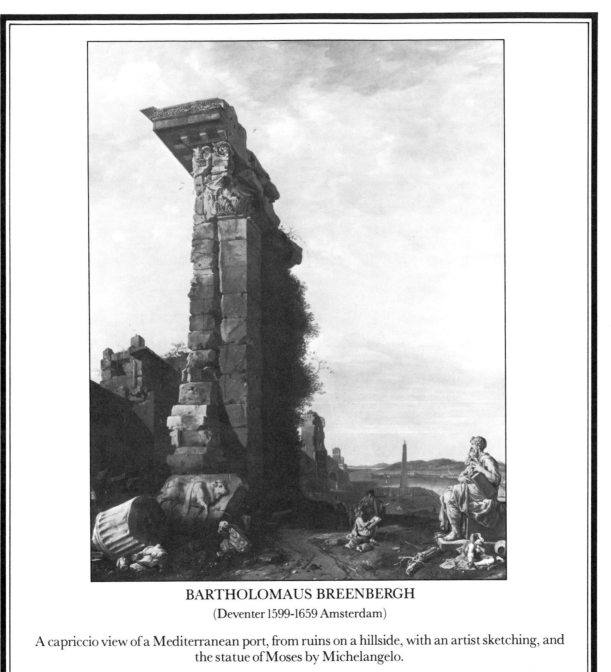

BARTHOLOMAUS BREENBERGH

(Deventer 1599-1659 Amsterdam)

A capriccio view of a Mediterranean port, from ruins on a hillside, with an artist sketching, and the statue of Moses by Michelangelo.

Signed and dated 1650

On canvas – $46\frac{1}{4} \times 35\frac{1}{2}$ inches

Johnny Van Haeften

13 Duke Street, St James's, London SW1Y 6DB
Telephone (01) 930 3062

Winifred Williams

MEISSEN

TEA-JAR and COVER

Height 16 cm. Painter — C. F. Herold. Circa 1735

Ex. Collection R. W. M. Walker

Illustrated W. B. Honey "Dresden China" Plate XV d.

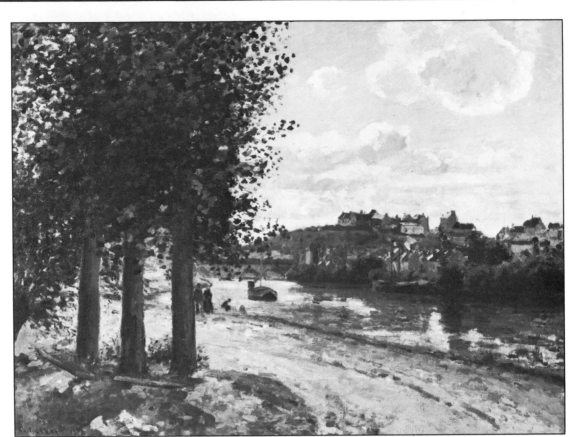

RICHARD GREEN

44 Dover Street
London W1X 4JQ
01-493 3939

4 New Bond Street
London W1Y 9PE
Telex: 25796 GREEN G

Eugène Boudin (1824-1898)
Barques de pêche au large
Signed and dated '95
Canvas: $17\frac{1}{2} \times 25\frac{1}{2}$in/$45 \times 65$cm
Provenance: Bernheim, Paris (sale: Paris, Hotel
Drouot, 23rd June 1900, no 26); Dr. Paulin, Paris (sale:
Paris, Hotel Drouot, 21st November, 1901, no 5)
Literature: Robert Schmit, 'Eugène Boudin', Paris
1973, Vol III, p 319, no 3452, illustrated

27

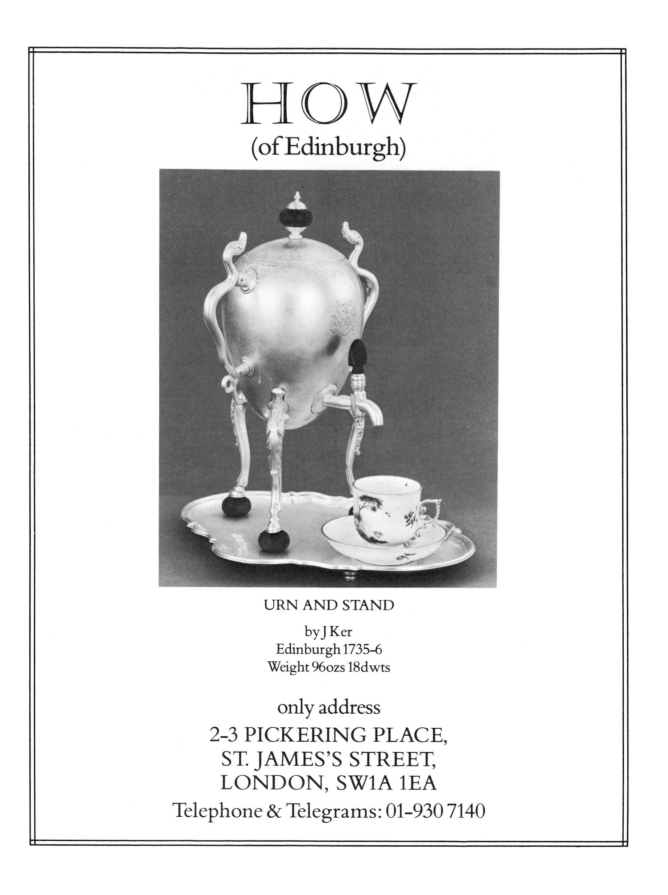

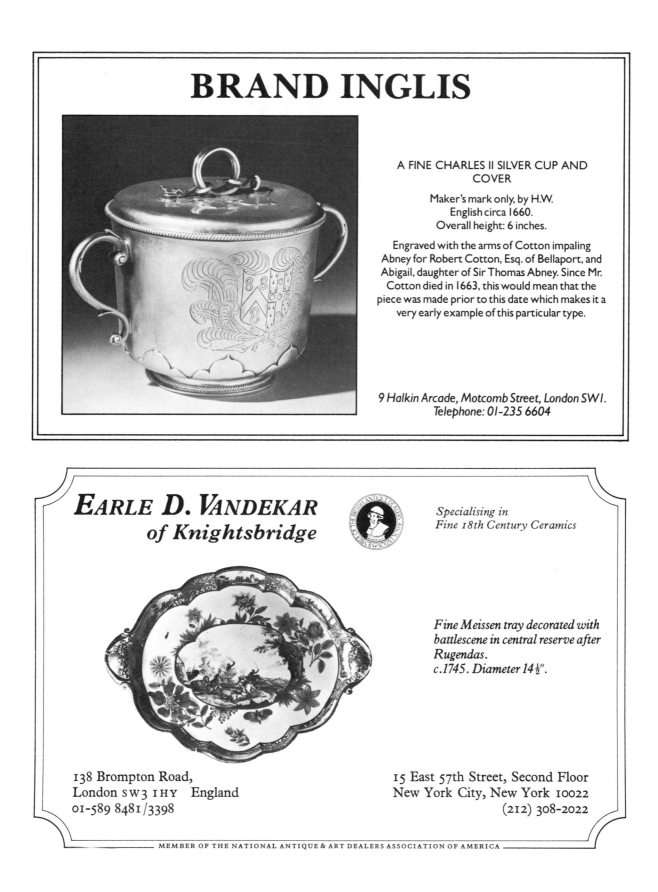
29

ALEX WENGRAF LIMITED

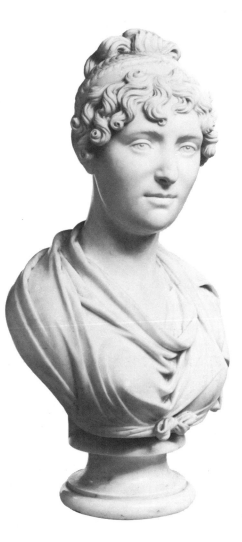

Louis Alexander Goblet (1764-1826)
White Marble Bust of Mrs Conolly
Signed and dated 1820
Height 25½ inches including socle

PAINTINGS AND SCULPTURE

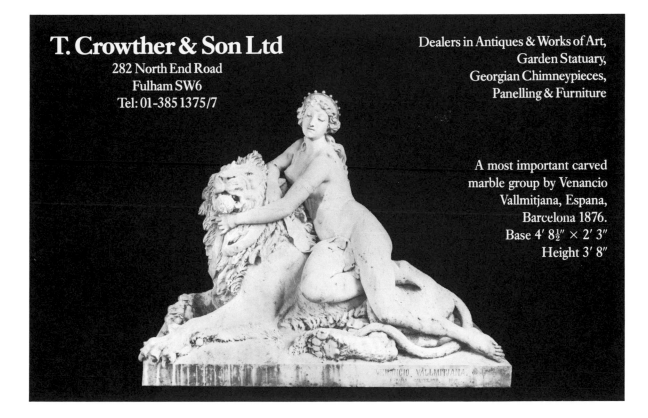

M. TURPIN
ANTIQUES AND OBJETS D'ART

An exceptionally rare Queen Anne walnut veneered kneehole desk of the finest quality and faded colours with original cabriole legs
and brasses. English, circa 1705.
Width 55 inches, depth 30½ inches, height 30 inches.

Select items from our large stock of English and Continental
18th century furniture may be viewed by appointment only at
21 Manson Mews, Queensgate, London SW7

Dealers and private collectors welcome

For all appointments
telephone 01-736 3417

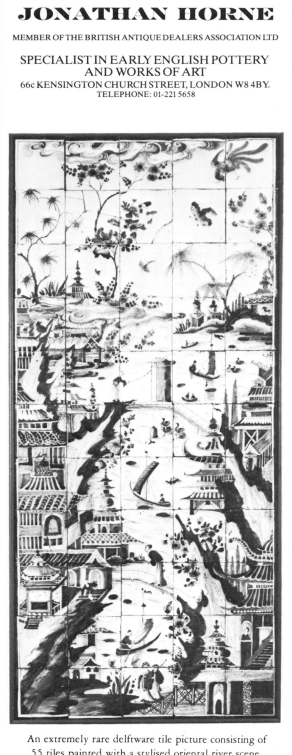
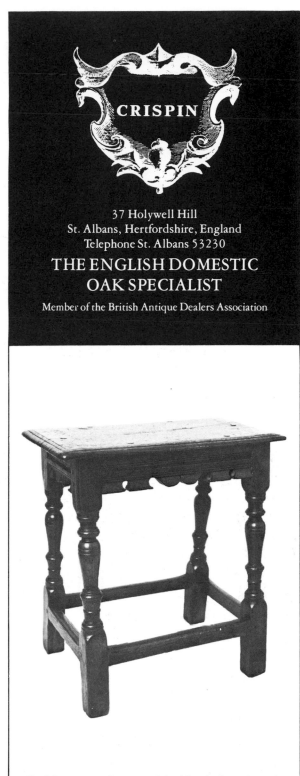
35

RONALD A. LEE

(Fine Arts) Ltd.

1-9 BRUTON PLACE LONDON W1
Tel: 01-629 5600 & 499 6266

A pair of George II Walnut Chairs with gilded-lead mounts, Verre Eglomise, panels bearing the Coat of Arms of Nicholas, 4th Earl of Scarsdale of Sutton Scarsdale. The peerage became extinct upon the 4th Earl's death in 1736. These chairs are part of the original set; the only other known survivors are in 3 New York collections. These two chairs are the only examples remaining in the British Isles.

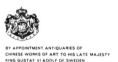

Bluett and Sons 1884-1984

To mark the centenary of the founding of the firm and as a tribute to its founder Alfred Ernest Bluett, and his son Edgar Ernest and Leonard Buckland, the present Directors have decided to institute a

BLUETT CENTENARY AWARD

Scholars are invited to submit papers on any aspect of the applied arts of China or Southeast Asia which will be passed to a panel of distinguished authorities and an award of £1,000 will be made for the paper judged to make the greatest contribution to original research. A further two awards of £200 each will be made for papers adjudged to be of outstanding merit.

Papers should be of about 5,000-7,000 words in length, unpublished, and must be lodged by December 31st 1984.

Whilst there will be no age restriction on contributors the primary intention is to encourage younger scholars to participate. It is regretted that all papers must be in English, either in the original or in translation, to facilitate adjudication. Chinese characters will be welcomed where applicable and papers may be illustrated but this is not essential. Announcement of the awards will be made as soon as practicable after the closing date, and it is hoped that it may be possible to arrange for the publication of the premier award winning paper in a suitable medium. Publishing rights for all three award winning papers will in any event remain with Messrs. Bluett.

Information of intention to submit a paper and its subject matter should reach Bluett and Sons not later than 30th June 1984.

Bluett and Sons Ltd.
48 Davies Street,
London W1Y 1LD

Cables: "Chineceram, London, W.1" Telephone: 01-629 4018 & 3397 Telex: 8952022 CTYTEL G Attn. Bluett

ℜorman 𝔄dams Ltd.

10 Hans Road, Knightsbridge, London SW3 (opp. west side Harrods)
Telephone 589 5266

An outstanding Chippendale period carved mahogany piecrust table.
Circa 1760

Height 27¾ ins 70.5 cms Diameter 28 ins 71 cms

Norman Adams Ltd.
Est. 1923

HAZLITT, GOODEN & FOX

Incorporating Henry Graves & Co Established 1752

French XIXth Century Paintings and Drawings

Italian Baroque and Rococo Paintings

English XVIIIth and XIXth Century Paintings and Drawings

38 Bury Street, St James's, London SW1Y 6BB

Telephone: 01-930 6422

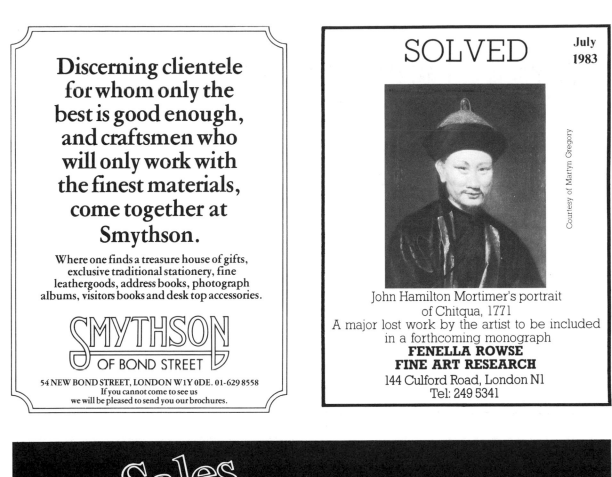

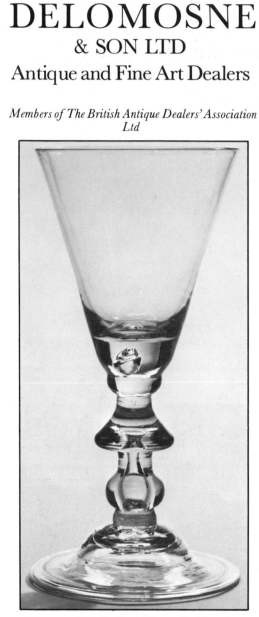

Rare English and Continental Silver, Miniatures.
Antique Jewels, Fine Snuff-Boxes

Valuations for Probate,
Insurance and Division

Commonwealth silver porringer and cover, maker AM (probably
Andrew Moore, see Jackson, page 129), London, 1657.
Height: 5.75 inches (to top of ring finial)
Weight: 22.60 ounces.
From our collection of XVIIth century English silver.

139 New Bond Street London W1A 3DL

Arts Review

- **Annual subscription £23.50**
Overseas £28.50
USA & Canada jet subscription $55.00
£1 per copy

- **Art Review Yearbook 1984**
£9 + £1.50 (p + p)

- **Exhibition Guide** Annual fee £20,
single entry £3.

- **Classified advertising** 50p per word run on,
£6.50 per single column centimetre semi display,
70p Box No (includes redirection)

- For **Display Advertising** rates contact
Jane De'Athe

Arts Review 16 St James's Gardens
London W.11 01 603 7530/8533

FINE ART BOOKS FROM PHAIDON

FRANCIS BACON

Full face and in profile

Michel Leiris

Francis Bacon's work has a strength and vitality that has led to his position as one of the greatest living British artists. This book, by far the most exciting and up-to-date exposition of Bacon's painting to have been published, includes 241 colour illustrations (and 12 fold-out triptychs) selected and supervised by the artist himself.

295 × 255mm, 272pp, 241 illustrations in colour
0 7148 2218 2 Phaidon Press Hb £50

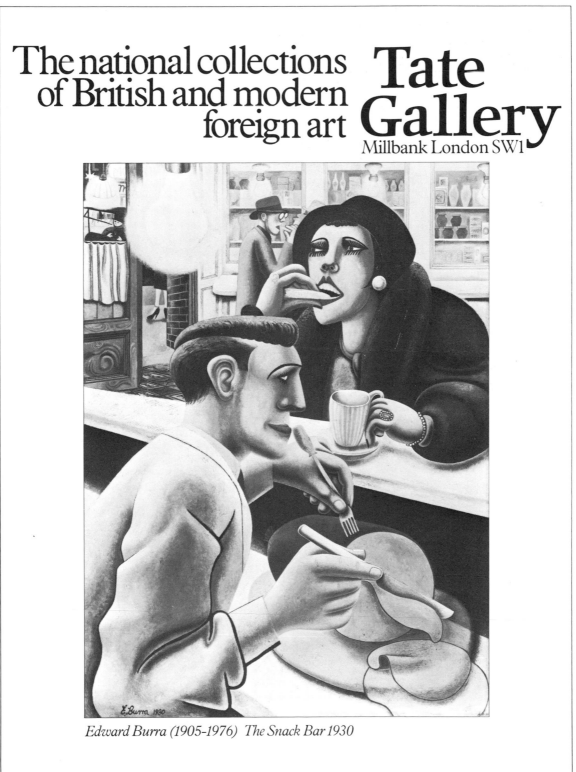

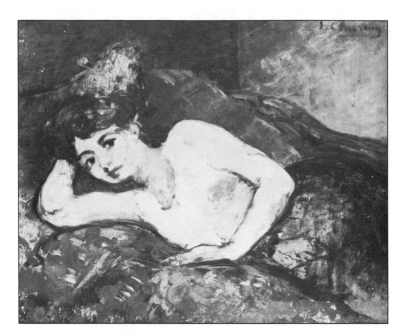
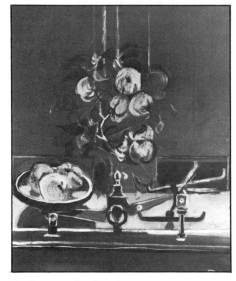

MARLBOROUGH

Marlborough Fine Art (London) Ltd
6 Albemarle Street
London W1X 3HF
Telephone: 01-629 5161
Cables: Bondartos London
Telex: 266259

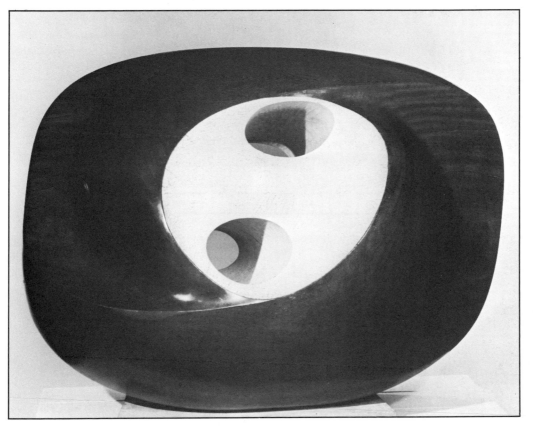

BARBARA HEPWORTH. Oval Sculpture (Delos), 1955, length 48in/121.9cm.

Acquired by The National Museum of Wales.

SELECTED OLD MASTERS, FINE IMPRESSIONIST AND 20th CENTURY PAINTINGS, DRAWINGS AND SCULPTURE

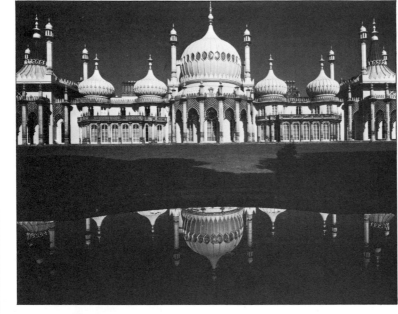
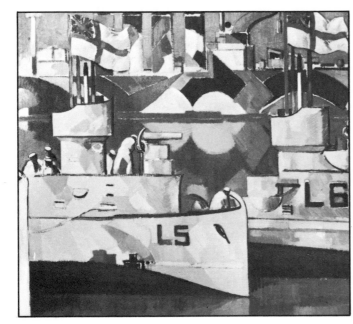

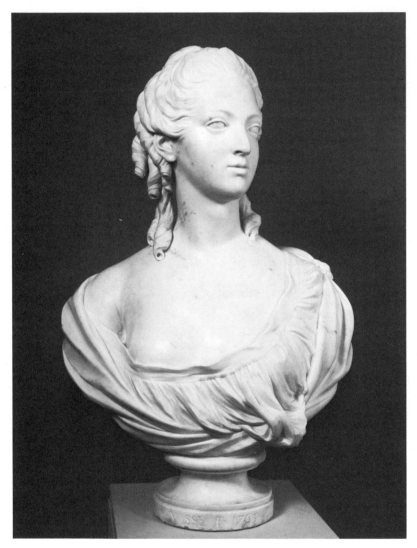

The <u>new</u> Zwemmer Art Bookshop

24 Litchfield Street London WC2

Cheltenham Art Gallery & Museums

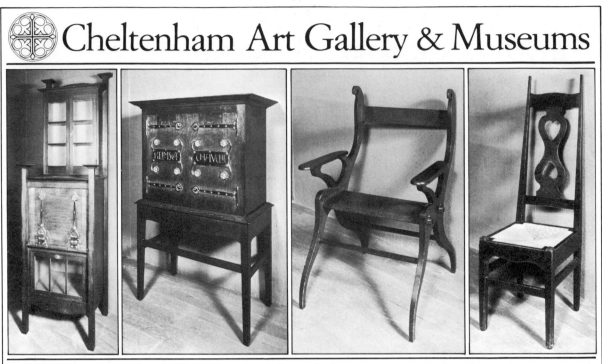

Acknowledged Centre for Study of the Arts and Crafts Movement

DIERDRE OF THE SORROWS
Chalk, 34" x 28".

One of a group of drawings by John Duncan RSA, RSW
(1866-1945) purchased by the National Gallery of
Scotland 1983.

BOURNE FINE ART

4 Dundas Street, Edinburgh, EH3 6HZ.
Tel. 031-557 4050

Scottish, Landscape, Sporting and Natural History Pictures

In Snowdonia—Anthony Vandyke Copley Fielding P.O.W.S.

Malcolm Innes Gallery

172 Walton Street London
01 584 0575

67 George Street Edinburgh
031 226 4151

Important 19th & 20th Century Paintings, Drawings, Sculpture, and Decorative Art

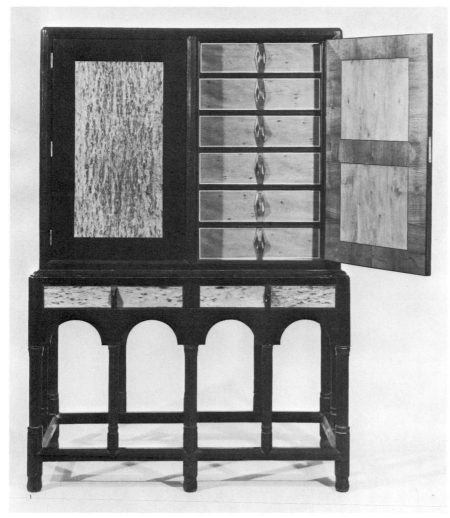

SIR GORDON RUSSELL

Print Cabinet & Stand,
1924/5

Collection:
Cheltenham Art Gallery
and Museum

30 King Street,
St. James's, London SW1

01-839 3942

Mon-Fri 10—5.30

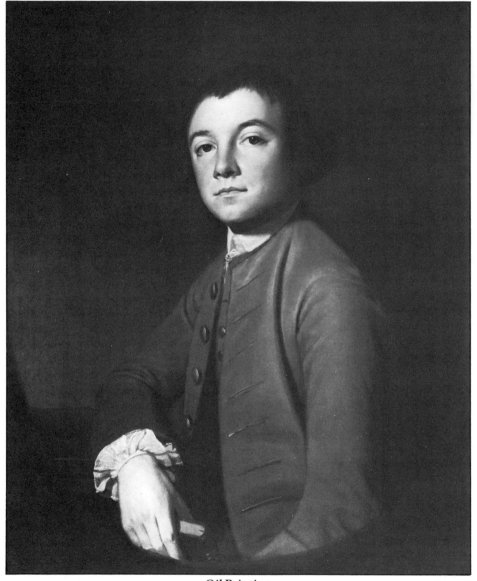

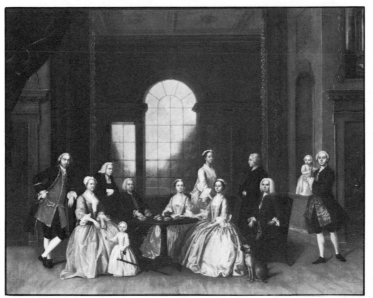
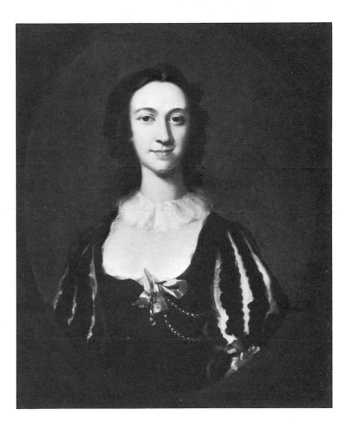

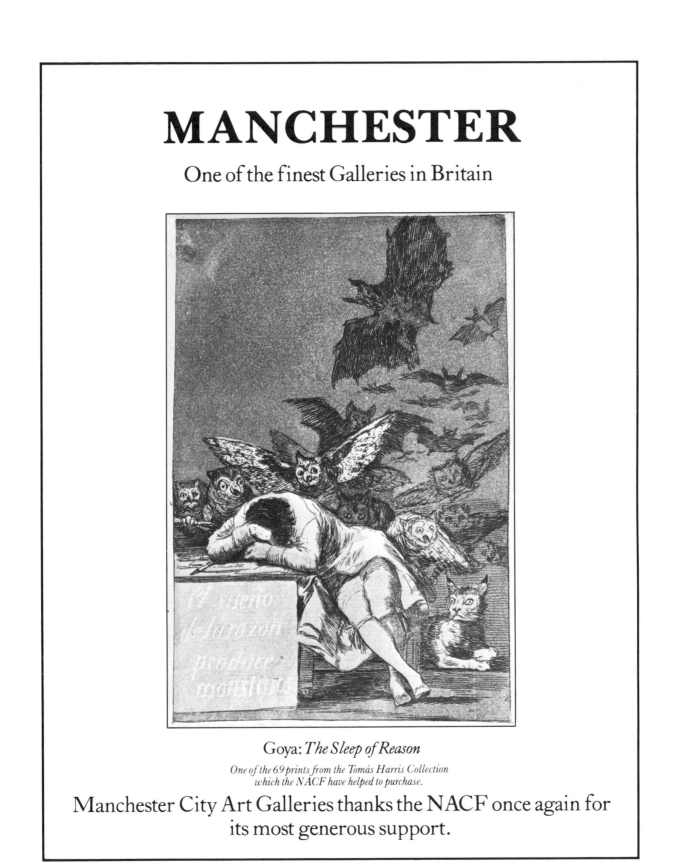

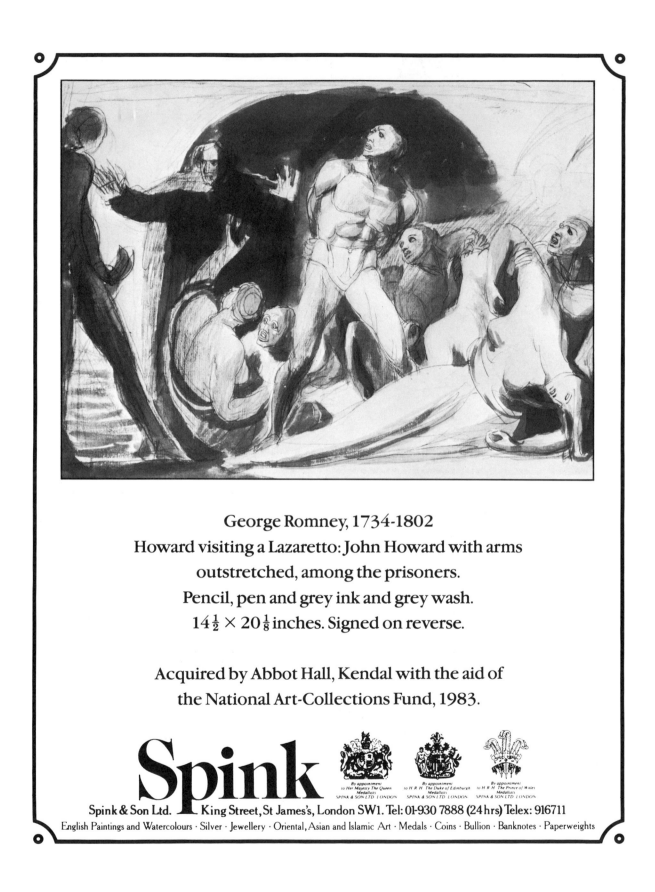

George Romney, 1734-1802

Howard visiting a Lazaretto: John Howard with arms

outstretched, among the prisoners.

Pencil, pen and grey ink and grey wash.

$14\frac{1}{2} \times 20\frac{1}{8}$ inches. Signed on reverse.

Acquired by Abbot Hall, Kendal with the aid of

the National Art-Collections Fund, 1983.

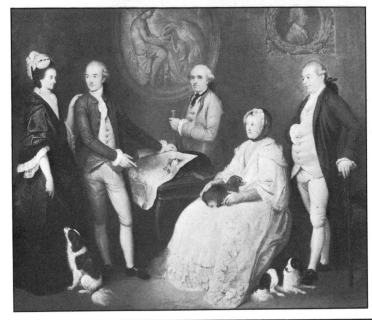

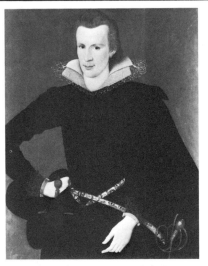

Pyms Gallery

Fine 19th & 20th Century British, French & Irish Paintings

Frank Holl RA ARWS 1845-1888
'Gone'
Oil on board 22 by 19 inches Signed, lower left
Ref: A. M. Reynolds, *The Life and Work of Frank Holl,* London 1912, p.148

Bought by the Geffrye Museum with the aid of a grant from the NACF

This picture is probably the smaller of the two versions, mentioned by Reynolds, of the subject first treated by Frank Holl in one of his most celebrated illustrations for *The Graphic.* The large version, 56 × 43½ ins, remains untraced. It was exhibited at Tooth's Winter Exhibition in 1877 and was so successful that, according to Reynolds, 'My father agreed to paint for them a sketch of the same picture ...' The larger version was shown at the Manchester Jubilee Exhibition in 1887, No. 183 and at the artist's Memorial exhibition at the Royal Academy in 1889. Both oil versions of the subject were derived from *Gone — Euston Station — Departure of Emigrants 9.15 Train for Liverpool, September 1875,* a two page illustration published in *The Graphic,* 19 Feb 1876, pages 180-1. The scene was described on page 176 with a Biblical quotation taken from the Book of Jeremiah, '... but weep sore for him that goeth away: for he shall return no more, nor see his native country'.

13 Motcomb Street Belgravia London SW1X 8LB

Tel: 01-235 3050 Cables: Pymsart London SW1

COLNAGHI

Established 1760

14 Old Bond Street
London W1X 4JL
Telephone: 01-491 7408

26 East 80th Street
New York, N.Y. 10021
Telephone: 212 772-2266

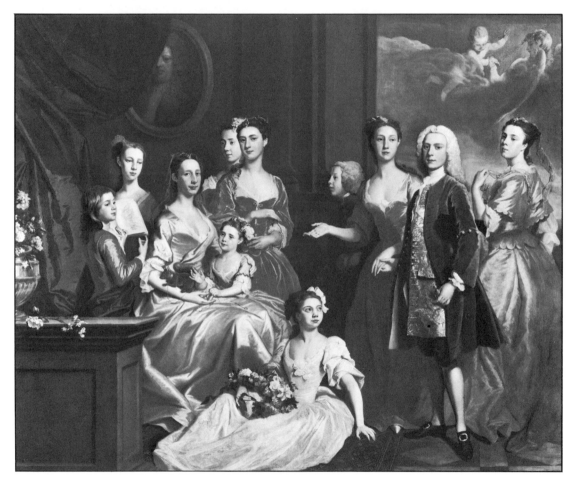

JOSEPH HIGHMORE
1692-1780

$93\frac{1}{2} \times 114$ inches
Signed and dated 1736

The Family of Eldred Lancelot Lee (1651-1734)

Acquired by the Wolverhampton City Art Gallery,
with the assistance of the National Art-Collections Fund and others.

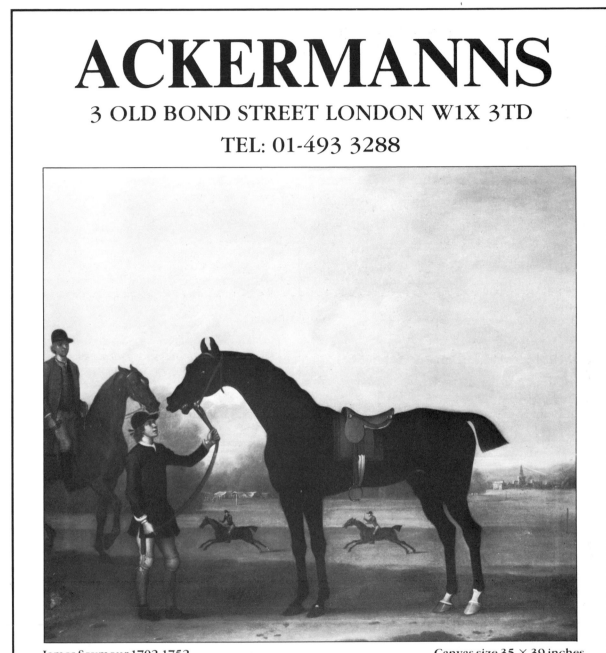

ACKERMANNS

3 OLD BOND STREET LONDON W1X 3TD
TEL: 01-493 3288

James Seymour 1702-1752 Canvas size 35 × 39 inches

Philip Ryley's "Killy-Cranky" at Newmarket
Signed and dated 1739

SPECIALISTS IN FINE ENGLISH
SPORTING PAINTINGS AND
ENGRAVINGS SINCE 1783

🔲🔲🔲🔲🔲🔲🔲🔲 See the glories 🔲🔲🔲🔲🔲🔲🔲🔲🔲 of the past as a whole, rather than as a collection of fragments.

The history of Mediterranean civilisation doesn't fall into small, separate boxes. It should be seen as one narrative, developing over many centuries. Exactly the perspective you'll enjoy on a Swan Hellenic Cruise.

Whether in Greece, Turkey, Italy, Yugoslavia, Egypt, Tunisia, the Holy Land, or around the Black Sea, we show you enough places during a fortnight to enable you to make sense of the whole.

Your ship, Orpheus, though spacious, is small enough to call at places off the beaten tourist track. As well as the famous cities and great historic sites.

To help you get more out of each place you visit, every Swan Hellenic cruise is accompanied by five experts on the area's history and culture. They share their enthusiasms and amusing anecdotes with you in informal lectures. Putting what you see into context. You'll also appreciate that the atmosphere aboard is friendly and not at all over-organised.

Fares — from £734 for 2 weeks — are not cheap but do offer unquestionable value. On a 13 night cruise departing 23 October 1984 there is a special reduction of 10% off brochure prices for NACF members.

Unusually they include all gratuities, most shore excursions and practically everything except drinks, tobacco and souvenirs.

It's one more reason why this is one of the most rewarding of holidays.

The pages of our 1984 brochure will show you many more. Simply cut out the coupon below or phone 01-247 7532.

Please send me the 1984 Swan Hellenic Cruises brochure. Post to Swan Hellenic Cruises, Beaufort House, St. Botolph Street, London EC3A 7DX or ring 01-247 7532.

Name _____

Address _____

ATOL 189B

SWAN HELLENIC
A Division of P&O Cruises.

🔲🔲🔲🔲🔲🔲🔲🔲🔲🔲🔲🔲🔲🔲🔲🔲🔲🔲🔲🔲🔲🔲🔲🔲🔲🔲🔲🔲🔲🔲

THE
BRITISH ANTIQUE DEALERS'
ASSOCIATION

———— & ————

THE SOCIETY OF LONDON
ART DEALERS

support the objectives of the

NATIONAL ART-COLLECTIONS
FUND

The Grosvenor House Antiques Fair 1934-1984

18-26 June 1984

At Grosvenor House, Park Lane, London W1

If you would like an advance copy of our Handbook and Catalogue, please send the Organisers your name and address and a cheque for £5.00. The Handbook will be available approximately 5 weeks prior to the Fair.

Overseas readers requiring a copy should contact the Organisers by letter or telephone for the price inclusive of postage.

 In association with the British Antique Dealers' Association

18 June 6.00 p.m.-9.30 p.m. **19-25 June** 11.00 a.m.-8.00 p.m. but **24 & 26 June** 11.00 a.m.-5.00 p.m.
Admission: £6.50 single ticket inclusive of Handbook or £10.50 double ticket inclusive of one Handbook.

Organised by:
Evan Steadman and Partners Limited, The Hub, Emson Close, Saffron Walden, Essex CB10 1HL. Telephone: (0799) 26699. Telex: 81653.
43506

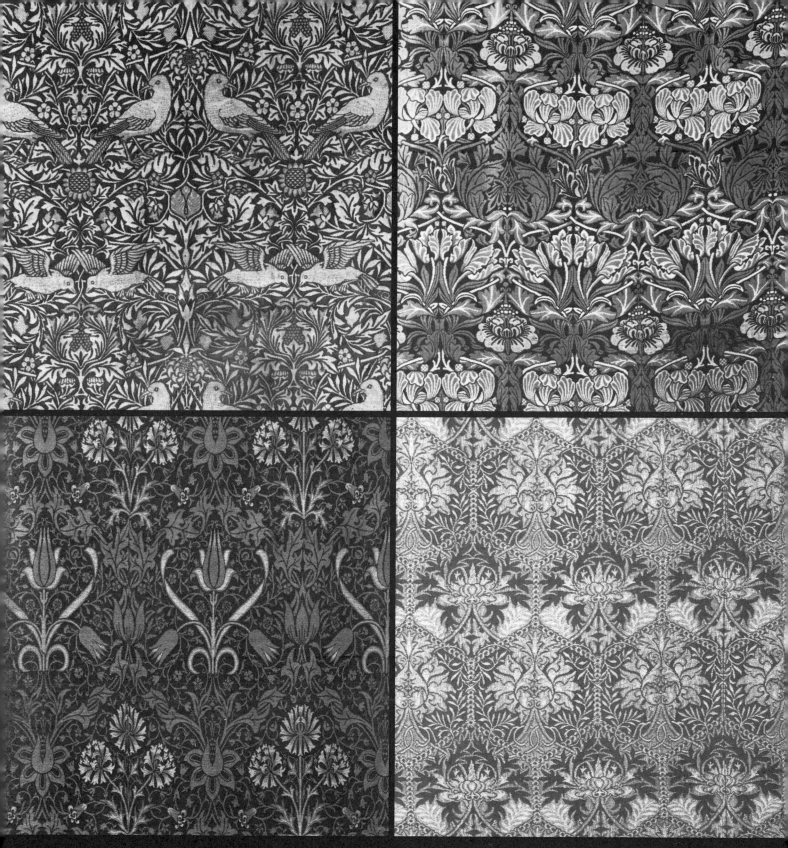

Woven textiles from William Morris & Co.
Top left Bird *Top right* Tulip and Rose *Bottom left* Tulip and Net *Bottom right* Honeycomb

S FRANSES LTD
Antique Tapestries, Carpets & Textiles

82 JERMYN STREET, ST. JAMES'S, LONDON SW1Y 6JD
Telephone: 01 235 1888/9, 930 1589 Telex: 892756

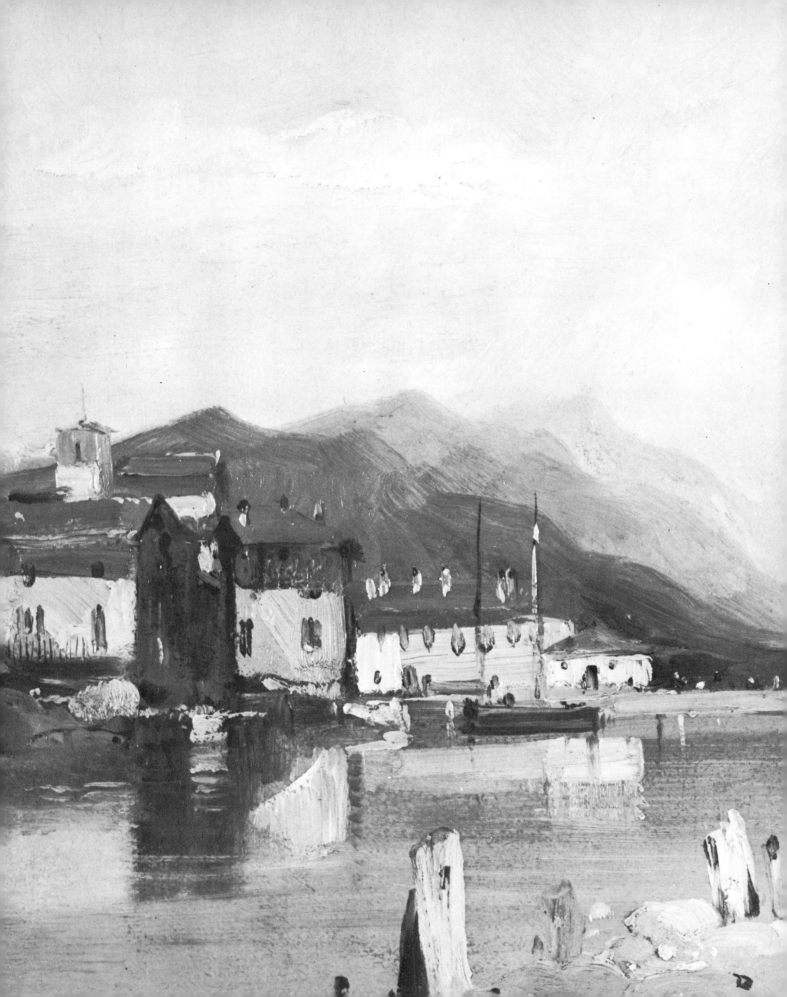

NATIONAL
ART-COLLECTIONS FUND
REVIEW 1984

An Illustrated Account of the Works of Art
acquired by Museums and Galleries
in Great Britain with the assistance of the NACF
in 1983

Representatives

London Projects Committee

Charles Sebag-Montefiore, Esq (*Chairman*);
The Hon. Mrs Parsons (*Vice-Chairman*);
Charles Jackson, Esq (*Hon. Secretary*); Miss Mary Bellamy;
William Clarke, Esq; Mrs Catherine Corbet-Milward;
Miss Caroline Crichton-Stuart;
Mrs Nina Lobanov-Rostovski; Jonathan Lubran, Esq;
Francis Russell, Esq; Francis Sitwell, Esq;
Michael Stewart, Esq; Miss Margaret Timmers; as from
January 1984, Miss Sarah Stowell; Nicholas Usherwood, Esq

Launching Committee for the Young NACF

Louis Jebb, Esq (*Chairman*); James Sainsbury, Esq
(*Hon. Treasurer*); Miss Claire Logan (*Hon. Secretary*);
Mrs Diana de Bussy; David Kelly, Esq;
Miss Elspeth Moncrieff; Jonathan Radford, Esq;
Miss Karen Taylor; Miss Charlotte Villiers;
Miss Mary Rose Wakefield; Miss Louise White

Scotland

Borders

Mrs Lionel Machin, Rosybank House, Coldstream,
Berwickshire
Committee: The Duchess of Sutherland,
The Hon. Mrs M. Christian, Mrs E. Shelley

Central Scotland

Dr John Skrimshire, Quarter, By Denny, Stirlingshire

Dumfries and Galloway

Mrs A. Murray Flutter, Tundergarth House, Lockerbie,
Dumfriesshire

Edinburgh and Lothian

Mrs C. P. Lowther, 15 Lennox Street, Edinburgh,
Midlothian

Fife

Mrs John Foster, Craigie Farm, Leuchars

Grampian

Mrs E. Clunas, 27 Queen's Road, Aberdeen

Highlands

Lady Burton, Dochfour House, Inverness
Committee: The Earl of Cawdor, A. Munro Ferguson, Esq

Orkney and Shetland

Mrs Eric Linklater, 20 Main Street, Kirkwall, Orkney

Strathclyde

William Hardie, Esq, 4 Braxfield Row, New Lanark,
Strathclyde

Tayside

The Hon. Mrs Michael Lyle, Riemore Lodge, Butterstone,
Nr Dunkeld, Perthshire

Wales

Clwyd

W. Lindsay Evans, Esq, 100 Erddig Road, Wrexham

Gwynedd

Temporarily without a Representative

South Wales

Mrs E. Hanbury-Tenison, Clytha Park, Abergavenny
Committee: Colonel W. K. Buckley; David Francis, Esq;
Mrs George Francis; Dr M. B. Jones; Mrs R. Laurence;
K. A. Markham, Esq; Mrs Owain Williams

Northern Ireland

Mrs W. Montgomery, Grey Abbey, County Down

Channel Islands

Guernsey

Geoffrey P. Jenkinson, Esq, Springfield, St Peter Port

Jersey

Viscountess Villiers, Bel Respiro, Mont-au-Pretre, St Helier, Jersey, CI

Isle of Man

Mrs John Shirley, Ormly Hall, Ramsey

Isle of Wight

C. M. Morton, Esq, 6 Fairhaven Close, Lane End, Bembridge

England

Avon

Mrs T. F. Hewer, OBE, Vine House, Henbury, Bristol

Bedfordshire

Mrs A. H. Allott, Rose Cottage, Biddenham, Bedford

Berkshire

Lady Montgomery Cuninghame, Lower Farmhouse, East Ilsley, Newbury

Buckinghamshire

Mrs Christopher Wall, The Apple Orchard, Bradenham, High Wycombe

Mrs P. D. E. Bergqvist, Moat Farm, Ford, Nr Aylesbury

Cambridgeshire

Lady Reid, Kingston Wood Manor, Arrington, Royston, Herts

Sean Hudson, Esq, 20 Cedar Court, Cambridge

Cheshire and Greater Manchester

J. R. E. Borron, Esq, 9 Wellfield Road, Culcheth, Warrington

Committee: A. R. Astins, Esq (*Hon. Sec.*);
Mrs A. G. Barbour; The Hon. Mrs A. Campbell;
T. P. P. Clifford, Esq; Mrs T. Dufort; F. W. Hawcroft, Esq;
Mrs H. Pilkington; Lady Worthington

Cornwall

Mrs Norman Colville, Penheale Manor, Launceston

Cumbria

Mrs T. Peter Naylor, The Clock House, Far Sawrey, Ambleside

H. Cornish Torbock, Esq, Crossrigg Hall, Cliburn, Penrith

Derbyshire

H. F. Harpur-Crewe, Esq, Calke Abbey, Ticknall, Nr Derby

Devon

Lady Stevens, East Worlington House, Crediton

Committee: Maj.-Gen. T. B. L. Churchill;
Mrs Anne Fanshawe; Mrs Stella Gibson;
Mrs Margaret Gibson; Mrs Penelope Kittow;
Dr M. G. Thorne; J. Tremlett, Esq;
Mrs J. Trusted

Dorset

Norman McKenna, Esq, CBE, Cotters Pound, Corfe Castle, Wareham

Co. Durham

Mrs Gerald Cookson, Highfield House, Whittonstall, Consett

Mrs Robin Morritt, Rokeby Park, Barnard Castle

Committee: Gerald Collier, Esq (*Hon. Sec.*);
Dr Gilbert Larwood; F. J. Leishman, Esq, CVO, MBE

Essex

Mrs Paul de Voil, The Grange, Chipping Hill, Witham

Committee: Mrs Kenneth Aberdow; Mrs Roy Grier

Gloucestershire

Lady Holland, Sheepbridge Barn, Eastleach, Cirencester

Hampshire

Lady Lucas, The Old House, Wonston, Winchester

Committee: Mrs M. Charrington; Mrs G. Cooke;
Mrs M. Drummond; Mrs W. Keppel;
The Countess of Selborne

Herefordshire

Mrs Vernon Harington, Woodlands House, Whitbourne, Worcester

Hertfordshire

Miss Dorothy Abel Smith, Greenhill, Bramfield

Humberside

Lady Manton, Houghton Hall, Sancton, York

Kent

Mrs David Lloyd-Thomas, Lidwells House, Goudhurst, Nr Cranbrook

Mrs Henry Villiers, Ulcombe Place, Nr Maidstone

Committee: Mrs F. R. Cobb (*Hon. Sec.*); Mrs P. Finch; Martin Hankey, Esq; Mrs F. Rainsford; Andrew Rolla, Esq

Lancashire

Temporarily without a Representative

Leicestershire and Rutland

The Lady King, Wartnaby, Melton Mowbray

Lincolnshire

The Countess of Yarborough, Brocklesby Park, Habrough

Merseyside and Lancashire

Clifford Brewer, Esq, TD, FRCS, 6 Mill Bank, Liverpool

Committee: John Entwistle, Esq; John McFarland, Esq; H. B. Ratcliffe, Esq

Northamptonshire

The Hon. Mrs Brudenell, Deene Park, Corby

Northumberland

Captain W. D. Thorburn, CBE, VRD, DL, RNR, Lansdown House, Morpeth

Nottinghamshire

Mrs P. V. Radford, Langford Hall, Newark

Oxfordshire

Mrs Christopher Harris, Swerford Park

Francis Russell, Esq, The Grange, East Hanney, Wantage

Shropshire

Mrs J. A. Fielden, Court of Hill, Ludlow

Somerset

The Hon. John Jolliffe, The Manor House, Kilmersdon, Bath

Committee: Mrs Tessa Davies; Mrs Maureen Davison; Lady Gass; Mrs Jane Kwiatkowski

Staffordshire

Arnold R. Mountford, Esq, MA, FMA, FSA, Director, City Museum and Art Gallery, Broad Street, Hanley, Stoke-on-Trent

Suffolk

Mrs Humphrey Brooke, Lime Kiln, Claydon, Ipswich

Surrey

Mrs G. E. Graham, 2 Garrick's Villa, Hampton Court Road, Hampton, Middlesex

Committee: Mrs Pamela Cowen; Mrs Kate Jemmett; Mrs Jean Scholfield

Sussex (East)

Henry N. Smith, Esq, FRICS, Lansdowne House, 42 Lansdowne Place, Hove

Committee: Mrs Yveline Milner; Miss Elise Newington; Miss Pamela Reynolds; Mrs Ann Smith

Sussex (West)

The Hon. Mrs David Blacker, Molecomb, Goodwood, W. Sussex

Tyne and Wear

J. R. Bernasconi, Esq, FRICS, 37 Montagu Court, Gosforth, Newcastle upon Tyne

West Midlands

Mr and Mrs Paul Spencer-Longhurst, 55 Charlotte Road, Edgbaston, Birmingham

Wiltshire

H. F. W. Cory, Esq, The North Canonry, The Close, Salisbury

Worcestershire

Mrs J. Wharton, Bartlam House, Shrawley, Nr Worcester

Committee: Stewart Anton, Esq; Mrs Michael Brinton; Richard Lockett, Esq; Henry Middleton, Esq; Mrs David Williams-Thomas

York

P. A. Womersley, Esq, DFC, AE, DL, Mount Villa, 306 Tadcaster Road, York

Yorkshire (South)

The Earl of Scarbrough, DL, Sandbeck Park, Maltby, Rotherham

Yorkshire (West)

Mrs Humphrey Boyle, Beacon Hill House, Langbar, Ilkley

Mrs Marshall Roscoe, North Deighton Manor, Wetherby

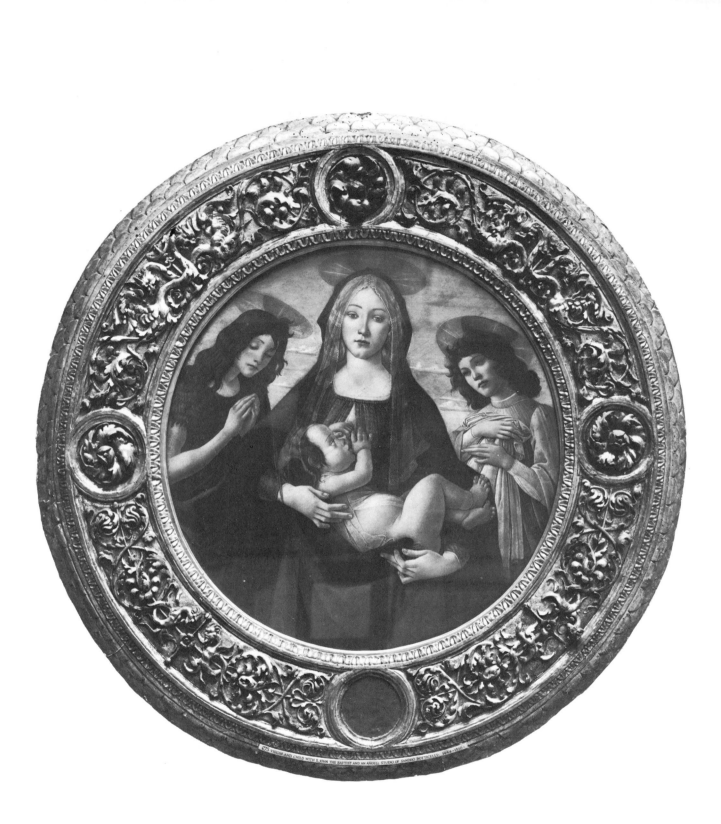

Late 15th century Central Italian frame, lent from the Victoria and
Albert Museum. Workshop of Botticelli: *Madonna and Child with two
Saints*. National Gallery, London.

84

Picture Framing: A Neglected Art

Peter Cannon-Brookes

In the flurry of excitement of making a new acquisition the future problems of presentation are all too often ignored and the impact of many fine paintings in British collections is sadly marred by unsympathetic framing. Shortly after receiving the splendid bequest of the Davies Collection, the then Keeper of the Department of Art in the National Museum of Wales, Rollo Charles, reported that at least eighty percent of the collection required reframing, and the same is true of a depressingly large number of collections the world over. In Britain, at least, the frame has tended to fall into a scholarly limbo, peripheral to the concerns of both the orthodox art historian and the furniture historian, whilst of interest to the historian of interior decoration only in general terms. Consequently it is to the professional framer rather than the scholar that the student of frames must turn. The literature on frames is decidedly patchy, with a strong bias towards the practical aspects, and only now is scholarly interest increasing. In part this is due to a more general recognition by curators and owners of the importance of good framing, and to the sharp increase in the cost of top quality frames. However this begs the question of what precisely constitutes 'a good frame' and in justifying the expenditure of many hundreds or thousands of pounds on a frame the curator today needs to be rather more sure of his ground.

A top quality French eighteenth century frame in good condition costs as much as a piece of French eighteenth century furniture – which indeed it is – or even a minor painting of the period, and consequently the need to avoid expensive and embarrassing mistakes is very real. The present author recalls that, after buying for the City Museums and Art Gallery of Birmingham the *Portrait of the Régent Orléans* by J.B. Santerre at a highly advantageous price, the local press protested loudly when the Museums and Art Gallery Committee was asked to pay for the frame almost double the cost of the portrait. Today Birmingham possesses not only a good eighteenth century French portrait but also a fine eighteenth century 'pièce d'ameublement'. Indeed, the frame cannot be seen in isolation from the setting which it occupies, as much as it cannot ignore the painting which it encloses, and thus the act of selecting a frame for a painting is the summation of a series of aesthetic and intellectual decisions as to the environment of which it is to form a part. Hence the importance of the curator and the framer forging a partnership as close as that shared by the curator and his conservator or his architect/ interior designer.

Nevertheless this continues to beg the question as to what precisely constitutes 'a good frame' since by its very nature such a partnership demands knowledge and taste on the part of the curator as well as the framer if the full potential is to be realised.

If anyone needs to be convinced of the need for frames at all they have only to visit the Palazzo Bianco in Genoa. The original museum interiors, dating from the late nineteenth century, were reconstructed by Franco Albini in 1950–51 and many of the modern design solutions pioneered there have proved highly influential. One of his most striking innovations was to unframe the paintings – even when they possessed fine period frames – and display them naked within an uncompromisingly modern ensemble. This provides an excellent test case for an extreme solution to the problems posed by picture frames and picture framing, and it is worth taking a closer look at the North Loggia. Here seventeenth century paintings, unframed, are mounted on steel poles implanted in stone blocks and they are seen against white smooth-plastered walls. By no stretch of the imagination does this system bear any resemblance to the settings envisaged by the artist who created the paintings and, apart from well-aimed criticisms to the effect that the ensemble represents a crudely insensitive triumph of the Modern Movement over traditional values, the contrast between those dark seventeenth century paintings and the white walls makes the rectangle of the canvas a very strong visual element and the painting itself insignificant. This display draws our attention to the need to balance contrasts so that the surroundings of the painting support it and do not reduce its legibility.

The problems posed by a dark painting against a glaring white wall are paralleled by the difficulty to be experienced in seeing properly a dark Spanish painting, for example, in a brightly gilt frame. The strong contrast along the edges can render much of the peripheral areas of the painting very difficult to read. During the setting up of the exhibition

L'Ideale Classico del Seicento in Bologna (1962) one painting arrived from a British noble collection in a fine eighteenth century French frame which had recently been regilded. For reasons best known to the owner, this frame had not been toned and such was the disruptive effect that urgent telegrams were sent to the owner requesting permission to display the painting unframed as the lesser of two evils. Modern taste, at least in certain circles, prefers very bright gilding and the present author was once told, in the Midlands, by a local gilder, that if he wanted to have the new gilding on a large tabernacle frame toned he 'could damned well do it himself' because the gilder was not going to 'spoil' his finish!

This is not the place to attempt a potted history of frames and framing, but it is perhaps an appropriate moment to draw attention to some of the factors to be taken into account when reaching the decision to frame and carrying it out. Most Old Master paintings of any importance have a long history of reframing and, apart from changes in use and the vagaries of taste, frames will not stand up well to the rigours of trips to the auction rooms. Consequently the question first to be asked is whether the existing frame is the original and, if not, when was it made? and when were frame and painting united? High quality Old Master paintings with their original frames, apart from altarpieces, are very rare indeed and it is difficult for the would-be student of frames to discover the status of a particular frame without examining its reverse. This has resulted in a chicken-and-egg situation whereby there are few specialists in the field and, since virtually no frame catalogues are easily available, there are few opportunities for learning about frames. Rare also are the painting collection catalogues which include information concerning their frames, and even the otherwise exemplary National Gallery catalogues are silent in this respect. Count Antoine Seilern formed a superb collection of frames and it is to be hoped that these will be fully published by the Courtauld Institute soon. However, an original frame, when it can be identified correctly, is not necessarily a good frame and may come as a considerable disappointment – for example those on the Monets in the Vienna collection. Such a frame nevertheless remains an historical document and if it is decided to reframe the painting the original frame should always be preserved as part of its documentation. In 1979 the National Museum of Wales purchased Monet's *Pool of London* (1871) which had passed down the Cassatt family in Philadelphia. According to the family the former frame had been selected by Degas and its subsequent disappearance, if only a document of Degas's taste, is greatly to be regretted.

In choosing a frame for a painting the principal questions to be borne in mind are 1) What kind of frame would have been envisaged by the painter? and would this have been a significant factor in his treatment of the subject?; 2) Is it either feasible or appropriate to consider framing the painting as it would have been originally?; 3) How is the framed painting to relate to other paintings and other frames in that room/gallery in which it is to hang?; 4) Are there any other historical precedents to be considered?; and 5) What practical considerations are there with regard to size, weight and portability? In Medieval times and during the Early Renaissance the frame precedes the painting, and both the technical examination of these paintings and the documents available demonstrate that it was only when the specialist craftsman had completed the construction of the panel or polyptych, including the integral planks of wood which were to be painted, was the painter called in. Even the gilding of the frame had been completed by then and the painter's contribution was the last to be made. This pattern of work continued, at least for altarpieces, until the beginning of the sixteenth century and the evidence concerning the richly decorated aedicule altarpiece in the Frari, Venice, indicates that the splendid carved and gilt frame by Jacopo da Faenza (signed and dated 1488) preceded the execution of the paintings by Giovanni Bellini. The close relationship between painting and frame at this date is further exploited, both North and South of the Alps, in their integration into a single illusionistic ensemble and the evidence tends to suggest that this innovation was conveyed from Flanders to Italy, partly through the medium of Flemish portraits.

Architectural framing and the development of illusionistic structures go hand in hand, and the Cornbury Park Bellini (signed and dated 1505, City Museums and Art Gallery of Birmingham) provides a most illuminating parallel to his San Zaccaria altarpiece in Venice of the same year. In the latter the painter picks up the architectural structure of the real world – as represented by the carved stone frame to the painting – and extends it illusionistically in the form of a fictive side chapel to the church. It would be unthinkable for the frame carver to have been instructed to follow the painted elements in the altarpiece, and even in the second half of the century in Venice the richly carved and gilded wooden structures of the ceilings of the Doge's Palace were completed before consideration was given to which painters might be commissioned to paint the canvases to be inserted in the openings. In the Cornbury Park miniature altarpiece the remains of tongues on the panel demonstrate that the original frame had been integral with it, whilst from the double shadow in the foreground it can be deduced that the original frame had a free-standing column on each side of the centre panel and that the altarpiece had been designed for a small oratory with two windows in the left hand wall. In Northern Europe composite altars with both sculpture and paintings were common in the Middle Ages and the surviving fifteenth century altars were, like their Italian counterparts, architectonic

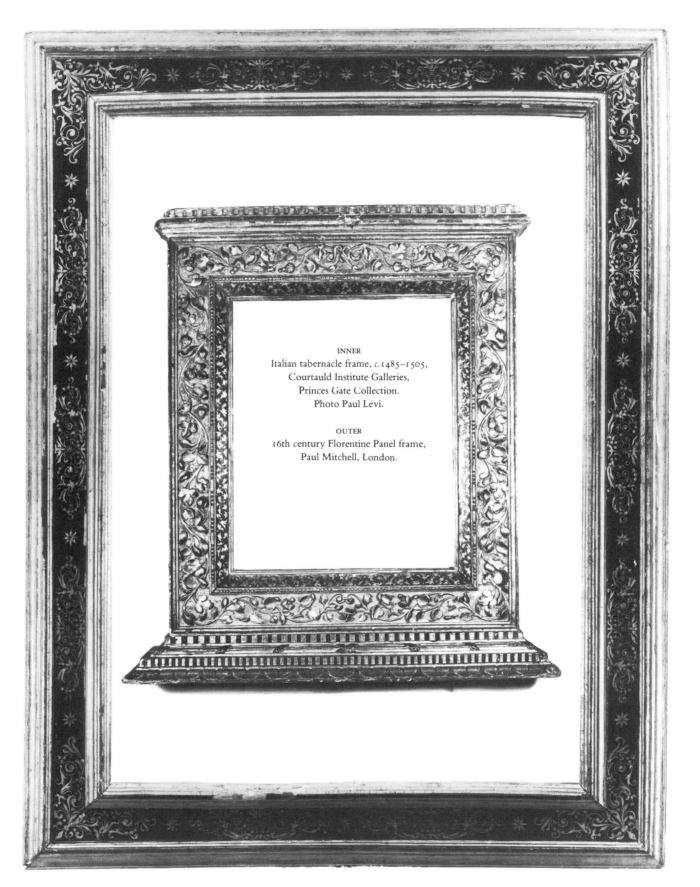

INNER
Italian tabernacle frame, *c.*1485–1505,
Courtauld Institute Galleries,
Princes Gate Collection.
Photo Paul Levi.

OUTER
16th century Florentine Panel frame,
Paul Mitchell, London.

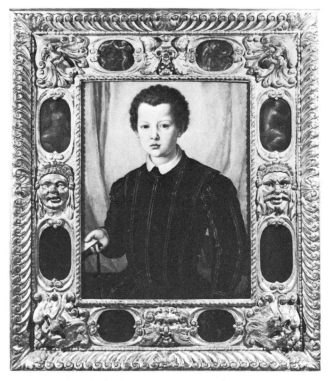

Portrait of Giovanni de' Medici by Agnolo Bronzino. Mid-16th century Florentine frame with painted inserts from the circle of Giorgio Vasari. Ashmolean Museum, Oxford.

structures in their own right. Thus the mid-fifteenth century Flemish altars with fictive sculpture in fictive architectural settings, often painted in grisaille, follow faithfully the precedents established in those other two fields of artistic production. The painted mouldings parallel those employed by contemporary stone masons, and the real and the fictive are closely integrated. For example, in the *Virgin Annunciate* by Jan van Eyck (1430–35) in the Thyssen Collection, the fictive architectural setting painted in grisaille merges imperceptibly with the real, 'engaged' wooden frame which is in turn marbled. Marbling is common on the surviving fifteenth century Flemish portrait frames and on occasion the composition is allowed to flow out over part of the frame.

Italian Renaissance carved wood altars similarly reveal close parallels, in their mouldings and detailing, to those employed by the stone carvers and terracotta modellers, and during the first quarter of the sixteenth century many of the latter transferred to the production of stucco decorations. Throughout the sixteenth and seventeenth centuries there is a close rapport between the development of stucco decorations and that of carved wooden picture frames, and since the former are often reliably dated they provide a valuable chronological sequence. In Florence the relationship between the frame carvers and the architects is possibly illustrated by the 'M Giuljano da san Ghallo' scrawled in a

contemporary hand on the reverse of a tondo from the workshop of Botticelli, now in the National Gallery. Dating from *c*.1490 this inscription is presumed to have been a workshop 'aide memoire' that the painting was to be sent to the architect Giuliano da Sangallo for framing, and he is documented as having made the frame for Botticelli's altarpiece of *c*.1485 now in Berlin. Close in date are the splendid series of frames in Santo Spirito in Florence and the Capponi altarpiece by Piero di Cosimo (National Gallery, Washington) almost certainly post-dates the carving and gilding of the wonderful frame by Chimenti del Tasso (payment in 1489) which is still in situ. Dürer combined both roles in his Landau Altarpiece of *All Saints*. A preliminary design for the frame, signed and dated 1508, is at Chantilly, whilst the wooden frame was carved by Veit Stoss in 1511 (Germanisches Nationalmuseum, Nuremberg). On the other hand the richly carved frame for Michelangelo's tondo of the *Holy Family* in the Uffizi, carved by Antonio Barile, owes little to the master himself.

This very elaborate frame developed from the glazed terracotta wreaths round modelled coats of arms evolved by the Della Robbia workshop during the previous century and carved and gilded circular frames with foliage and fruit are amongst the most characteristic productions of the period. Circular and oval paintings tend to retain their original frames slightly more often than rectangular paintings if only because of the difficulty in adapting or reusing them (that is except as mirrors, but mirror plates of the requisite size were not available until long after both paintings and frames had passed out of fashion, and the utilisation of such frames for mirrors has been mainly in recent times). A considerable number of small Renaissance tabernacle frames survive, though now separated from the paintings for which they were carved, and also owing to the relative ease of adapting them for paintings slightly different in size few Renaissance panel frames remain united with the paintings for which they were made. The *Portrait of Giovanni de' Medici* by Bronzino in the Ashmolean Museum, which is displayed in an exceptionally fine, contemporary Florentine frame with painted decorations is, unhappily, only the product of a brilliant modern marriage. With Renaissance paintings it is relatively easy to postulate the kind of frame which might have been envisaged by the painter or the patron, but whether it is either feasible or appropriate to frame a painting in this way will depend upon the plans for the room in which it is to be housed and the resources which can be allocated. A single Renaissance devotional painting in a tabernacle frame can set the atmosphere for a whole sector of a display, but ten tabernacle frames clustered together could look slightly ridiculous. Hence the preference for a predominance of panel frames rather than architectonic frames – including Venetian and Tuscan 'Sansovino' frames – for a collection

of Renaissance paintings.

In general it is more rational and visually acceptable to display a painting in a frame whose period is the same as that of the painting, or later, rather than earlier, notwithstanding the continued popularity of Louis XV frames for French Impressionists etc. The great altarpiece of the *Raising of Lazarus* by Sebastiano del Piombo presumably acquired a contemporary frame when the Régent Orléans obtained it from Narbonne Cathedral for his gallery early in the eighteenth century, but it was reframed by Angerstein after he had purchased it at the Orléans Sale in 1798. There are many who bemoan the loss of the massive gilt frame supported on the backs of crouching lions enjoyed by earlier visitors to the National Gallery.

Monumental altarpieces which have in the course of time been taken into secular galleries present particular difficulties and the voracious collecting by the Medici family during the seventeenth century of Renaissance altarpieces gives the main rooms of the Galleria Palatina in the Palazzo Pitti one of their particular qualities. It was one of the first galleries to be reframed en suite and these richly exuberant frames, entirely gilt, must have provided a startling contrast to the much more sombre dark panel frames with little or no gilding preferred during the earlier decades of the seventeenth century. In Northern Europe Cardinal Mazarin would also appear to have been a leader of taste in this respect, preferring gilt frames, and to reframe, for example, a major painting by Claude in the kind of mid-seventeenth century Roman frame preferred by most collectors then would today appear to many dowdy or perverse. Consequently it is often not feasible or appropriate to consider framing the painting as it might have been when first painted, not least because of the preconceptions of today's viewers and the company which the painting is to keep.

The question of how the framed painting is to relate to other paintings and frames in the room which is to house it becomes, in consequence, relatively much more important than the historical considerations, and thus most large Claude paintings tend to be displayed in eighteenth century French frames rather than, for example, seventeenth century Barberini frames. The frame is inevitably part of the decoration of the room and in extreme cases – such as the Galleria Palatina – the frames are so richly carved and

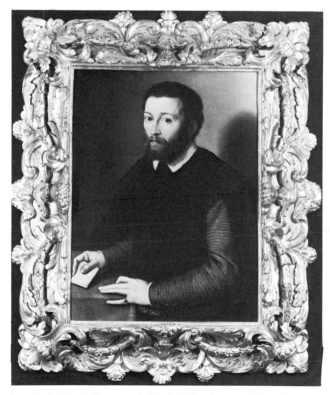

Portrait of a Man by Francesco Salviati. Mid-17th century Florentine frame of the 'Pitti' type. With Heim, London 1982.

Charles II by Thomas Hawker, *c*.1680. The splendid 'Sunderland' frame is contemporary. National Portrait Gallery, London.

Portrait of Cardinal Jacopo Rospigliosi by Carlo Maratta, 1667–69. The superb frame is contemporary, carved in Rome. Fitzwilliam Museum. Cambridge.

closely packed together that they themselves alone constitute the wall decoration. Certain designs of frames, such as the Dutch 'Lutma' frame and its English equivalent – the 'Sunderland' frame – belong as much to the world of furniture and interior decoration as to that of paintings, whilst the basic Roman frame type dating from the latter part of the seventeenth and early eighteenth centuries which bears the names of 'Maratta' and 'Salvator Rosa' was the model for innumerable permutations and combinations executed all over Europe until the present day. The superb original Maratta frame ornamenting, most appropriately, Carlo Maratta's *Portrait of Cardinal Jacopo Rospigliosi* (1667–69) in the Fitzwilliam Museum is one of the finest examples of its kind, and that museum possesses a particularly good series of antique frames.

However, the precedent consolidated by the Medici in the Galleria Palatina, and followed locally for the Casa Tempi, was greatly developed during the eighteenth century when distinctive house-styles of framing were evolved for a number of the more important European princely galleries. The Régence house-style created by Effner for the Elector Max Emanuel of Bavaria early in the century was followed by equally distinctive Rococo

frames for the collections of Augustus III of Saxony and Frederick the Great, and more classical patterns for the Dusseldorf Gallery (1770–75) and the Munich Hofgarten Gallery (Lespilliez, *c.*1779). Although the French court and the frames created for it exercised immense influence throughout the eighteenth century, there were never the same distinct house-styles as were favoured in Central Europe, or the equivalent of the frames created at the close of the century for the Spanish Bourbons. One consequence of the massive programmes of house-style reframing during the eighteenth century was the custom which then grew up of displaying seventeenth century Dutch and Flemish paintings in richly carved and gilt frames. This taste survives even today and only a few of the more alert public galleries have initiated programmes of reframing their Dutch and Flemish paintings back into the black frames which so greatly improve their legibility and enable us to appreciate fully the atmospheric effects. The adoption of a house-style of framing was continued in Germany into the nineteenth century with Schinkel's frames for the Berlin Gemäldegalerie (1823–30) and Klenze's for the Alte Pinakothek (1830–36), both intended to be complementary to the design of the buildings and the gallery interiors. Rarely imitated elsewhere in public collections, the movement has been away from house-styles and it has to be admitted that a Dresden Cranach in a Rococo Augustus III frame does look a little odd. However certain frame designs are associated instead with specific artists – such as Pietro Rotari and the Longhis – rather than collectors and the influence of the artist in post-Renaissance times on the framing of his paintings depended to a very considerable extent on the methods of marketing. The Longhi conversation pieces and their distinctive Venetian moulding frames with 'turned-over' foliage along the rebates survive together so often that some kind of direct link must be postulated.

Nevertheless the identity of specific framemakers in the eighteenth century and before is rarely recorded and signed frames are few and far between. These are mostly eighteenth century French, but additional research in the archives will undoubtedly enable the names of further craftsmen and designers to be identified and linked with distinctive frames. The process is often tantalising and, to take an example, for the exquisite carved and gilded French Rococo frame ornamenting the *Portrait of Richard Bateman* by Robert Tournières Le Vrac, in the City Museums and Art Gallery of Birmingham, the name of the supplier in Paris, the price paid and all the arrangements for packing and transport are documented, but not the workshop which carved this little masterpiece. Virtually the same is true of the superb frames for the series of portraits of Sir Robert Throckmorton and his daughters by Largillière at Coughton Court, Warwickshire, and these are surely amongst the finest eighteenth century French frames in Britain. On the other hand we are

Nicolas Poussin: *Adoration of the Golden Calf.* Very richly carved frame made for the Régent Orléans, *c.*1710, when the painting was in his collection. National Gallery, London.

only just beginning to identify the origins of British frames of comparable importance such as the splendid Rococo frame attributed to Chippendale ornamented with lions and martial trophies, carved for the *Portrait of George III when Prince of Wales,* by Knapton (*c.*1751); now in the Victoria and Albert Museum, and thought to be by the carver and gilder, Paul Petit. The importance of Robert Adam for the design of frames has long been recognised and his integrated designs for interiors, such as the Saloon at Saltram, demanded specially designed frames for relatively few paintings in fixed positions within the rooms. However, such frames out of context can be most uncomfortable.

Few groups of paintings present more intractable problems than those of the mid- and late-nineteenth century. Pre-Raphaelite paintings, mercifully, often retain their original and highly distinctive frames which contribute so much to the overall impact of these works and thus it is always possible to copy standard patterns when required.

More difficult are the often exotic frames of artists such as Franz von Stuck and those designed for Klimt and the painters of the Vienna Secession. These are by their very nature both unique and wilful, and only recently has it become possible again to obtain carved frames which faithfully reconstruct their spirit. Whistler recognised the problem and designed his own style of reeded moulding frame, much imitated subsequently, but for most nineteenth century artists the more or less florid gilt gallery frames demanded by the Salons and Royal Academy Summer Exhibitions set the tune. These were often executed in composition rather than carved and after a century or more they are extremely fragile if not already damaged almost beyond repair. French Impressionist paintings were originally framed by Durand Ruel and others in frames of this type. With the rising value of these paintings early in the twentieth century the dealers sought to improve the status of their stock by reframing them in Louis XV frames or imitations thereof except for those by Manet. Manet's paintings have always tended to be framed in the twentieth century in Spanish or provincial Italian types of frames, thus

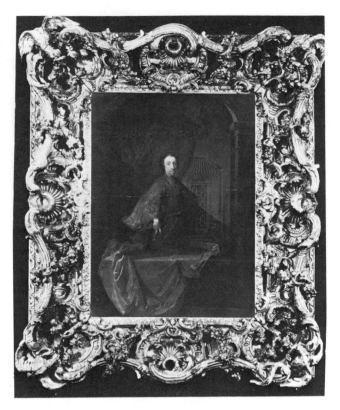

exploiting one element in his stylistic evolution. The Post-Impressionists, and above all Cézanne's later paintings, are the most problematical and in this respect the 1978 exhibition *Cézanne, the Late Work* was a vivid demonstration of the total confusion reigning. From the naked pine frames of the Russian loans to the most expensive French Rococo frames virtually every possibility had been tried, usually with a marked lack of success. For this reason, if no other, such monograph exhibitions provide a wonderful opportunity to assess the relative merits of the different styles of framing available and the simple, severe forms of a few Late Louis XVI frames stood out as providing precisely that harmonious support of the painting which is the aesthetic basis of all framing. The owner or curator considering the reframing of a painting may indeed be setting out on a long road, but it is one which affords a rich crop of new insights and, when successfully achieved, the provision of a good frame is the source of immense, shared satisfaction.

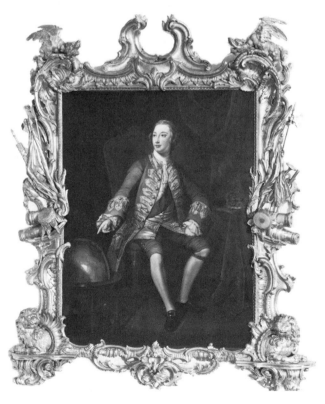

Above: Hyacinthe Rigaud: *Antoine Paris, Conseiller d'Etat,* 1733. Contemporary Paris frame of exceptionally fine quality. National Portrait Gallery, London. Photo Heim, London.

Above right: Robert Tournières, Le Vrac: *Portrait of Richard Bateman,* 1741. One of a pair of miniature full-length portraits in spectacular Paris frames of different designs carved in 1741. City Museums and Art Gallery, Birmingham.

George III as Prince of Wales, studio of George Knapton, *c.*1751. Elaborate English Rococo frame probably designed and carved by Paul Petit, who worked for Frederick, father of the sitter. Victoria and Albert Museum,

Madame Moitessier Seated by J. D. A. Ingres. The flowers were made of
composition using a large number of moulds. National Gallery, London.

Balaam and his ass (f.43).

The Rutland Psalter

D.H. Turner

In the thirteenth century, the early Gothic period, English painting was second to none in Europe. Mostly it is to be found on the pages of illuminated manuscripts, although there is also the magnificent Westminster Retable. The British Library is fortunate in having in its keeping many of the finest of English thirteenth century illuminated manuscripts. Outstanding amongst them are the Westminster Psalter from the beginning of the century, the Evesham Psalter from the middle of the century, and the Oscott Psalter from the third quarter. To these has now been added the splendid psalter which since at least 1825 had been in the possession of the Dukes of Rutland at Belvoir Castle and is known as the Rutland Psalter. The acquisition, by private treaty purchase, has been made possible thanks to extremely generous assistance from the Friends of the National Libraries, the National Art-Collections Fund, the National Heritage Memorial Fund, and the George Bernard Shaw Bequest. Both the British Library and the vendors, the trustees of the ninth Duke of Rutland's Will Trust, benefit from the exemption from capital tax applied to private treaty sales of works of art to the nation. A large part of the net proceeds of the sale will go towards the maintenance and preservation of Belvoir Castle. The sale was negotiated by Christie's.

The Rutland Psalter comprises 190 leaves, of which the last twelve are late fourteenth or early fifteenth century additions. All the leaves measure 29·8 × 20·3 cm and virtually all have some decoration on them. The major ornamentation of the book consists of six splendid full-page miniatures, one of each of which precedes psalms xxvi, xxxviii, li, lxxx, xcvii, and cix, and there is an elaborate initial at the beginning of psalm i, which occupies a whole page. The initial, the 'B' for 'Beatus' ('Blessed', the first word of the psalm) has its loops formed by the bodies of two dragons and on its stem are two lions. On the back of each of the dragons is a man fighting with his fellow on the back of the other dragon by seizing his hair. The dragons are being attacked by a man with a sword and shield on the back of each of the lions and whilst the dragons bite the men's shields the lions are biting the dragons' tails. The composition probably represents a fight between good and evil, with the lions symbolizing good and the dragons evil.

In each of the loops of the 'B' is a scene: in the top one, King David playing a harp; in the bottom one, the Judgement of Solomon. The initial is surrounded by a rectangular border, which has a round medallion at each corner, and there are three more round medallions arranged vertically to the left of the 'B'. In the medallions are scenes of the Creation and Fall.

The subjects of the six full-page miniatures are (i) the anointing of Solomon; (ii) Balaam, with his ass and the angel; (iii) King Saul casting a javelin at David; (iv) Jacob's ladder; (v) King David playing the organ; and (vi) Christ in Majesty. Besides the large Beatus initial there are eight other smaller initials, one each preceding psalms xxvi, xxxviii, li, lii, lxviii, lxxx, xcvii, and ci, which incorporate scenes in their designs. At the beginning of the manuscript is a calendar which has on each of its twelve pages two roundels, one containing a representation of a sign of the zodiac, the other one of a labour of the month. A particular feature of the Rutland Psalter is that there is a wealth of marginal illustration, the subjects of which are drawn from contemporary English life or from fables, or consist of monsters, dragons, fanciful animals, and grotesques. Amongst the genre scenes are a beggar carrying a baby, a captive bear, a ducking-stool, a jongleur, a woman juggling with knives, a captive monkey being taught to dance, two men having words – the words being given, namely 'tu es asin[us] ('you are an ass'), in mirror writing – and rabbit-hunting. Games and sports appear, such as chess, putting the stone, and wrestling. The fanciful animals include a bear playing a pipe, a bear chasing a naked man up a tree, mice hanging a cat, a fox attired as a bishop preaching to chickens, a rabbit playing cymbals, and a rabbit playing a pipe. Marginal illustrations similar to those in the Rutland Psalter appear on occasion in earlier manuscripts but this is the earliest example of them as a sustained ingredient of book illumination. Such marginal illustration was, of course, to become a feature of English illumination and the Rutland Psalter stands at the beginning of a great tradition which culminates in such manuscripts as the Gorleston Psalter and the Luttrell Psalter.

There is no obvious provenance for the Rutland Psalter. The entries in the calendar and the litany in it offer no clues.

Note may, however, be taken of an obit added in a thirteenth century hand on May 24th, 'O[bitus] do[mi]ni Edm[un]di de Laci'. This has been taken as referring to Edmund de Lacy, Earl of Lincoln, and died in 1258, although other sources give different dates in June for the day of his death. Edmund's mother, Margaret, was Countess of Lincoln in her own right and outlived her son. He had an Italian wife, Alice, daughter of the Marquess of Saluzzo. There is not sufficient evidence to connect the Rutland Psalter definitely with the Lacys and some iconographical peculiarities in it have royal undertones. These peculiarities are the appearance of the Judgement of Solomon as a scene in the Beatus initial and the large miniature of the anointing of Solomon. The anointing of David by the prophet Samuel is a common enough illustration for psalm xxvi, 'Dominus illuminatio mea: et salus mea' ('The Lord is my light, and my salvation'), but here are two figures, one anointing and the other crowning a young man who is seated on a throne and holds a sceptre. It seems that this could be a representation of Zadok the priest and Nathan the prophet anointing Solomon rather than of the anointing of David, and such a representation would appear to be unique. However the Glazier Psalter in the Pierpont Morgan Library in New York, executed *circa* 1225, which also has in its miniatures an emphasis on regality, has as one of these a scene of a king being crowned by two bishops which is clearly labelled as the coronation of David. The participation of two figures, therefore, does not preclude the picture in the Rutland Psalter from referring to David. It has been suggested that the miniature in the Glazier Psalter bespeaks an interest in contemporary debate about the significance of anointing in the coronation ceremony. This interest seems to be still there in the Rutland Psalter, and heightened, for whereas in the Glazier manuscript the king is only crowned, in the Rutland one he is definitely both crowned and anointed.

Even more intriguing than the miniature preceding psalm xxvi in the Rutland Psalter is the next one, that before psalm xxxviii, 'Dixi custodiam uias meas: ut non delinquam in lingua mea' ('I said, I will take heed to my ways: that I offend not in my tongue'). The use of the story of Balaam as an illustration for psalm xxxviii appears to be without parallel and it seems that it should be a definite allusion. What might be the significance of the parable of the prophet whom St Thomas Aquinas termed 'the prophet of the devil' and who blessed when he intended to curse and who was rebuked by his own beast of burden? The only idea which has so far come to the present writer – which he has not, as yet, had an opportunity to pursue properly – is whether the allusion is to Simon de Montfort. Simon was extremely devout and pious, but in the eyes of the people surrounding the King, Henry III, he was a fraud and a traitor. It does not seem too implausible to relate the miniature of Balaam and the ass in the Rutland Psalter to the downfall of Montfort at the battle of Evesham on 4 August 1265. This, together with the royal undertones which have been remarked elsewhere in the book, seems to orient it towards the court of Henry III.

Another iconographical oddity in the Rutland Psalter is the appearance twice of a eucharistic host in the hand of the Almighty. The initial 'S' at the beginning of psalm lxviii, 'Saluum me fac deus: quoniam intrauerunt aquae usque ad animam meam' ('Save me, O God: for the waters are come in, even unto my soul'), is a historiated initial containing the scene of Jonah being cast overboard to the whale. Above, is a half length figure of the Almighty, who raises his right hand in blessing and holds in his left a host. In the miniature of the anointing of Solomon there is again a half figure of god at the top of the page. His right hand is stretched down to bless and in his left he holds a host. This is presumably meant also to represent the sun since on the Almighty's left is the moon. Devotion to the sacramental body of Christ was on the increase in the thirteenth century and brought about in 1264 the institution by Pope Urban IV of a feast of Corpus Christi. However, the observance was slow in gaining general acceptance and does not seem to have been introduced into England until the early fourteenth century.

The illumination of the Rutland Psalter is throughout of the highest quality. Stylistically it can be dated to the third quarter of the thirteenth century, between the Evesham Psalter (*circa* 1250–1260) and the Oscott Psalter (*circa* 1270). Perhaps three artists can be distinguished at work in the figural illumination. To one can be attributed the Beatus page, the miniatures of the anointing of Solomon and Jacob's ladder, the historiated initials, and the marginalia. To another may be assigned the miniatures of Balaam and his ass and Christ in Majesty, whilst the picture of Jacob's ladder seems to be by yet another hand. However, the style of all the illumination in the manuscript, decorative as well as figural, is very coherent, clearly the product of one atelier. In conversation with the writer Nigel Morgan (an expert in the field and Director of the Index of Christian Art at Princeton) has said that he thinks this atelier was situated in London and that it was a secular, commercial, one specializing in the production of illuminated manuscripts to order. The miniaturist to whom is being assigned the Beatus page and other work has a sharp, clear, manner, which looks forward towards the style of the Oscott Psalter. There is even a similarity of *traits,* such as the V-shaped markings on foreheads and the developed musculature in necks. The colouring tends to richness. By contrast, the other two Rutland miniaturists employ smoother colours and Balaam and his ass and Christ in Majesty are in almost pastel shades. The drapery in the Rutland miniatures is conservative in style, with pronounced folds which recall garments in mid-thirteenth century English painting.

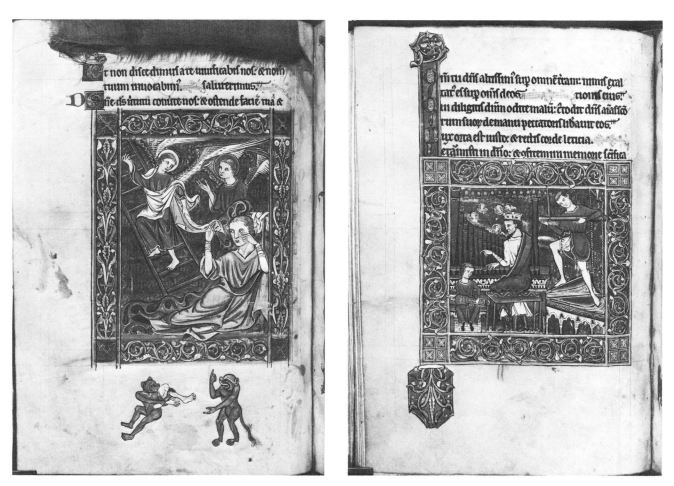

Jacob's Ladder (f.83b).

King David playing the organ (f.97b).

There are only two definite pieces of information about the history of the Rutland Psalter before it is mentioned in a manuscript catalogue dated 1825 in Belvoir Castle library. Both are supplied by entries in the Psalter. The first is an erased inscription, which when it was temporarily restored by means of a reagent revealed that the book had been given to Reading Abbey by John Clifton, Prior of that house. He is not otherwise known, but the writing of the inscription appeared to date from the late fifteenth century. Then, on 2 October 1587, one Ethelbert Burdet recorded his ownership of the Psalter. He was a fellow of All Souls College, Oxford, in 1546 and a canon of Lincoln Cathedral in 1565. In 1896 the Rutland Psalter was lent to an exhibition at the Society of Antiquaries of London. Whilst there it excited the cupidity of William Morris, who made an unsuccessful attempt to acquire it. '*Such* a book! *my* eyes! and I am beating my brains to see if I can find any thread of an intrigue to begin upon, so as to creep and crawl toward the possession of it.' It is related that shortly afterwards the Psalter was lent to Morris and it has been conjectured that it may have been the book brought to the bedside of the dying Morris by Emery Walker, who gave up all hope of Morris's life when he found he was too ill even to look at it.

The Rutland Psalter (Add. MS 62925) illuminated manuscript mainly mid-13th century
190 pages, nearly all decorated, six with full page miniatures, one with an elaborate initial 'B'. Size of page (average) 29·8 × 20·3 cm
Bought for £870,000 (Trustees of the 9th Duke of Rutland's Will Trust) by the British Library with the help of a contribution of £50,000 from the NACF (William Leng Bequest)

A Pair of Etchings by Kolbe

Antony Griffiths

Carl Wilhelm Kolbe (1759–1835) has had only one book devoted to him, a monograph published by Ulf Martens in 1976. In the preface the author laments the lack of general awareness of Kolbe's work, but admits that this is hardly the public's fault. The blame should be laid firstly on Kolbe himself for never making a painting but confining himself to drawings and etchings, and then on the printrooms of the world for hardly ever putting his works out on public view. If anyone does know Kolbe's work, Martens continues, it will probably be through the chance print coming onto the market and arousing interest. The British Museum can perhaps escape Martens's strictures although the few works by Kolbe that it collected in the nineteenth century are unrepresentative and of low quality. But Martens guessed correctly how interest might arise. For many English print-lovers Kolbe only became more than a shadowy name in 1977 when Christopher Mendez held a remarkable exhibition of most of his finest plates. Then, and subsequently, the British Museum managed to acquire eleven of his prints. The two etchings illustrated here were, however, not in that exhibition. They appeared at auction at the end of 1982 and were presented to the Museum by the National Art-Collections Fund, with the balance of the fund subscribed in memory of Lord Crawford and the income from the Campbell Dodgson Fund. The quality of the prints is self-evident; but their strangeness cries out for explanation or elucidation.

Kolbe was born in Berlin; his father was a maker of wallpaper, his mother was French. He was educated at the French school in Berlin, and after leaving was appointed to teach French at the Philanthropin in Dessau – at that time the most famous school in Germany and a pioneer in the introduction of Rousseau's ideas into education. The letter of recommendation spoke of Kolbe's taciturnity, timidity and under-estimation of his own capabilities. In 1782 he briefly took up a post as secretary to a minister in Berlin but soon returned to his old job in Dessau, where he was given the additional responsibility of drawing master. A chance visit in 1789 by a distant relative, the famous etcher Daniel Chodowiecki, decided Kolbe to abandon teaching and take up the study of art in earnest. In Berlin he found himself cut off by age from most of his fellow-students, but devoted himself to drawing from casts (under A.J. Carstens) and from life. Curiously he took no lessons in landscape, the subject for which he knew himself to have a gift, nor in etching, which he laboriously taught himself in 1793. In 1795 he became a member of the Berlin Akademie der Künste, but his timidity and ill-health led him back once again to Dessau where he was reappointed to his old post teaching French and drawing in the reconstituted Hauptschule. With the exception of three years in Zurich in 1805–8, he never again left Dessau, retiring from the Hauptschule in 1828 at the age of 69. In 1825 he published a short autobiography, and also wrote a number of treatises on French philology.

Under an enlightened Duke (Leopold Friedrich Franz, 1st Duke of Anhalt Dessau, 1740–1817), the last years of the eighteenth century were Anhalt's 'golden age'. A stimulus to artistic creativity was supplied by the foundation of a Chalcographische Gesellschaft, which attracted a large number of professional printmakers to the town, though characteristically Kolbe reacted by fearing that he would be forgotten in the mêlée. The years between 1796 and 1805 however saw a remarkable flow of etchings from his needle, including most of his finest works. With the exception of some plates showing nude bodies in violent action, all were landscapes. In letters of 1795–6 to his Berlin friend J.F. Bolt

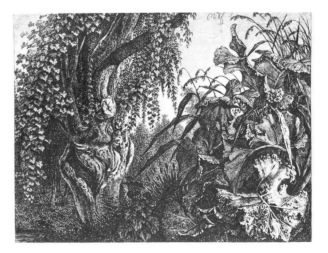

he declared his sources of inspiration. First and foremost was nature herself, and in particular the vast oak forests that surrounded Dessau. Second was the work of two artists, the Swiss painter and illustrator Salomon Gessner (1730–88) and the Dutch etcher and draughtsman Anthonie Waterloo (c.1610–90). Gessner gave him his pastoral motifs and idyllic mood, Waterloo his landscape structure and use of trees. The types of landscape produced were varied: some were heroic, some Italianising, but the most remarkable were the 'Kräuterstücke', which are unparalleled in the work of any other artist. Leaves of cabbages and other plants are expanded to such a size that they dwarf men, animals and even trees. The greatest of these plates is entitled 'Auch ich war in Arkadien' (Et in Arcadia Ego), and this is perhaps the print of Kolbe's most likely to be familiar since it is discussed and reproduced in Panofsky's famous essay on that theme. The British Museum possesses what might be called its companion piece, the 'Landscape with a youth playing a lyre by a fountain', made in 1802 or 1803. Towards the end of his career in the 1820s Kolbe returned to his 'Kräuterstücke', but in the two prints illustrated here, all figures whether animal or human are omitted. All that is left are the leaves, but with the dislocations of scale inbuilt so cunningly that what are in fact very small etchings (barely six inches across) appear to be colossal.

Kolbe's place in the history of art defies conventional assessment. Runge admired his work, but it was too backward-looking to be of interest to the new school of landscapists around the Nazarenes. But it clearly forms a crucial component of the collection of German prints of the Romantic era that the British Museum is now attempting to put together.

Carl Wilhelm Kolbe (1757–1835)
Krauterblätter, a pair of etchings
12·8 × 15·5 & 12·3 × 15·6 cm

Reference: Martens, nos. 72 and 73; Jentsch, nos. 222 and 223.

Bought for £613.25 (Christopher Mendez) for the British Museum by the NACF with contributions from the fund in memory of Lord Crawford and the Campbell Dodgson Fund.

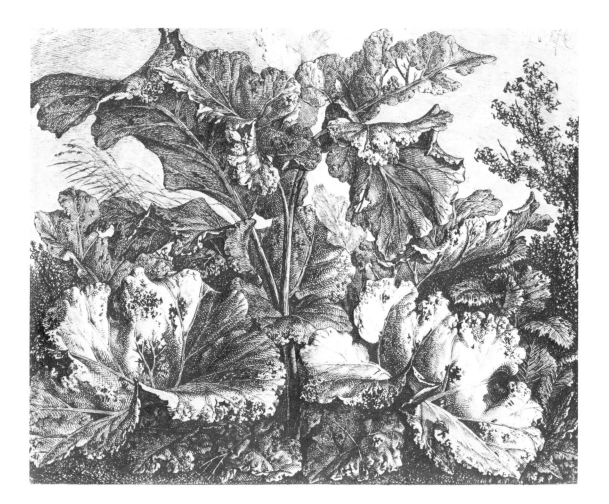

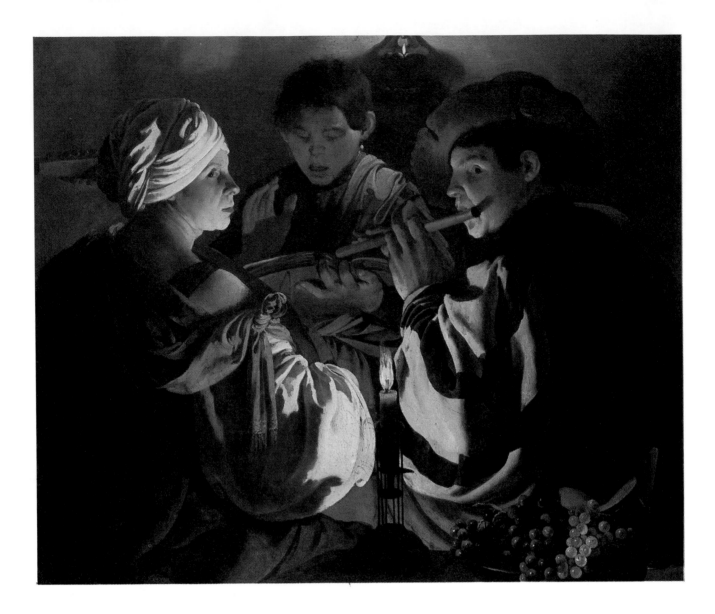

The Concert by Hendrick Terbrugghen

Christopher Brown

In May 1983 the National Gallery purchased Terbrugghen's *The Concert* with the aid of a contribution of £500,000 from the National Heritage Memorial Fund and donations from the Pilgrim Trust and the National Art-Collections Fund. *The Concert* has strong claims to be Terbrugghen's finest treatment of a secular subject. He has taken a subject favoured by Caravaggio and his followers – a group of flamboyantly dressed musicians seen by candlelight – and rendered it in his own distinctive manner, placing the dramatically lit half-length figures against a light background. The candle throws the elaborate folds of their costumes into relief, the deep brown and black shadows enlivened by plum, green and light blue highlights.

Hendrick Terbrugghen (1588?–1629) is today considered to be the most outstanding member of a group of painters from Utrecht – Dirk van Baburen and Gerrit van Honthorst were others – who travelled to Italy in the earliest years of the seventeenth century and were profoundly influenced by contemporary developments in painting there, especially by the work of Caravaggio and his Roman followers. They are known collectively as the Dutch *Caravaggisti*. Terbrugghen was born in Deventer into a wealthy and distinguished Catholic family. His father moved to Utrecht in about 1591, the year in which Prince Maurits defeated the Catholic faction in Deventer. Hendrick was trained in the studio of the leading history painter in Utrecht, Abraham Bloemaert, until about 1604, when, at a very early age, he travelled to Italy. He was in Italy for about ten years, principally in Rome, where he met Rubens. In 1614 Terbrugghen was in Milan on his way back to the Netherlands, crossing the Alps through the St Gotthard pass that summer. Back in Utrecht, he married in 1616 and entered the guild soon after. He continued to live and work in the city until his early death. He was buried in the Buurkerk in Utrecht.

Terbrugghen was the first of the Dutch *Caravaggisti* to return to the Netherlands. None of his paintings done in Italy which, according to the life of the artist in Arnold Houbraken's *De Grote Schouburgh*, included an altarpiece for Naples Cathedral, are known. Back in Utrecht, he painted genre scenes of musicians and drinkers as well as Biblical, mythological and literary subjects. His style is an individual interpretation of that of Caravaggio and, even more importantly, of Caravaggio's Roman followers, in particular Orazio Gentileschi, Bartolommeo Manfredi and Carlo Saraceni. Paintings such as Gentileschi's *Female Lute-player* (Washington, National Gallery of Art) and Manfredi's pendants, *The Concert* and *The Cardplayers* (Florence, Palazzo Pitti) are prototypes for his depiction of secular subjects: the large-scale figures, half- or three-quarter length, their crowding together within the composition and their closeness to the edges of the canvas (in some cases elbows and even the backs of heads are sliced off), and the bright, colourful palette, less sombre than Caravaggio's own, can all be found in Terbrugghen's *Concert*. However, Terbrugghen brings to this format a quite individual fluency in modelling the soft edges of his forms and a remarkable subtlety of palette – which includes light blues, lemon, purple and cerise.

The Concert was painted in about 1626. Before its purchase, the National Gallery already owned two paintings by Terbrugghen, the half-length singing *Luteplayer* of 1624 and the *Jacob and Laban* of 1627. With the addition of a multi-figured secular composition, the Gallery now represents the artist with a comprehensive range of his work.

The Concert came to England at a very early date, around 1700, when it was acquired by William III's Lord Chancellor, Lord Somers. It remained in the family at Eastnor Castle until its sale in 1982 to a foreign consortium, from which it was purchased by the National Gallery.

Hendrick Terbrugghen (1588?–1629)
The Concert
Oil on canvas 99·1 × 116·8 cm

Provenance: Lord Somers, thence by family descent

Bought for an undisclosed sum by the National Gallery with the help of a contribution of £10,000 from the NACF.

Three Early Georgian Portraits

John Kerslake

Thanks to the NACF three paintings spanning the years 1721 to 1747 came last year to public collections close to their original homes. From Rolls Park, Chigwell, sadly bombed during the last war, Kneller's *Harvey Family* went to the Passmore Edwards Museum, Newham; Highmore's *Family of Eldred Lee,* until 1819 in Coton Hall, Shropshire, moved to Wolverhampton Art Gallery, near the church in which he was married and George Beare's *Miss Fort* of Alderbury House, Wiltshire was purchased by the Salisbury Museum in the Cathedral close.

A household name, Sir Godfrey Kneller hardly needs introduction to the members of the NACF who presented his famous Kit-Cat portraits to the National Portrait Gallery in 1945. His painting of the *Harvey Family* is much less familiar. Like the other two acquisitions, it had not been exhibited before last year. It is not found in the usual sources and mentioned only briefly in Douglas Stewart's new study of Kneller. It was reproduced in a 1918 *Country Life* article on Rolls Park, and can be seen in a photograph of the Music Room, stated to have been added to the house about 1770. But by 1918 its identity was probably lost, for it is not referred to in the text, and, when eventually sold from the house, was catalogued simply as a family on a terrace.

A note in the Harding MS (List of Portraits, Pictures in Various Mansions of the United Kingdom, vol. I, p. 71) dated 1804, when Rolls Park had passed to Sir Eliab Harvey, commander of the Temeraire at Trafalgar, runs: 'William Hervey (*sic*) Esq MP, and Mary his wife daughter and coheiress of Ralph Williamson of Berwick upon Tweed and their three Sons.' This does not mention an older lady in the portrait, or the identity of the artist, possibly because Kneller's signature and the date 1721 had become obscured with dirt. It confuses two generations, but it is a step in the right direction, and is the earliest evidence, apart from the date for the Music Room, by whose elaborate plasterwork it was prominently framed. Since their ancestor the great William (I) Harvey of circulation of the blood fame – his portrait from the Music Room is now in the National Portrait Gallery – six Harvey sires were forenamed William before the end of the eighteenth century. William (II) would have been about fifty-eight years old when the group was painted and therefore seems too old to be identified with any of these figures. Unlike his father and his sons, William (III) was not an MP, but his wife was Mary Williamson, who was three years his senior. These ages look right and they must be the parents. William (III) had three sons: William (IV) 1714–63; Eliab 1716–69, KC; and Edward 1718–78, the Adjutant-General, all MPs. But in the painting surely only one, or, if the youngest is not yet 'breeched', no more than two of the children are boys. William (III) had two daughters also, Mary and Philadelphia. Their dates are not readily available though they might have been born in 1715 and 1717. They are likely candidates. Women and children are often omitted from even contemporary reference works, so the path of the curator should lead to the grave, or at least to the church in the hope of a memorial tablet or parish records. He might also try for the elder lady stated to be Mary's mother.

The Lee history is known in greater detail. The family goes back to Saxon days and has American descendants including General Robert E. Lee. The arms of both the English and American branches of the family are carved on the contemporary frame of Highmore's canvas, which is signed and dated 1736. It depicts the family of Eldred Lee and his wife Isabella, youngest daughter of Sir Henry Gough, of Perry Hall. They married in 1713 and had ten children. Eldred died in 1734, but his portrait is on the wall behind. Catherine, their penultimate child, survived birth for only one month and is born aloft by angels, right. Mrs Lee sits on the left, surrounded by six of the children. Four more are to the right, Lancelot, the eldest, in the front, his advance seemingly halted by the sister who points toward the mother and whose gesture unites the group.

A recent theory that the picture commemorates Lancelot's coming-of-age is hardly tenable, since this was not until 1740, though the sister might be pointing to his future responsibilities as head of the family. His eldest sister was twenty-one in 1736. He had four, baptised at year intervals; but she is thought to be the one on her mother's left, fingering a rope of pearls on her forearm. The family jewels, emeralds and pearls, were to go to her under her father's will, when she came of age; she is the only girl in the group wearing jewels. Her position in the group is not

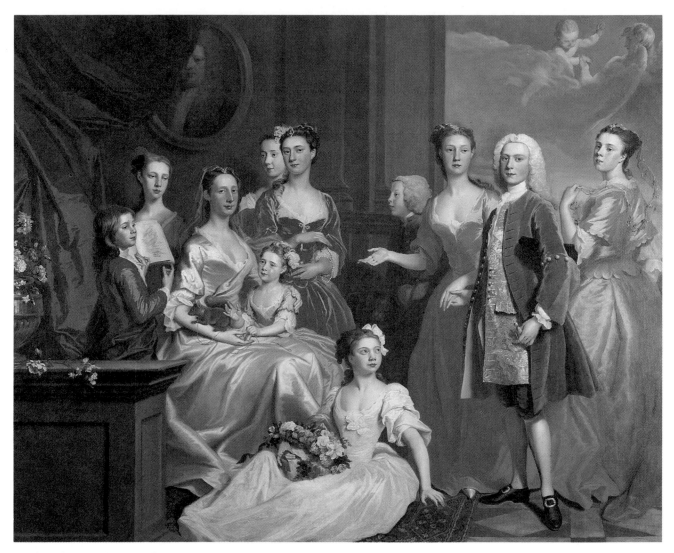

Joseph Highmore, *The Family of Lancelot Lee.*

nearly as prominent as Lancelot's however and the meaning of the painting is not yet fully resolved.

Problems can seldom be solved in the short time usually available before acquisition. Rather less is known of George Beare's *Miss Fort.* The portrait has descended in the Fort family which has been associated with Alderbury House since the seventeenth century, but no details of the family history in her time seem available. The ermine collar she wears does not necessarily imply aristocratic connections – ermine robes would of course – and it is not an uncommon fashion. This has been described as a marriage portrait but the lady is apparently of quite mature years. Not that a late marriage would be improbable in a country where, to the astonishment of Goldsmith's Chinese philosopher, many ladies might remain unmarried out of choice. The white blossom she holds to her nose might provide a clue. It is tempting to read it as the scented white jasmine, introduced

here in the seventeenth century, and which by Victorian times, and probably earlier, can symbolise amiability. Eighteenth century engravings, however, clearly show four petals for this jasmine, not the five seen in the portrait, where the plant seems carefully drawn. However the same plant occurs in a nineteenth century Florentine inlaid table, just acquired by the Metropolitan Museum. Perhaps further investigation will be repaid. What is quite certain is that this fine portrait, rich in characterisation and in colour is by an artist who has very close connections with Salisbury. It is signed and dated 1747 by Beare, the very year in which he painted the portrait of the self-taught philosopher and theologian Thomas Chubb for the Corporation, which was described by Alexander Pope as a 'wonderful phenomenon of Wiltshire'; as well as the architect Francis Price, surveyor and clerk of the works to the Cathedral. Price's *Observations . . . on Salisbury Cathedral,* 1753 was the first full account of

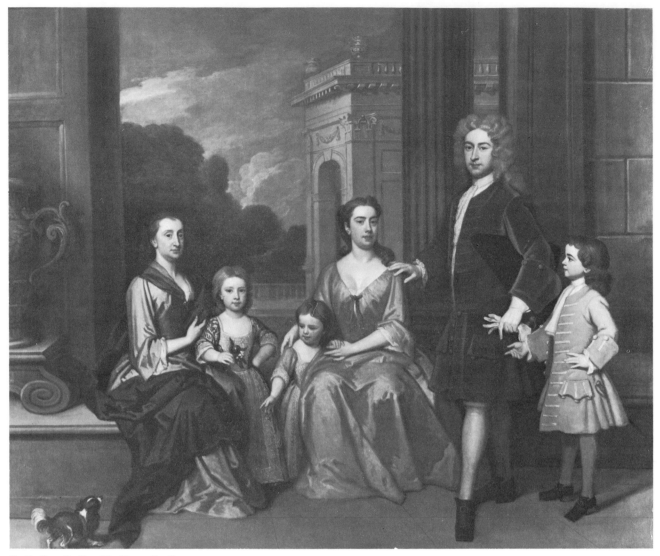

Sir Godfrey Kneller, *The Harvey Family*.

such a medieval building, and in Beare's portrait he holds a drawing of a typical truss for the choir roof.

All three acquisitions are rarities. Sometimes Kneller painted a mother and child, or a father and son together, but paintings of whole family groups here by him are particularly scarce now that the Chandos family group from Cannons, Edgware has gone to Ottawa. Highmore, according to his son-in-law the Rev. John Duncombe, painted 'more family pieces than any one of his time.' The Lee family must be one of few on such a scale to survive. In 1958 we knew about a dozen portraits by George Beare; the total is now about double, but examples seldom come on to the market.

The acquisitions well illustrate the fortune of the native artist in the period. Kneller was the third and last of the great foreigners to have dominated English portrait-painting since Van Dyck. The *Harvey Family* is a typical example of the late technique of the artist of whom Addison wrote

'Thy pencil has . . .
The Kings of half an age display'd'

It is a majestic composition. The figures, contained by the little dog, left, and young William (IV), right, are placed full centre stage. There is hardly a ripple of movement, yet the sheer inexpressiveness of the features expresses the aloof dignity required by high Augustan clientele.

Joseph Highmore forsook the law to study in Kneller's Academy, and by 1736 his style is completely different from Kneller's. The *Lee Family* demonstrates Highmore's ability, noted by Vertue, to paint 'Faces from life and often in one sitting', a spontaneity not always evident in Kneller's

studio, where high output necessitated the near-repetition of pose, drapery and accessories, frequently from standard drawings rather than from the sitter. Both Kneller and Highmore drew on Van Dyck's example, even to the use of 'terraces', curtain and columns suggestive of prestige rather than of location: Rolls Park looked nothing like that. But Highmore's inspiration is fresher, more direct, and above all remarkable for its glorious colour. His sense here of the poised moment and the references to family personalia, the pet squirrel, the ornithological drawing, the two mastiffs, help to place it clearly in the next generation of style, a rococo conversation piece on the grand scale. Ability and training might have made him heir to Kneller's practise; but in a long career, the King never sat to him. His successes were with less exalted clients and with the illustrations to Richardson's *Pamela*.

Beare's biography can only be inferred from his portraits; but he seems to have worked only in the 1740s and never to have reached London. Both he and Highmore deserved better: their gifts were higher than most. But high British taste was not yet ready. With Hogarth, they were in good company.

Sir Godfrey Kneller (1646–1723)
The Harvey Family, 1721
Signed and dated lower left
Oil on canvas, 229 × 291 cm

Provenance: by family descent to A. F. Lloyd of Rolls Park, Chigwell, Essex

Exhibited: Colnaghi, *English Ancestors, A Survey of British Portraiture 1650–1850*, 1983, no. 30

Bought for £11,500 (Colnaghi) by the Passmore Edwards Museum with the help of a contribution of £2,875 from the NACF.

Joseph Highmore (1692–1780)
The Family of Eldred Lancelot Lee (1651–1734)
Signed 'Joseph Highmore pinx' and dated 1736, lower left
Oil on canvas, 240 × 291 cm

Provenance: by family descent

Exhibited: Colnaghi, *English Ancestors, A Survey of British Portraiture 1650–1850*, 1983, no. 17

Reference: R. Edwards, 'Hogarth into Highmore, or a wrong redressed', *Apollo*, August 1969, pp. 148–51

Bought for £22,500 (Colnaghi) by Wolverhampton Art Gallery with the help of a contribution of £5,625 from the NACF.

George Beare (fl. 1744–1749)
Miss Fort of Alderbury House, Wiltshire
Signed and dated 1747, lower left
Oil on canvas, 76 × 63 cm

Provenance: the Fort family by descent

Exhibited: Colnaghi, *English Ancestors, A Survey of British Portraiture 1650–1850*, 1983, no. 3

Bought for £6,000 (Colnaghi) by the Salisbury and South Wiltshire Museum with the help of a contribution of £1,500 from the NACF.

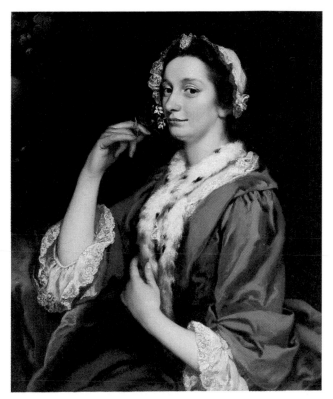

George Beare, *Miss Fort of Alderbury House*.

Baroque Ivory Carving in France and England

Malcolm Baker

The art of the ivory carver had an importance during the 17th and early 18th centuries that it had not enjoyed since the Middle Ages. In Germany and the Netherlands especially many of the leading baroque sculptors worked in this small-scale medium; on the other hand, the achievements of ivory carvers in France and England are far less familiar. With the support of the NACF, however, the Victoria & Albert Museum has been able to add to its rich collection of baroque ivories two of the most outstanding examples of ivory carving executed in these countries in the post-medieval period.

The French work is a large Crucifixion group by Simon Jaillot comprising the crucified Christ, flanked by the two thieves, with figures of the mourning Virgin and St John, while below the cross kneels Mary Magdalene and above would have been attached the two pairs of cherubs. The figure of Christ is signed on the loin cloth, 'P. S. Jaillot 1664'. First recorded in 1787, when it was presented to the Curé of St Germain l'Auxerrois, Paris, the group was acquired by Lord Astor in 1903 and appeared at the Hever Castle sale at Sotheby's (6 May 1983, lot 332); following its purchase by an American private collector, an export licence was refused and the ivories purchased by the Museum with a contribution of £10,000 from the Fund.

French ivory carving has been little studied and few of the carvers identified. However, a considerable amount is known about Jaillot, thanks to accounts of his acrimonious dispute with Louis XIV's artistic adviser, Charles Le Brun. Born in St Claude, in the Jura, he lived in Paris from 1657 until his death in 1681, having been expelled from the Academie three years earlier. He was renowned in particular for his ivory crucifixes, a number of which are recorded although only three apparently survive. The Hever group is by far the most impressive of these and is to be regarded as the sculptor's most ambitious work. Quite apart from the value of the Christ as a signed and dated crucifix figure, that offers a rare fixed point in the study of this notoriously problematic class of object, the Jaillot group represents an aspect of French ivory carving quite distinct from the later small-scale and essentially decorative works by Dieppe carvers such as Belleteste, exquisite though these are.

Most surviving baroque ivories take the form of individual figures or figure groups and complete ensembles of ivory carving on this scale are quite exceptional, among the few parallels being the ivory and wood group by Simon Troger (1683–1768) of the Judgement of Solomon, and the mid-18th century South Netherlandish wood and ivory Lamentation, both in the Museum's collection. Particularly striking is the monumental quality both of the group as a whole and its individual components, all of which have the power usually associated with large-scale monumental sculpture in marble, wood or bronze. In this respect, the Jaillot group belongs to a tradition of French devotional sculpture established by Sarrazin and developed by Girardon, the Crucifixions of the latter artist offering the closest analogies for Jaillot's Christ. In addition to its importance as the masterpiece of French baroque ivory carving, this ensemble should also be ranked as a major example of French 17th century sculpture in general.

While we are well informed about Jaillot, specific facts about David Le Marchand, the carver of the English crucifixion figure, are limited to those recorded in an entry of 1723 in George Vertue's note books: 'Mr Marchand an Ingenious Man for carving in Ivory. born at Dieppe has been many years in England. done a vast number of heads from ye life in basso relief some statues in Ivory'. Although a few allegorical figures are known, most of Le Marchand's work consists of portrait reliefs, no doubt reflecting the taste of his English patrons. In their form and composition these follow late baroque conventions well-established in continental portrait medallions and French painted portraits. Another aspect of baroque, far less familiar in England, is represented by the crucifixion figure which is signed 'D L M F'.

Formerly on loan to the Victoria & Albert Museum, from a private collection and earlier in the collection of the Earl of Caledon, it was acquired with a contribution of £5,000 from the Fund. Its quality confirms Le Marchand's reputation as the most distinguished ivory carver working in England in the early 18th century. Only two other religious subjects by him are known, a relief of Christ healing the Man with the Withered Hand (National Museum of Wales, Cardiff) and a statuette of the Virgin and Child (University of Missouri), so that it is difficult to

place this figure within the context of Le Marchand's other work; it is even uncertain whether it was executed in France or England. The subtly modelled musculature of the torso and the heavily bunched draperies of the loin cloth give the figure a monumentality unusual for its size and make it a worthy successor to the Jaillot crucifixion. It is indeed from this tradition of French sculpture that Le Marchand's Christ is ultimately derived, making the Museum's acquisition of both works within the same year particularly appropriate.

David Le Marchand (1674–1726)
Corpus Christi
Carved ivory, height of figure, 39·4 cm
Signed with initials 'DMLF' on the perizonium

Provenance: the Earl of Caledon

Bought for £32,760 by the Victoria and Albert Museum with the help of a contribution of £5,000 from the NACF.

Pierre Simon Jaillot (1631–1681)
Crucifixion Group
Signed and dated 1664
Carved ivory, height of figure of Christ Crucified, 48 cm

Provenance: Lord Astor of Hever, Hever Castle Collection sale, Sotheby's, 6 May 1983, lot 332.

Bought for £94,775 by the Victoria and Albert Museum, with the help of a contribution of £10,000 from the NACF.

Top: Christ Crucified, ivory. By David Le Marchand. Signed D.L.M.F. Height of figure, 39·4 cm.
Bottom: Crucifixion group, ivory. By Pierre-Simon Jaillot. Signed and dated 1664. Height of Christ Crucified, 48 cm. The figures are shown here in their 19th century case but will be displayed in an arrangement thought to follow their 17th century grouping.

Top: Alexander Carse, *The Village Ba' Game.*

Bottom: John Quinton Pringle, *The Curing Station, Whalsay.*

Two notable Scottish pictures

William Hardie

By the acquisition of these two interesting works, the Galleries of Dundee and Aberdeen further enhance their already splendid holdings of Scottish paintings and add for the first time to their respective catalogues the noteworthy names of Alexander Carse (d.1838) and John Quinton Pringle (1864–1925).

The large *The Village Ba' Game* dated 1818 now at Dundee is an ambitious composition which further helps define the still somewhat unclear personality of Carse, a rare and little-studied painter inevitably overshadowed by his great contemporary Wilkie. Carse belongs firmly with Kidd, Geikie and others to that group of countrified painters of Scottish genre inspired first by David Allan and then by Wilkie himself. His early subject-matter seems indeed to have had some influence on the young Wilkie and further evidence of independence is provided by the delicate *Arrival of the Country Relations* (*c*.1812; private coll.). Delicacy of theme or treatment however is not a salient feature of the present picture, which possesses a rude vitality more typical of the school's preoccupation with the humbler rustic scene especially in its comic manifestations. A comparison of *The Village Ba' Game* with Wilkie's *The Penny Wedding* of the following year, 1819 – another documentary of an old Scots tradition – immediately reveals Carse as an artist content with his provincial horizons and methods, although in the Carse picture touches of red and blue enliven the characteristically brownish palette of the Wilkie follower.

The subject is tentatively identified as the Jedburgh Ba' Game. A recent book on mass football in Scotland (J. Robertson: *Uppies and Doonies*), to which I refer football fanatics among readers, shows how widespread this game was in Scotland at one time, although its main survival today is the annual Uppies and Doonies match played at Kirkwall in Orkney, where the men of one half of the town attempt to convey the ball by kicking or carrying it through or past the men of the other half of the town to the goal. From the Dundee picture it is uncertain whether we are witnessing the efforts of two players to 'hook' the ball or to kick it forward; certainly in terms of physical contact the game is more akin to rugger or American football than soccer, although in the invasion of the pitch by spectators it

may seem closer to the modern Association game.

The *Curing Station, Whalsay, Shetland,* now in Aberdeen Art Gallery, which is dated 1921, is by an artist of a very different stamp. J.Q. Pringle's associations are entirely with Glasgow, where he was born. He studied at the Glasgow School of Art's evening and early morning classes from 1885–95 and from 1899–1900, all the while uninterruptedly pursuing his daytime profession of practising optician at his shop near Glasgow Cross. He was thus a thoroughly trained but never a professional artist in the financial sense and to this independent position and a consequent lack of temptation to over-produce can be attributed the smallness of his output, his extreme consistency of quality, and his individuality of style. In many ways he is the most original and the most accomplished artist of his period in Scotland, his technique showing a degree of refinement unique in the Scottish and indeed in the British context of the day.

Pringle's earliest pictures (a celebrated example is *The Loom,* 1891, Edinburgh City Art Centre) exhibit the most fastidious and minute execution allied to detailed realism and not surprisingly include a number of portrait miniatures. In a slightly later group of pictures painted from approximately 1903–1908 we find a more poetic conception of subject-matter (eg *Girls at Play,* 1905, Hunterian Art Gallery) and a more open, transparent execution which is also intriguingly close to the pointillisme of the Neo-Impressionists whose work Pringle is very unlikely to have known at that stage in his career, as the late James Meldrum has pointed out. This phase Pringle referred to as his 'very extreme' style (in a letter belonging to the Trustees of the late Eva Meldrum). Tantalisingly of this very rare artist, it is known that a continental dealer bought several canvases from him at around this time, although it was not Pringle's normal practice to dispose of his pictures outside the small circle of his family and friends.

The Aberdeen Art Gallery picture of the Curing Station at Whalsay dates from Pringle's last period and in fact marks a return to the oil medium after a decade of painting only in watercolour. The legacy of long practice in the more fluid medium is visible in the increased transparency and fluidity of the *Curing Station.* The return to oil painting caused Pringle no difficulty and he wrote happily in a letter of this

time from Whalsay where he was staying with his friend Dr Wilson, '. . . my hand is as light as a feather, no difficulty in what I want . . .', adding that his new Orkney pictures were *not* of the 'extreme school' – a view with which we would now concur. The *Curing Station, Whalsay,* painted only a year or so before the onset of the artist's final illness, shows that Pringle's limpid style had lost nothing of its subtlety with the passing of a decade.

It is particularly fitting that this fine example of J.Q. Pringle as a landscape painter should have been purchased from the collection of the late Eva Meldrum, who is well known in Glasgow musical circles as a pianist and as the niece of the composer Zoltan Kodaly, and whose late husband James Meldrum did so much to preserve Pringle's work. Her father-in-law William Meldrum was a close friend of the artist, and this picture once belonged to him.

Alexander Carse (d. *c.*1838)
The Village Ba' Game, 1818
Signed and dated 'A Carse 1818' lower left
Oil on canvas, 87·6 × 130·8 cm

Bought for £7,000 (Bourne Fine Art) for the Dundee Art Gallery, with the help of a contribution of £1,750 from the NACF (Scottish Fund).

John Quinton Pringle (1864–1925)
The Curing Station, Whalsay, 1921
Signed and dated 'John Q Pringle' 1921, lower left
Oil on canvas, 50 × 60·5 cm

Provenance: William Meldrum; bequeathed to Mrs E. Meldrum 1942

Bought for £13,600 (Mrs E. Meldrum) by the Aberdeen Art Gallery, with the help of a contribution of £3,400 from the NACF (Scottish Fund).

The Village Ba' Game detail.

The Byres Family by Franciszek Smuglewicz

Brinsley Ford

The Scottish National Portrait Gallery has few conversation-pieces, but last year it acquired, with the help of the Fund, one of outstanding interest. This was the conversation-piece of James Byres and his family by Franciszek Smuglewicz, a Polish painter who was in Rome from 1763 to 1784.

James Byres (1734–1817) was the principal antiquarian, cicerone or guide to the English visitors to Rome during the greater part of the second half of the eighteenth century, a profession which he combined with the more profitable one of dealing in antiquities and works of art. In consequence he played a large part in forming not only the taste, but also the collections of the many young English and Scottish cavalieri who visited Rome on the Grand Tour.

Byres, the son of a Jacobite, Patrick Byres of Tonley in Aberdeenshire, came to Rome in about 1756, at the age of twenty-two, as a student of painting. He is said to have worked for five years under Raphael Mengs during which time he presumably discovered that he had no aptitude for that branch of the arts for, when Mengs left Rome for Spain in 1761 to take up his appointment as Court Painter to Charles III, Byres ceased to be a student of painting and became one of architecture. It was as an architect that he was elected a member of the Academy of St Luke on 20 November, 1768. Although he executed a number of designs for grand mansions for some of his richer patrons, such as Sir Lawrence Dundas and Sir Watkin Williams-Wynn, none of his projects seems to have risen above the drawing-board.

It must be assumed that he saw no more chance of earning his livelihood as an architect than as a painter for by 1764 he had embarked on his career as an antiquarian.

One of the earliest, and certainly the most famous, of those to whom Byres acted as antiquarian was Edward Gibbon, who arrived in Rome with his friend, William Guise, early in October, 1764. The tour of Rome under Byres's direction proved so fatiguing that Gibbon had no strength left to continue the journal which he had kept on the journey from Geneva to Rome. Byres's tour of Rome usually lasted for about six weeks and we know from the detailed account of it given by Dr John Parkinson in his journal in 1784 that it continued to be a gruelling experience. What Dr Johnson said of Burke, 'His stream of mind is perpetual', was also true of Byres, and some of the young Englishmen must undoubtedly have been bored with the mass of information, archaeological, architectural, historical and mythical with which he belaboured them.

Byres was a very opinionated guide. He judged everything by the standards of antiquity. His chief bugbear was the sculpture of Bernini. He considered the statue of St Bibiana 'too much in the stile of an Opera Girl', while that of St Theresa was condemned 'as affected and *maniérée* to the highest degree.'

Byres not only exhausted those who employed him as their antiquarian, but he exhausted himself, and his temper became frayed lecturing to young men who did not know the difference between a triglyph and a triptych, a modillion and a *modello*.

It was as the result of acting as antiquarian to the English and Scottish cavalieri that he was able to make a profitable business out of selling works of art to them. His clients included such rich patrons as Sir Watkin Williams-Wynn, Lord Exeter, and William Constable of Burton Constable. Through such contacts he was able to obtain commissions for many of the artists working in Rome, and his drawing-room in his house in the Strada Paolina was hung with paintings by his contemporaries, whose works were thus brought to the notice of possible patrons.

Mention can be made only of Byres's two most famous purchases. In about 1780 he bought from Donna Cornelia Barberini-Colonna, who needed the money to pay for her heavy losses at the card-table, the beautiful first century B.C. Roman cameo glass vase. This was bought from him soon afterwards for £1,000 by Sir William Hamilton who, in turn, sold it to the Duchess of Portland. Her son later deposited what had now become known as the Portland Vase in the British Museum, where it was smashed into more than two hundred pieces by a drunken Irishman in 1845. Miraculously restored, it is now one of the great treasures of the British Museum.

In 1785 Byres crowned his art-dealing activities with one of the major coups of the eighteenth century. This was the purchase for £2,000 from the Bonapaduli family of Poussin's *Seven Sacraments,* which he sold to the Duke of Rutland. In the conspiracy which led to Byres's acquiring

these pictures, he proved himself as great a master of duplicity as his rival, Thomas Jenkins. Permission to export these pictures had been refused in the past, and since then the regulations had been tightened rather than relaxed. Byres arranged with the owners, the Bonapaduli brothers, for the Poussins to be copied 'with the greatest secrecy'. As soon as each copy was completed it was hung in place of the original. By November 1785 the originals were all in Byres's possession, and by August they had reached England. The Bonapaduli palace was visited by foreigners solely on account of these pictures, and Byres had been in the habit of showing them to the Englishmen attending his courses. It appears to have been part of the bargain with the Bonapaduli family that he should continue to bring people to the palace and presumably to expatiate on the beauty of the copies as though they were the originals.

The conversation-piece of the Byres family, which has been acquired by the Scottish NPG, first became known to me when it was published amongst the shorter notices in the *Burlington Magazine* in February, 1943. The article was unsigned, but it was almost certainly written by Dr Tancred Borenius, who was Editor of the magazine at the time and keenly interested in anything with a Jacobite connection. The ownership of the picture was not given but the author mentioned in the text that it had descended until recently in the Moir-Byres family. Apparently the name of the artist had been lost but Dr Borenius stated that the name of Gavin Hamilton (1723–98) had recently been put forward by 'two excellent connoisseurs of the English school of portraiture'. In the light of our present knowledge of Gavin Hamilton's work, we can realise how implausible this suggestion now seems.

In the conversation-piece Byres is shown pointing to a map of Italy. The elegant young woman on the left is his sister Isabella (Mrs Sandilands), who was the subject of one of Batoni's most beautiful female portraits which hung in the dining-room of the house in the Strada Paolina.

The portly figure on the right is Byres's partner Christopher Norton. Having studied at the St Martin's Lane Academy he came to Rome in about 1760, presumably with the object of studying painting but, having made little headway as an artist, beyond obtaining some commissions as a copyist and as an engraver, he became Byres's partner, had a room in his house, and remained with him until they both left Rome in 1790. Norton's only known works are the engravings he made for the illustrations to James Byres's book on the *Sepulchral Caverns of Tarquinia*. It used to be thought that Byres was also responsible for the drawings, but it has now been established that they are by Smuglewicz.

The elderly couple in the centre of the picture are James's parents, Patrick Byres of Tonley and his wife (née Janet Moir). It is not known when they arrived in Rome, but Dr

John Moore met them there in 1776, and they returned to Scotland in 1779. In Dr Moore's entertaining book *A View of Society and Manners in Italy* (1781), he records the lively dialogue that took place between Patrick Byres and an Englishman when they were looking at the view from the terrace of the Capuchin convent at Genzano. At first the chauvinistic old Caledonian confined himself to making some invidious comparisons between the scenery of Italy and Scotland, belittling Lake Nemi and glorifying Loch Lomond, asserting that the Campagna was a desert to anyone familiar with the fertile valley of Stirling. Then, as the argument grew warmer, he brought England into the scales, dismissed the Thames at London as 'a mere gutter, in comparison of the Firth of Forth at Edinburgh' and condemned St James's Palace as 'a shabby old cloister, hardly good enough for monks', while praising Holyrood House as a residence fit for Kings. Patrick Byres stands in front of a basrelief of Ganymede and the eagle, and on the wall behind Norton is the profile of a man, which is probably that of the Pretender, Prince Charles Edward, in his old age.

The smaller of the two conversation-pieces of the Byres family by Smuglewicz appeared at Christie's on 18 October, 1957, where it was catalogued, with less accuracy than is practised today by the learned team in the picture department, as 'Lot 148. Devis [sic]. A family group on a terrace with St Paul's [sic] in the foreground [sic].' The picture was clearly not by Devis, while the building in the background was obviously not St Paul's but St Peter's. Recalling the Byres family group reproduced in the *Burlington* I looked on the back of the picture where I found a label on which was written 'Byres Manchester Pantechnicon 245'. I left a small bid on the picture but it was bought against me by a man acting for a Bond Street dealer for 84 guineas. After the picture had been cleaned and reframed the price asked for it was £250. Thinking that the Scottish NPG might be interested in the picture, I brought it to the attention of the then Director, but he decided not to make an offer on the grounds of expense, and because Byres was already represented at the Gallery by the James Tassie medallion of him. I therefore decided to buy the picture myself.

There can be no doubt that the same family group and the same lap dogs are represented in both pictures although in the one belonging to me Mrs Byres looks older and is given a distinctly more aquiline nose. At one time I was tempted to attribute these two groups to Philip Wickstead, an artist who is known to have been patronised in Rome by both Byres and Norton. However I later found evidence amongst some Byres papers, lent me by a member of the family, which proved that they were beyond doubt by Franciszek Smuglewicz. In Rome he had studied under the Austrian painter, Anton Maron, who was a friend of Byres and had painted his portrait. Besides employing Smugle-

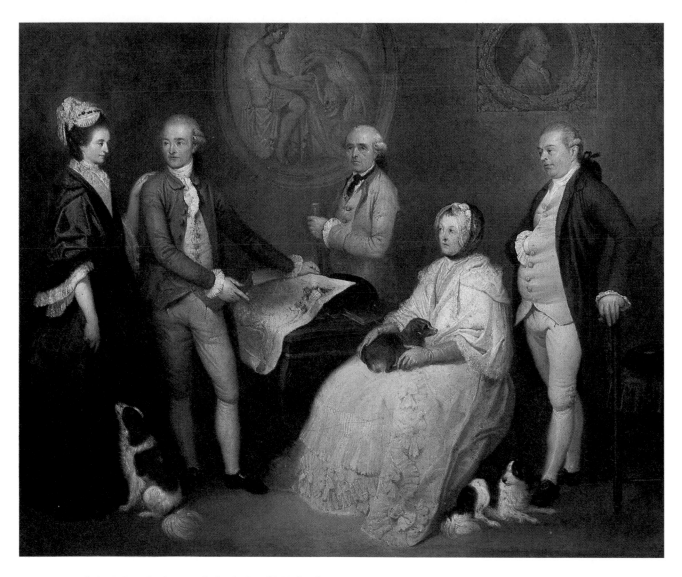

The Byres Family by F. Smuglewicz. Bought by the Scottish National
Portrait Gallery with the aid of a contribution from the NACF.

wicz to paint the two conversation-pieces of himself and
his family, Byres obtained other portrait commissions for
him including that of the Hon. Philip Yorke and his
Governor Colonel Wettestein. This picture, which shows
the two men walking arm-in-arm with St Peter's in the
background, has recently come to light.

Byres, who had portraits of the Hon. Aubrey and Lady
Catherine Beauclerk hanging in his house, was probably
also responsible for getting them to commission from
Smuglewicz the two conversation-pieces of themselves and
their children. One was sold at Christie's in 1978, while the
other was acquired some years ago by the Cheltenham
Museum as a work by David Allan.

Smuglewicz was also a copyist and in the beautiful
Harlequin Saloon at Ribston in Yorkshire there can still be

seen the large copies he had made for Sir John Goodricke
of Reni's *Rape of Helen* and Guercino's *Death of Dido*.
Among the portraits on the walls of the house in the Strada
Paolina were portraits of James Byres and Christopher
Norton by Hugh Douglas Hamilton (*c.*1739–1808). By the
time he arrived in Italy in 1778, Hamilton had already
established a great reputation for his small crayon portraits.
He remained in Rome until 1791, and, during this time,
drew the portraits of the exiled Stuarts and of a number of
Englishmen, probably introduced to him by Byres. How-
ever the masterpiece of his Roman years was unquestion-
ably his large pastel of *Canova in his Studio with Henry
Tresham, R.A.*

The portraits of Byres and Norton remained in the
possession of the family until 1977, when they were sold at
Christie's on 22 November (lots 107 and 108). Unfortunately
the pair was then split up, but the portrait of James Byres

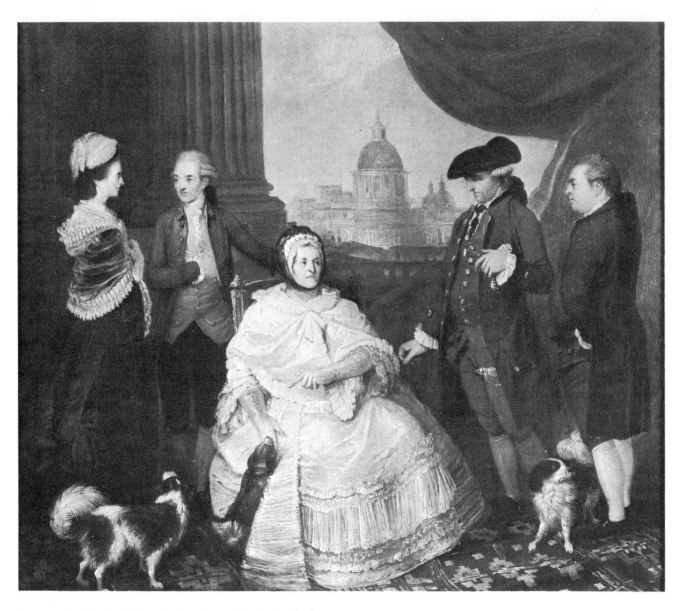

The Byres Family with St Peter's in the background by F. Smuglewicz.
Brinsley Ford Collection.

was bought by the NACF for £1,120 and presented to the
Aberdeen Art Gallery.

The same gallery did however secure another portrait
of Christopher Norton by Nathaniel Dance (1735–1811),
which had also been hanging in Byres's house in Rome,
and which appeared at Christie's from the same provenance
as the other two portraits and was sold during the same
week (25 November 1977, lot 80). The portrait was
bought by Spink and Son and sold by them to the Aberdeen
Art Gallery in 1979 for £3,780, towards which the NACF
made a grant of £1,000 (see Report, 1979 no. 2759).

Since Norton came to Rome in about 1760, and Dance
left the city in 1765, the portrait must have been painted
when Norton was a comparatively young man, and indeed
at a time when he was still pursuing his unsuccessful career
as an artist for he is shown holding a palette and brush.

It gives me great satisfaction that these portraits of James
Byres, whose importance in so many fields became increas-
ingly clear to me in the course of my researches on the
English in Italy in the eighteenth century, should have
found appropriate homes in Scottish museums during the
time that I had the privilege of being the Chairman of the
Fund.

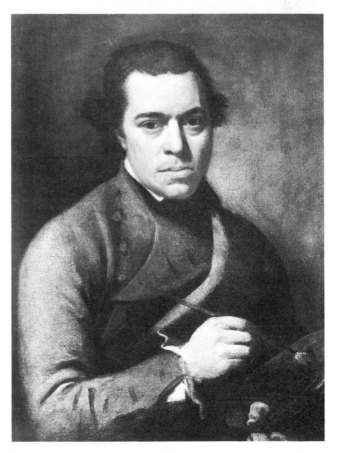

Above:
James Byres by H.D. Hamilton. Presented by the NACF to the Aberdeen Art Gallery.
Above right:
Christopher Norton by H.D. Hamilton. Private Collection.
Right:
Christopher Norton by Nathaniel Dance. Bought by the Aberdeen Art Gallery with the aid of a contribution from the NACF.

Franciszek Smuglewicz (1745–1807)
James Byres and his Family
Oil on canvas, 60·9 × 73·6 cm

Provenance: Mrs Robert Tritton, Godmersham Park, Kent; sale Christie's, 15 July 1983, lot 66

Reference: B. Ford, 'James Byres: Principal Antiquarian for the English Visitors to Rome', *Apollo,* June 1974, pp. 454–5, fig. 8.

Bought for £17,500 (private treaty sale through Christie's), by the Scottish National Portrait Gallery, with the help of a contribution of £4,375 from the NACF (Scottish Fund).

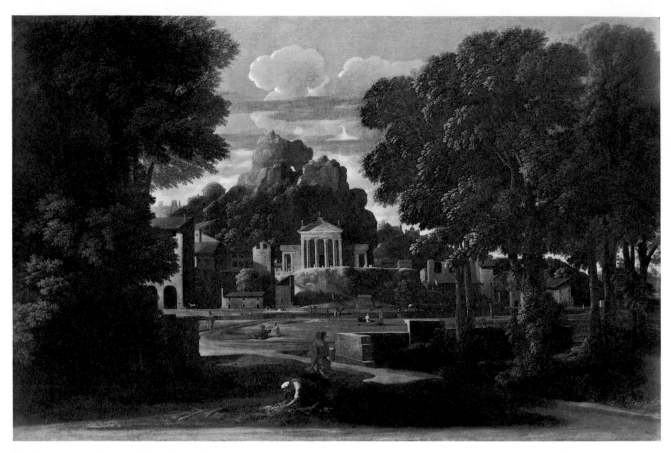

Nicolas Poussin, *Landscape with the gathering of the Ashes of Phocion.*

Paintings by Claude and Poussin

Christopher Wright

Paintings by the two great French artists of the seventeenth century are rare in public galleries outside London and it is particularly fortunate that the Walker Art Gallery should have been able to acquire Poussin's celebrated *Landscape with the Gathering of the Ashes of Phocion* from the Earl of Derby; and the National Museum of Wales Claude Lorrain's *Landscape with the Baptism of the Eunuch* from Viscount Allandale; both with the help of the NACF. Claude and Poussin were regarded as the epitome of British taste in the old masters in the eighteenth and nineteenth centuries, yet the representation of both artists outside London has until recent years been far from adequate. In 1926 Mrs Weldon presented to the Ashmolean Museum Claude's last picture, the *Landscape with Ascanius shooting the stag of Sylvia* dated 1682; in 1966 they were bequeathed a small *Landscape* by F.F. Madan. The City Museum at Birmingham received the *Landscape with the Ponte Molle* as part of the Cook Bequest through the NACF in 1955. Apart from these there are only five Claudes in public collections outside London (at Birmingham, one in the City Art Gallery and one in the Barber Institute, one at the Fitzwilliam Museum, one in Manchester City Art Gallery, and one in the National Gallery of Scotland).

Claude's genius for the depiction of soft morning or evening light has always been appreciated by connoisseurs but his reputation has been more difficult to justify to the layman. Like most artists Claude's art underwent a complex but subtle development over almost sixty years. He started with rather clumsy port scenes and small landscapes painted on copper but soon refined them, introducing his own special lighting effects. His painting then became much more ambitious and elaborate and by the mid-1640s it seemed that he had perfected his style and there was little further that he could do to improve it. Examples of this high achievement are particularly well represented in the National Gallery – the *Mill* and the *Seaport with the Embarkation of St. Ursula*.

In the last thirty years of his life Claude changed his approach and became much more introspective and less obviously decorative. The *Landscape with the Baptism of the Eunuch* is a very late work, painted in 1678 when Claude was 78; its pair, the *Landscape with Christ appearing to the*

Magdalen now in the Städelsches Kunstinstitut at Frankfurt, was painted in 1681. The two pictures were painted for Cardinal Fabrizio Spada and probably remained in the Palazzo Spada in Rome, until the end of the eighteenth century. They were brought to England in 1803–4 and subsequently belonged to William Beckford. In 1842 they were with the Bond Street dealer John Smith, who sold them to the great Turner collector Munro of Novar (who also owned the *Virgin and Child* by Poussin now at Preston Manor, Brighton). At the Munro of Novar Sale in 1878 the two pictures were separated, and in 1912 the *Landscape with the Magdalen* went to Frankfurt. Even though they were obviously intended to be seen together, the gap of three years between them (1678 and 1681 respectively) means that the Cardiff and Frankfurt pictures are rather different from one another. Recent cleaning has revealed the Cardiff work to be in a near-perfect state of preservation with very little of the deterioration which is often the characteristic of Claude's last pictures. The Frankfurt canvas on the other hand now appears much darkened. Both pictures have a wistful and fragile quality which Claude evoked in his last years. He abandoned the obvious rays of sunlight and elaborate compositions of temples, water and trees in favour of a much more naturalistic landscape, based on the distant panoramas of the nearby Roman Campagna. The placing of the trees in Claude's landscapes of this type may appear artificial or classically inspired but those who know the Campagna will remember that the landscape is constantly forming itself into Claudian compositions, especially in the area round Tivoli, and thus that Claude should be seen as a painter who observed nature to create his own brand of poetry. In his last years Claude was much inspired by the poetry of Virgil and even though the Cardiff picture is of a religious subject, much the same atmosphere is present. Claude tried to create a pastoral idyll as found in the *Eclogues* or the *Georgics* and achieved this by enveloping his pictures in a soft light and not allowing the subject to play an important part.

The Cardiff picture is unusual among Claude's last pictures because it allows us to see more or less how Claude worked. The delicate atmosphere is preserved (a characteristic which has been partly lost in the much more damaged

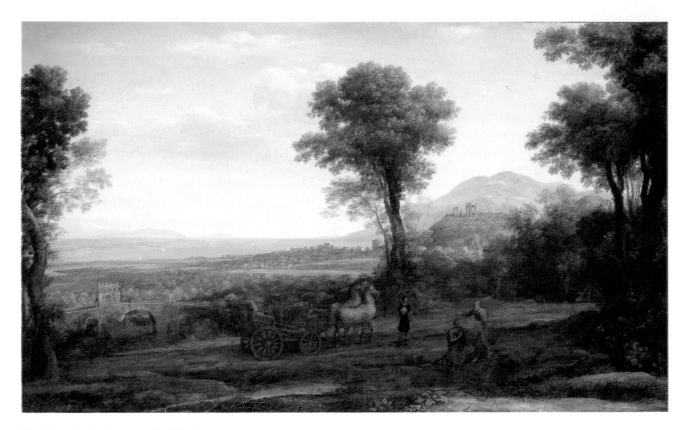

Claude Lorrain, *Landscape with St Philip Baptising the Eunuch.*

Enchanted Castle in the National Gallery) and the only major change which has occurred is an increase in blueness overall, which is caused by a fading out of the yellows. Many writers have taken this observation too far because it is clear that Claude intended his last pictures to have a bluish tonality. The *Landscape with the Baptism of the Eunuch* stands out as one of Claude's greatest pictures; it does not dazzle by any spectacular display of lighting effects, but achieves its power almost by stealth. It requires patience on the part of the spectator to allow the artist's infinite subtleties of light and atmosphere to have their effect.

The contrast with Poussin's *Landscape with the Gathering of the Ashes of Phocion* could not be greater. The two artists have so often been compared that it seems as if convention is being flouted to point out their differences. Poussin was not primarily a landscape painter and only some twenty landscapes by him have survived, many of them in British collections. It comes as a quirk of history that the pair to the Liverpool picture, *Landscape with the Body of Phocion carried out of Athens* is at present on loan from the Earl of Plymouth to the National Museum of Wales.

The representation of Poussin in the museums outside London is as inadequate as was that of Claude until recent years. Apart from the second set of *The Seven Sacraments* on

loan from the Duke of Sutherland to the National Gallery of Scotland, and the minor work at Brighton already mentioned, only the Ashmolean, the Barber Institute and Edinburgh own works by him.

Poussin's *Landscape with the Gathering of the Ashes of Phocion* is a particularly fitting addition to the Walker Art Gallery's collection of major seventeenth century paintings, which includes works by Rubens and Rembrandt. Poussin's *Landscape with Nymphs* (in the Royal Institution since 1842) has been the victim of a prolonged controversy over its authenticity, with Denis Mahon supporting it and Anthony Blunt against it; it is particularly interesting therefore that this major work of Poussin's maturity should be placed alongside the much earlier landscape, which is in my opinion a particularly fine if rather damaged early work.

The Phocion *Landscape* is almost too famous, being reproduced in so many anthologies as an example of a classical landscape, incidentally by Poussin. The picture has to be taken out of this rather facile context and seen for what it is – a deeply felt statement of Poussin's ideas about the way landscape can be used to express an emotion. Claude worked all his life to this end but achieved it by different means. Claude became obsessed with the poetical content of his work, Poussin with the philosophical. It is therefore easy to understand Claude's point of view simply because it is

achieved through infinite gradations of atmosphere. For Poussin such an approach was far too seductive and he had to concentrate on expressing his ideas through very much more formal and less intuitive means.

Poussin attempted to explain his position through his numerous letters to friends and patrons but such self-justification is hardly going to help the visitor to the Walker Art Gallery more than three hundred years later, confronted by the rigid framework into which are fitted very formalised landscape elements. Poussin was working for a small circle of like-minded patrons, unlike Claude who had a much broader and more aristocratic clientele. Poussin could therefore explain to his patrons his precise intention. The picture was painted in 1648, along with its pendant, for M. Sérisier, a wealthy silk merchant of Lyons. Its subsequent history was lost sight of until acquired by the 12th Earl of Derby between 1776 and 1782. The two Phocion Landscapes were to act as an illustration to stoic philosophy, a doctrine to which Poussin was much attracted. Phocion was an Athenian general of the fourth century BC, unjustly executed by the Athenian democracy, which further decreed that his ashes should not be buried within the frontiers of the state of Attica. Lord Plymouth's picture shows the body being carried out of the city to the funeral pyre, and the other picture the faithful widow gathering her husband's ashes in order to give them burial. Phocion was posthumously pardoned. Poussin had a very difficult task in getting the story across because he chose to express the idea of the triumph of virtue over vice by means of an arrangement of trees and a few incidental figures. He gave the two landscapes, but more especially the Liverpool work, a rigidity 'that ill accords with nature' (to use the words of John Smith). This lack of naturalism immediately makes the spectator ill at ease because it is perfectly clear that each individual element in the picture is painted with the greatest possible attention to its real character. Poussin observed very carefully from nature as his landscape drawings well illustrate; he was also the friend and neighbour of Claude. It is only in the Liverpool picture that such an extreme of formality is reached, making the picture untypical of Poussin's work in this genre.

The Walker Art Gallery has acquired a picture that is exceptional on more than one level. It rises above so many of Poussin's more subtle landscapes into a direct statement about his strongly held philosophy. It has been taken for the wrong reasons to be a milestone in the history of art. Such a picture strayed too far from the accepted norm of the time to be truly influential. Poussin's less formal and more obviously poetical landscapes such as the *Diogenes* in the Louvre were more easily assimilated by such artists as Gaspard Dughet, Poussin's brother-in-law, of whose art the Walker already owns a very good example.

There are not enough pictures of this uncompromising type in the regional galleries. All the truly great master-pieces in the Walker Art Gallery – and there are more there than in most galleries outside London – make some form of extreme statement. This ranges from the pathos of the attenuated Christ in Ercole de'Roberti's *Lamentation* to Rembrandt's bizarre get-up as a Renaissance prince of his *Self-Portrait*. Poussin's *Landscape with the Gathering of the Ashes of Phocion* makes a fitting extension to this group.

Nicolas Poussin (1594–1665)
The Ashes of Phocion Collected by his Widow
Oil on canvas, 114 × 175 cm

Provenance: painted for M. Serisier, a Lyons silk merchant in 1648; Lord Derby of Knowsley Hall from 1782.

Bought for £1,150,000 (Trustees of Lord Derby's Heirlooms Settlement) by the Walker Art Gallery, with the help of a contribution of £50,000 from the NACF, including a special donation of £25,000 from the Woolfson Foundation. In addition donations of £1,000 (Messrs. Thomas Agnew) and £25 (Mrs Judy Edgerton) were made through the NACF.

Claude Lorrain (1600–1682)
Landscape with St Philip baptising the Eunuch
Signed and dated 'CLAVDE INV. ROMA 1678' and inscribed 'S Filippo battesta Lenucco della Regina'
Oil on canvas, 84·5 × 140·5 cm

Provenance: painted for Cardinal Fabrizio Spada (1643–1717); in Rome until 1798. Bt. Sloane, 1802, in England by 1803–4; his sale 1804; William Beckford by 1837; John Smith of Bond Street by 1842; Monro of Novar by 1854, his sale 1878; bt. W.B. Beaumont, by descent to Lord Allandale.

Reference: Recorded by the artist in his *Liber Veritatis* (191) M. Roethlisberger, *Claude Lorrain, the Paintings,* 1961, pp. 447–8.

Exhibited: Newcastle, *Pictures from Northumberland Houses,* 1951.

Bought for £500,000 (Allandale 1949 Settlement) by the National Museum of Wales, with the help of a contribution of £40,000 from the NACF.

The Schantz Fortepiano at Bath

Kenneth Mobbs

In the late eighteenth century, two of the most important centres for piano manufacture were Vienna and London, where two different types of pianos existed with their different methods of construction, their very individual types of action, and therefore their own tonal character-istics. The classic 'Viennese' piano is noted for its flute-like treble and reedy bass, its extremely light action with shallow key dip, and above all, for its very precise damping, allowing a skilled performer full scope for the most subtle articulation of phrases. The 'English' instrument, although still comparatively light in touch, is considerably more robust in sound, with a bigger dynamic range and a much less precise damping system – intentionally so – enabling the instrument to build to its full resonance.

There are many more English early pianos surviving than Viennese, for several reasons: the English (particularly the firm of Broadwood) were the first to develop intensive methods of manufacture, so many more were made; their instruments were more elegantly cased and therefore were more likely to survive as objects of furniture, they were also more immune from most of the catastrophies that war inflicts. What business traffic there was tended also to be from London to the continent. Early Viennese pianos are therefore rare, particularly so in this country, and in good playing order even more so. The author knows of about a dozen pre-1810 Viennese fortepianos in this country, of which two are in public collections. Of these two the only eighteenth-century instrument is the Schantz at Bath, and this is one of only four pre-1800 Schantz instruments known to have survived.

Johann Schantz was born in 1762 in Kladrub in Bohemia and died on 28 April 1828 in Vienna. In 1791 he had taken over his brother Wenzel's workshop, after the latter's death in 1790. The Schantz firm takes its place with others, such as those of Stein, Walter, Könnicke, Rosenberger and Streicher, as one of the most important in Vienna around 1800. According to surviving correspondence the house of Schantz was Joseph Haydn's favourite. An amusing com-mentary on the composer's influence with the publisher Artaria is obtained from the following letters (quoted from *Haydn: Chronicle and Works* by H.C. Robbins Landon):

26 Oct. 1788

'In order to compose your three piano sonatas (piano trios Hob XVII: 11–13) especially well, I was forced to buy a new fortepiano, and therefore may I presume to request of you, honoured Sir, that you pay the sum of 31 ducats to the organ and instrument maker Wenzel Schantz who resides at No. 22 Laimgrube at the "Blue Ship".'

16 Nov. 1788

'I give you humblest thanks for having paid over the correct sum to Herr Schantz on my behalf.'

Two letters to Marianne von Genzinger, the dedicatee of the piano sonata in E flat (Hob XVI no. 49), give further insight into the reasons for the composer's preference:

27 June 1790

'Only a pity Your Grace does not own a Schantz forte-piano on which everything is better expressed . . .'

4 July 1790

'I know the (Walter) fortepiano belonging to Herr von Nickl. It is very fine but far too heavy for your Lady-ship's hand; one cannot play everything with the appropriate delicacy and for this reason I would like Your Grace to try one of Herr Schantz's. His fortepianos have a quite special lightness and are very nicely finished.'

Letters revealing Beethoven's more stormy love-hate relationships with his instruments and their makers are also preserved (*Letters of Beethoven*, trans. Emily Anderson). He mentions Schantz in one letter of 1810 and several of 1815. The 1815 evidence is contradictory, for in one of spring 1815 we have:

'For Schantz has sent me such a bad one that he will soon have to take it back again.'

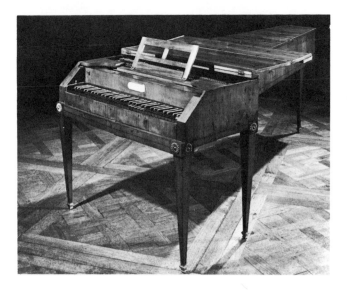

The piano is bichord (i.e. two strings to a note) for over two octaves from FF to b^1 flat, the rest is trichord. It has two bridges, an unusual Viennese feature which Schantz probably copied from English instruments arriving in Vienna, and by no means always found in Viennese instruments fifteen years later. Separating the bridge enables the soundboard to vibrate more freely and the tenor strings to be closer to their theoretically optimum lengths. The knee lever to the left operates all the dampers (a skilled fortepiano player needs to develop as much subtlety in his left leg as the modern pianist in his right foot!). The right knee lever operates the 'moderator'; this invaluable effect is achieved by tongues of cloth being inserted between the little leather hammers and the strings, thereby softening the sound. A third, less useful, effect is obtained by the 'bassoon' stop, operated by a knob on the front facia, which applies a strip of parchment covered by silk to the lower strings.

Haydn visited Bath during August 1794; now an instrument by his favourite maker is available for occasional public concerts there. The inaugural recital was in fact given on 21 October 1983 by the brilliant young fortepiano player Melvyn Tan. Unfortunately a rattle which had been known to afflict the instrument periodically chose that evening to re-appear, and although a temporary human solution was applied (namely a noble volunteer's finger pressed on the bridge) some restoration work of a more permanent nature is necessary and planned. All being well, this should be accomplished by the time these words are read.

Nevertheless the experience could not have put him off, for in a letter of 23 July 1815 we learn that he has been successful in acquiring an instrument for Joseph von Varena, and

> 'The instrument has been made by Schantz – I too possess one of his.'

The Bath Schantz is thought to date from c.1795–1800. It is veneered in yew, with gilt metal mounts, the keyboard is of ebony with bone facings to the accidentals, and the enamel plaque bears the inscription 'Johann Schantz, No 52 in Wien' (no. 52 was the address). Its compass is five octaves and a third (FF to a^3) – an interesting feature demonstrating how very gradually the compass extended from five octaves in Vienna compared with the sudden jump to five and a half octaves FF to c^4 in the 1790s in London. Haydn's 'English' C major Sonata of 1794/5 (Hob XVI/50) touches top a^3 (no doubt he also wanted it playable back in Vienna!). Beethoven doesn't go above this limit until the 'Appassionata' Sonata of 1804/5. Thus all Mozart and Haydn and twenty-two of the thirty-two Beethoven piano sonatas are playable.

Fortepiano, c.1795–1800
by Joseph Schantz of Vienna
Case veneered in yew, keyboard five octaves and a third

Bought for £15,000 by the Holburne of Menstrie Museum, with the help of a contribution of £3,000 from the NACF (William Leng Bequest).

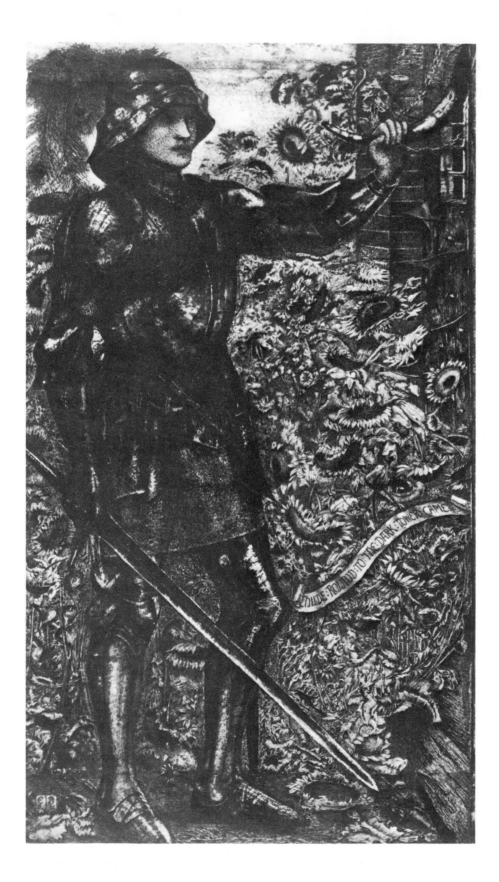

Burne-Jones's 'Childe Roland'

John Christian

It is not often these days that outstanding works by Burne-Jones appear on the market, and when they do they are likely to command prices far beyond the reach of a comparatively small English regional museum, however enterprising its curator. Such a work, however, has recently been acquired by the Cecil Higgins Art Gallery at Bedford, with the help of a government grant, the NACF, and the tax concessions allowable on private treaty sales to public institutions.

Childe Roland belongs to the small group of pen and ink drawings, many of them on vellum, that Burne-Jones produced very early in his career – that is to say between 1856, when he left Oxford, determined to become an artist under the guidance of D.G. Rossetti, and 1861, when he turned to watercolour as his primary medium of expression. Elaborated to the highest degree of finish, these drawings are really pictures in their own right. They naturally show the strong influence of Rossetti, and are full of the romantic feeling for the Middle Ages so characteristic of his circle at this time. In fact they form a close parallel to Rossetti's contemporary watercolours with 'chivalric Froissartian themes', and to William Morris's volume of early poems, *The Defence of Guenevere,* published in March 1858.

Burne-Jones had drawn in pen and ink long before meeting Rossetti, but it was Rossetti's own preference for the medium that led him to use it so exclusively during this period. In 1856 he had also met Ruskin, another great early hero, and Ruskin recommended the pen for beginners in his textbook, *The Elements of Drawing,* published the following year. Burne-Jones's technique is much dryer and more finicky than Rossetti's, but very similar to the method advocated by Ruskin, in which the tones are built up with minute touches and dots and the pen-knife used to soften forms and erase unwanted lines. Ruskin also urges his readers to study Dürer's engravings, and Burne-Jones's pen drawings, both technically and in their use of certain motifs, often suggest that he had such models in mind. Indeed Rossetti described them in 1857 as 'marvels of finish and imaginative detail, unequalled by anything unless perhaps Albert Dürer's finest works'.

Burne-Jones only completed about twelve pen drawings, and *Childe Roland* is a particularly interesting example. It is

the latest of the series in date (1861), and one of the largest in scale. It is also Burne-Jones's most specific and considered attempt to illustrate Browning, the subject being taken from the well-known poem *Childe Roland to the Dark Tower Came,* published in *Men and Women* in 1855.

At this period Browning still suffered from public neglect, his work being dismissed as 'difficult'. But he was passionately admired by Rossetti and therefore by Burne-Jones, who was introduced to him by Rossetti in July 1856 and encountered him again in Italy in 1859. At his first, awe-inspiring meeting with Rossetti the young artist had seen his hero 'rend in pieces' someone who dared to speak 'disrespectfully' of *Men and Women,* which had just appeared, and these poems remained among his favourites. In 1857 he wrote glowingly of 'the fifty men and women . . . all sung out as if old Browning sat continually at the roots of human life and saw all things'.

Browning's genius, however, was too dramatic to suit Burne-Jones's conceptual approach, and he made little use of him as a literary source. Only two other examples are known: a slight pen sketch of 1859 inspired by the poem *Rudel to the Lady of Tripoli,* and the much later watercolour, *Love among the Ruins,* finished in 1873, which is loosely related to the poem of the same name, again from *Men and Women.* Even in *Childe Roland* Burne-Jones handles the subject remarkably freely. Whereas the mood of the poem is introspective, the drawing is conceived in decorative terms, including an arbitrarily placed scroll inscribed with the title. As for the poem's ghastly landscape, naked of all vegetation ('I think I never saw/Such starved ignoble nature; nothing throve:/For flowers – as well expect a cedar grove!'), Burne-Jones replaces this with a riot of sunflowers. Lady Burne-Jones in her *Memorials* (1904) describes how carefully he studied these in preparation for the drawing.

Childe Roland also has a remarkable provenance. In the record of his work that he began to keep in 1872, Burne-Jones noted that it belonged to Ruskin. Indeed Ruskin may have commissioned it, as he certainly did another pen drawing in 1859. At all events he probably saw *Childe Roland* as a successful expression of those central principles of *Modern Painters* that he was trying to instil in the artist at

this stage: the importance of a profound understanding of nature as the only true basis of a sublime imaginative vision, and the value of symbolism and allegory in giving that vision the deepest significance. Burne-Jones's painstaking study of the sunflowers is interesting in this context, as indeed is his choice of subject. For Browning was widely regarded in the circle as a 'prophet' in the Ruskinian sense, his work full of moral meaning. 'He is the deepest and intensest of all poets', Burne-Jones wrote of him in 1857, and about the same time Rossetti described how *Childe Roland* had been read to the pupils at the Working Men's College (where he and Ruskin taught) in the hope that 'it would do them good, whether they understood it all at first hearing or not'.

The drawing must have been one of the works, by a variety of artists, that Ruskin lent to Winnington Hall, the girls school in Cheshire he 'adopted' in the late 1850s; for, according to evidence that has recently come to light, he was unable to reclaim it when Miss Bell, the headmistress, went bankrupt in 1873 (see M. Olive Wilson, *op. cit*). A few years later it had found its way into the possession of F.S. Ellis, the bookseller and publisher who had published William Morris's *Earthly Paradise* (1868–70) and Rossetti's *Poems* (1870), and was later to assist Morris with the Kelmscott Press. In his privately printed (and undated) *Memories of Men, Places and Things,* Ellis recorded a little of its subsequent history. 'I bought it at a sale at Sotheby's about 1878 for something between twenty and thirty pounds . . . and was afterwards persuaded by a New York picture-dealer to let him have it; but a year later, to my great satisfaction, he brought it back, and I gladly repurchased it.' From then on it was 'lost' for many years, not even a reproduction being known. It reappeared only in 1975, shortly before the Arts Council's Burne-Jones exhibition that year, in which it was included.

Childe Roland is an ideal acquisition for the Cecil Higgins Art Gallery, which has an outstanding collection of English drawings, including several fine examples of Burne-Jones of later date. However, a perhaps more significant context is the collection of furniture and other items designed by the architect William Burges which the Gallery has formed in recent years. One of the most original (not to say eccentric) exponents of the High Victorian Gothic style, Burges

would have warmed at once to *Childe Roland,* with its medieval theme and Düreresque technique, and indeed the drawing was made at a time when he and Burne-Jones were in close communication. Both were members of such current artistic-cum-social bodies as the Medieval Society and the Hogarth Club, and Burne-Jones was involved in a number of Burges's decorative schemes. In 1860 he was among the artists who painted panels for a great bookcase which the architect conceived to hold his books on art (Ashmolean Museum); and about the same time he designed the east window which is one of the most striking features of Burges's restoration of Waltham Abbey. Last year the NACF helped the Cecil Higgins Art Gallery to buy a painted cabinet to complete the furnishing of its Burges Room (1983 *Review,* no. 2979). *Childe Roland* will provide a fascinating point of comparison to the Burges collection as a whole.

Edward Burne-Jones (1833–1898)
Childe Roland
Pen and ink with grey wash, 43 × 24 cm
Signed and dated *EBJ 1861* lower left, and inscribed
CHILDE ROLAND TO THE DARK TOWER CAME on the scroll at right

Provenance: Probably acquired from the artist by John Ruskin; F.S. Ellis by about 1878; Arthur West.

Exhibited: Burne-Jones, Arts Council (Hayward Gallery, London, Birmingham and Southampton), 1975–6, no. 22.

Reference: F.S. Ellis, *Memories of Men, Places and Things . . .,* n.d., pp. 7–8, no. 6; Malcolm Bell, *Sir Edward Burne-Jones. A Record and Review,* 4th ed., 1898, p. 28; F. de Lisle, *Burne-Jones,* 1904, p. 57; G(eorgiana) B(urne)-J(ones), *Memorials of Edward Burne-Jones,* 1904, I, p. 225; *The Diaries of George Price Boyce,* ed. Virginia Surtees, 1980, pp. 32 and 93, note 5; M. Olive Wilson (ed.), *My Dearest Dora: Letters from John Ruskin to Dora Livesey . . .,* 1984.

Bought for £15,000 (private treaty sale through Christie's) by the Cecil Higgins Art Gallery with the help of a contribution of £2,500 from the NACF.

Drinking Glasses from the Lazarus Collection

Karin Walton

To many the name 'Bristol' is synonymous with glass and visitors to the city's Museum and Art Gallery have been disappointed to find little English glass on display apart from a relatively small though highly important group of documentary Bristol pieces. The eighteenth-century drinking glass which, probably more than any other item, epitomises English glass at its best, was scarcely represented. The purchase of one hundred and sixty-four drinking glasses selected from the collection of the late Peter Lazarus has therefore added significantly to the scope of the collections.

Peter Lazarus was the headmaster of a preparatory school near Bristol. He began collecting glass in the early 1960s and so quickly did he master the subject that in 1967 he was asked by John Harvey & Sons Ltd of Bristol to form a collection of glasses and decanters. Three years later he received a similar commission from Cinzano. He was a friend of Bristol Art Gallery in name and deed, advising on acquisitions and often donating his lecture fees to the Friends whom he served as Chairman from 1975 to 1978.

The glasses acquired for the Art Gallery cover the period from the late seventeenth century to the early years of the nineteenth century and illustrate the enormous variety of form and decoration that the glassmakers employed. Probably the earliest glass is the crizzled goblet (illus.) with its pincered 'nipt diamond wais' decoration and hollow-blown quatrefoil knop. Peter Lazarus's own favourites, the baluster-stemmed glasses are well represented; in addition to the more common forms of knopped and plain, true and inverted balusters there are examples of the less common acorn and cylinder-knopped stems. These glasses with their exquisite proportions and minimal decoration reflect the sculptural quality of the English Baroque.

The Excise Act of 1745 which taxed glass (but not opaque glass) by weight, encouraged the glassmakers to develop smaller and lighter forms and to abandon knops in favour of air- and opaque-twist stems. The decorative element was transferred to surface engraving or painting with the motifs often giving an indication of the intended contents of the glass: fruiting vines, barley and cider apples are all represented. The majority of the glasses are clear but the collection does include eight green glasses ranging from emerald to bright peacock, and six colour-twist stems.

While the early glasses make their impact through form, the later glasses appeal more on account of their decoration. The best-known decorators of eighteenth-century glass are James Giles and the Beilby family. There are four glasses with gilded decoration of rose sprays, vines and crossed barley stalks, that can be attributed to the workshop of the London gilder and decorator James Giles, and fruiting vines, this time in white enamel, also feature on the glasses (illus.) attributed to William Beilby and his sister Mary of Newcastle, but it is their delightful exotic birds and landscape scenes in the rococo manner (illus. cover) that charm the eye. The fourteen 'Beilby' glasses also include a Masonic firing glass and a tumbler inscribed JN⁰ & M. HARRISON 1768, perhaps a marriage piece. Far more sophisticated are the three stipple-engraved glasses. Stipple-engraving is executed with a diamond point which creates the design out of many tiny dots; shading is produced by varying the closeness of the dots. This form of decoration seems to have been the exclusive province of the Dutch but they preferred to work on English glasses, in particular the light baluster type made in Newcastle. The lead content of the glass made it better able to withstand the hammering of the diamond point. On two of these glasses the engraving betrays its Dutch origin: one depicts a young girl and a lion with two Dutch mottoes, the other, the Arms of William IV of Orange and his consort Anne, daughter of George II of England. The third glass (illus.) which shows a contented cat curled up above the legend 'LIBERTAS' is initialled and dated 'A.S. 1747'; it was engraved by Aert Schouman who is known to have worked in Dordrecht and the Hague.

More Dutch engraving, this time done with an abrasive wheel, decorates a group of glasses with Royal coats of arms, carousing scenes (illus. cover) and inscriptions. Again, the glasses are mainly of the Newcastle light baluster type. The example illustrated here, engraved with a sunburst and an inscription that translates as 'He who friendship's joys would shun, from the world expels the sun', is signed and dated on the foot, 'Jacob Sang inv＝ct Fec Amsterdam 1761'.

The examples of English engraving, though often less accomplished than the Dutch, are particularly valuable for their historical and social interest. To balance the four

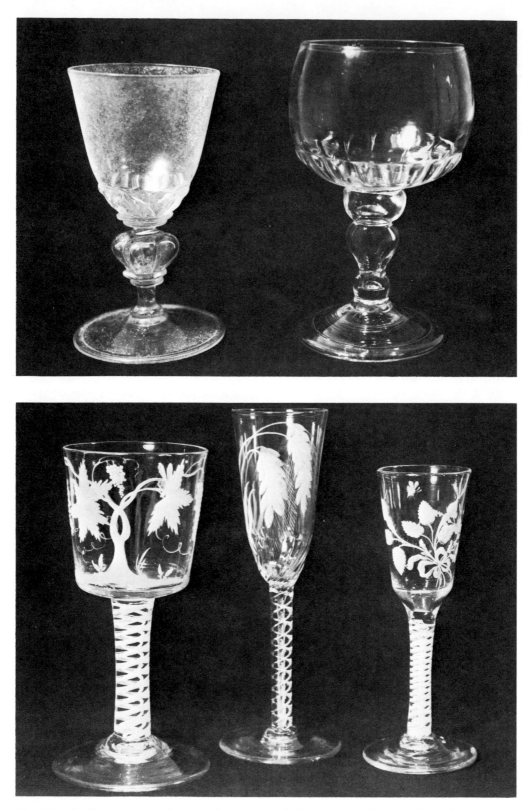

Top: Crizzled goblet, last quarter of seventeenth century. Mead glass, *c.*1700. Cuo bowl on hollow baluster stem.

Bottom: Goblet and two ale glasses, *c.*1760–70. Enamelled decoration, that on the two outer glasses in the manner of the Beilby family.

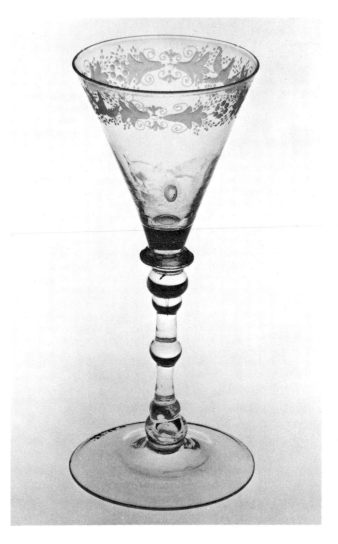

Drinking glass, dated 1747. Newcastle light baluster type stipple-engraved by Aert Schouman.

drew in favour of Robert Clive). Of a more intimate nature are the glass presented by 'Bridt Alderson/to/Ann Brooks' and a pair of miniature rummers dated 1796, the one intended 'FOR MY DEAR EDWARD MARSHAM', the other 'FOR MY DEAR HENRY MARSHAM'. Most endearing of all is a glass diamond-point-engraved on the foot with two lines from Pope and on the bowl 'Gaze on her Charms and they will clearly prove, That Nancy Holme's the/beauteous Queen of Love/Dear Nanny Holme'.

The Lazarus glasses on their own give a comprehensive view of the English eighteenth-century glassmaker's art. In the wider context of the Museum & Art Gallery's total holdings they play a more significant role. They take their place alongside the Bomford Collection of Ancient glass (purchased 1979 with assistance from the National Art-Collections Fund and others) and the H.F.B. Abbey Collection of Chinese glass (presented in 1950 through the National Art-Collections Fund) to provide a history of glass-making which spans ten centuries.

The Lazarus Collection of Drinking Glasses
164 English stemmed glasses ranging in date from c.1680 to c.1810.

Bought for £91,310 by the Bristol City Museums and Art Gallery with the help of a contribution of £11,410 from the NACF (Eugene Cremetti Fund).

Jacobite glasses there is another proposing 'Prosperity to the Duke of Cumberland'. 'OUR GLORIOUS AND IMMORTAL KING WILLIAM III' is commemorated twice, the King of Prussia once. A number of glasses bear the legend 'LIBERTY' and one, more specifically 'WILKES AND LIBERTY' above an escaped bird perched atop his now empty cage. (John Wilkes was imprisoned for his outspoken criticism of Lord Bute's government and George III in his newspaper 'The North Briton'; the people took up his cause under the slogan 'Wilkes and Liberty' and he was released.) There are three electioneering goblets favouring 'MORTIMER & FREE-DOM' (Hans Wintrop Mortimer was elected MP for Shaftesbury in 1774, 1780 and 1784); 'SHAFTO AND VANE FOR EVER' (both men were returned to Parliament for County Durham in 1761) and 'LORD PULTENEY AND PROSPERITY TO SHREWSBWRY' (Lord Pulteney stood for Parliament for the seat of Shrewsbury in 1761 but with-

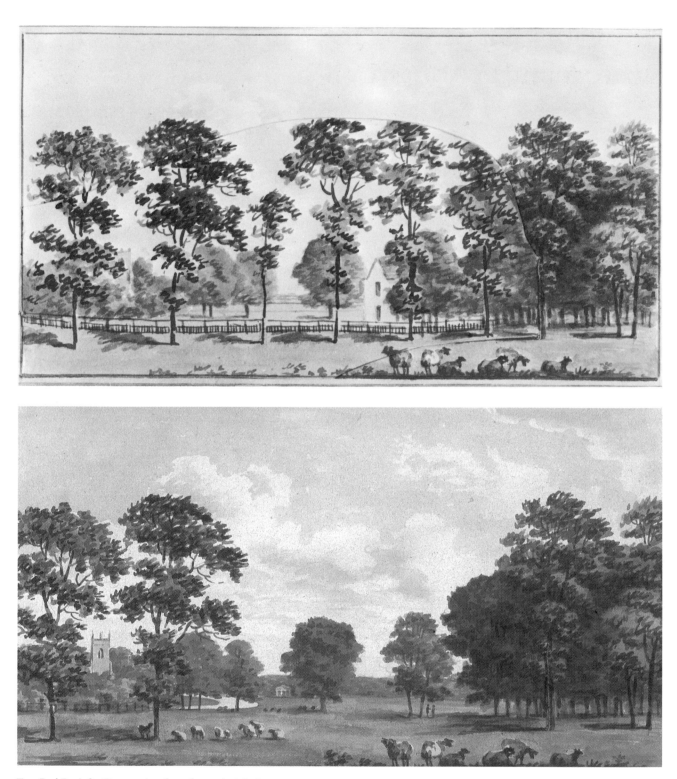

Top: Red Book for Ouston, view from the east (existing).

Bottom: Red Book for Ouston, view from the east (proposed).

Humphry Repton's 'Red Books' for Ouston and Abbots Leigh

Kedrun Laurie

Sir Walter Scott described Humphry Repton's Red Books as, 'a raree show omitting only the magnifying glass and substituting his red book for the box and strings'.

With the generous assistance of the NACF, Doncaster Museum and Art Gallery and Bristol University Library were each fortunate enough to acquire their own Red Book last year; the former that for Owston in Yorkshire (or Ouston, as Repton spelled it) dating from 1792/3, and the latter the splendid volume for Abbots Leigh near Bristol (now Leigh Court) of 1814. Taken together they mark the beginning and end of Repton's career as a landscape designer, a career which began in 1788 when he was 36, and ended in 1816, two years before his death.

The Red Books, so-called because they were bound in red morocco or calf, were masterpieces of self-publicity, beautifully made volumes designed with the intention of procuring for their author the commission to landscape a country seat. Usually of oblong quarto format (although the Abbots Leigh book is one of the rarer large folio volumes) they consist of passages of manuscript text interspersed with delicate watercolour sketches covered by slides or overlays. When flat these show the dull unimproved scene, but when lifted they reveal all the delights promised if only the client will be discerning enough to follow Repton's advice. Between text and illustration, one discursive and the other graphic, what Repton calls an 'occular demonstration' of his landscape theory is encapsulated in the Red Book.

Repton had worked for Bryan Cooke, the owner of Owston, before, at Bessacre Manor in the same county, but at Owston he had the difficult task of creating 'cheerful and interesting scenery' out of a park which did not boast any very striking features or extensive prospects. He did see some potential in the 'verdure', which was good, in the dry soil, and in the many trees which though still standing in formal row arrangement could, he felt, with judicious management, be grouped more naturalistically.

At Owston as at Abbots Leigh Repton devotes most of his Red Book to a discussion of the correct siting of the house, a decision which if botched could make his job of landscaping the park doubly difficult. He considered that a house should primarily be orientated according to the demands of comfort and convenience of the client and only modified by what might be considered the best views from the windows. This led, where he had a chance to influence the architect, to a much more asymmetrical and fluidly arranged house than had been common in the past, making Repton, with Nash, the leader of the movement towards picturesque planning.

Repton would modify the siting still further to accord with what he calls the 'congruity' of views from a gentleman's mansion, which is that what he sees from his window ought either to be his, or else appear to be his. The rider is a characteristic and attractive one, for it brings the imagination into play. A gentleman's grounds need not be ostentatiously large, provided the boundary is invisible, so that the eye may travel unimpeded into distant countryside. However, this liberal and Romantic theory inevitably has a careful qualification based on the realities of land ownership. At Owston Repton will not orientate the house towards the 'cheerful' village of Burghwallis, however pretty it may be, because Cooke does not actually own it and so could not control future development. What if the proprietor of the village were one day to cut down all the trees, and replace the picturesque thatched roofs with scarlet pantiles? – 'What a change might this produce!'. The site Repton suggests for the new house, a little way to the north-west of the old one, achieves with the thinning of a few trees and the sinking of a small lake to the south-east, a subtle and economical transformation of Cooke's park. The sticking point must have been the expense of Repton's basic premiss that a new house be built; William Lindley being called in merely to extend the old one in 1794–5, so bringing all Repton's plans to nought.

At Abbots Leigh Repton shows a similar concern for 'congruity' or 'appropriation' in the views from the mansion, where to his chagrin, the foundations of Thomas Hopper's new house had already been laid by the time Philip John Miles, a prominent Bristol banker, called him to the scene. Writing with a fairly bad grace he complains that although the view to the east incorporates both Blaise Castle and Cook's Folly on distant eminences, these can be seen from 'every field or lane in this neighbourhood'. According to the Repton canon the principal view from a

Top: Red Book for Ouston, view from the south (existing).

Bottom: Red Book for Ouston, view from the south (proposed).

Below right: Red Book for Ouston, approach.

gentleman in nineteenth-century semi-urban England than does the sweeping open landscape of Owston, but one which is capable of great prettiness of detail and which is in many respects the forerunner of our modern flower garden. So at Abbots Leigh we have a trellis fence in the French style, terrace gardens in the Italian style, and even a most grandiose terraced kitchen garden with fruit trees placed in arched recesses and passionflowers, creepers, and grape vines trained up the piers. This is an extremely important Red Book for an understanding of Repton's small-scale and decorative late style, just as the Red Book for Owston is a classic of the more heroic Georgian style which he derived from his predecessor Capability Brown and which was more characteristic of his early career. Both Doncaster and Bristol are to be congratulated on their acquisitions.

Humphry Repton (1752–1818)
The Red Book for Abbots Leigh, 1814
Nine pages of manuscript including drawings in watercolour and pen and ink, and a plan
Signed and dated 1814
Bound in red morocco by Sangorski and Sutcliffe, folio (41 × 26 cm)

Provenance: hitherto unrecorded; anon. sale Phillips, Son & Neale, 13 Jan 1983, lot 372

Bought for £3,500 by the University Library, Bristol, with the help of a contribution of £875 from the NACF.

Humphry Repton (1752–1818)
The Red Book for Ouston
Eleven pages of manuscript including drawings in watercolour and pen and ink, and a plan
Signed and dated 'August 28th 1792' and 'Feb. 1793'

Contemporary calf gilt binding, quarto (22 × 28·5 cm)

Bought for £3,300 (Myers Autographs Ltd) by the Doncaster Museum and Art Gallery, with the help of a contribution of £825 from the NACF.

mansion required some feature which belonged to the estate *alone* and to this end he suggested that a circular temple be placed *within* the grounds on this front.

By the same token Repton is extraordinarily irritated by what he sees as Hopper's crassness in so siting the house that the point blank view to the south is of 'a large staring yellow house . . . an obtrusive yellow mass of Ugliness' over which Miles has no control. All Repton can suggest is that the owner be persuaded to cover the front with slate or green trellis, and that three acacias be planted within Miles's pleasure-ground in an attempt to conceal it 'for it is not sufficient that the property near a large house actually belongs to it, it ought to appear to belong . . .'

Written twenty-one years after the Owston Red Book, Abbots Leigh shows one crucial difference in the way it deals with the problem of appropriation. The elaboration of the pleasure-ground by the house is a new way of expressing the separate character of a gentleman's residence; one which reflects the somewhat more besieged position of that

Top left: Red Book for Abbots Leigh, view to the east.

Top right: Red Book for Abbots Leigh.

Bottom: Red Book for Abbots Leigh, plan.

Italian Lake Scene by Richard Parkes Bonington

Marion Spencer

This vivid and elegant sketch is one of several made by Bonington in the course of his tour of Italy in the Spring and Summer of 1826. After his great success at the Paris Salon of 1824 where, though not only a foreigner but also by far the youngest of the English contributors, he had been awarded a Gold Medal, he became one of the circle of Delacroix and his cosmopolitan friends. His travelling companion in Italy was the young Baron Charles Rivet (1800–1872), who was his staunch supporter and generous patron.

The Fitzwilliam sketch is a view of Desenzano, at the south-west end of Lake Garda, looking east towards the peninsula of Sirmione. Bonington and Rivet reached Milan on 11 April, and from there travelled on towards Venice. Rivet wrote: 'Bonington . . . makes sketches and works a little everywhere . . . After Milan the country is the most beautiful and the most fertile that can be seen; the roads are magnificent, the horizon glorious with mountains and glaciers.'

For his sketch Bonington used one of the pieces of prepared millboard of which he had laid in a supply from Davy, the artists' colourman of Newman Street, when in London in the summer of 1825. The millboards were already primed in cream, and on this Bonington indicates with a lightness as of watercolour and with the natural lushness of the oil paint, the features of his compositions. Much of the water is left with only the slightest glaze, thus reflecting the light from the sky. The strong accents, which because of the character of the millboard stay proud of the surface, establish the structure of the houses; of the campanile to the church; of the pier and customs post; and similar accents, the foreground shoreline with its several wooden piles. It has all the freshness, alertness and brilliance of a youthful work. One sees Bonington firmly anticipating the discoveries of the Impressionists: the paint has been applied to a light ground; the pigment itself is in the purest of tones: whites, moss-green, gentle blues, pinks and salmons, positive greys and rich cream, strong burnt siena for the areas in shadow: all presented as pure colour.

The painting belonged to the poet and collector Samuel Rogers; it is possibly to be identified with lot 159 in Bonington's posthumous sale, purchased by Rogers, but described in the catalogue as 'Spirited Sketch, Part of Genoa and the Bay'. Rogers had visited Italy in 1814, and had also stopped at Desenzano. In his journal for 13 and 14 October he recorded: 'Descended to the Lago di Garda & slept at Desenzano. An excellent Inn with spacious appartments & a balcony over the lake. Size of the boats told us the size of the lake indeed . . .

The sun is not visible, but the water in a golden glow from the reflection of the clouds in the east; Rivoltella [a *frazione* of Desenzano] throwing the shadows of its turrets on the lake; which, to the North, is hid in the clouds that have come down upon it from the Mountains . . . were it clear, we might see into the heart of the Alps, as the lake is 35 m[iles] long, & we look directly up it. On the right on a reach of land lies Sermione.'

Rogers is describing the scene from the viewpoint from which Bonington painted it, and it is no wonder that he was attracted to the picture.

For Rivet and Bonington the journey to Venice had been long. Rivet wrote to his family:

'Bonington thinks only of Venice; . . . He makes no effort to learn Italian, keeps to his tea, and requires the help of an interpreter in everything . . .'

and a few days later, by which time they had reached Venice, he continued:

'My friend has been a little more docile the last few days. He has had a letter from his father who tells him that . . . every [picture] that he had done, without exception, had been bought and paid for . . . But what is still better for his travelling companion is that he has begun to complain less about the little he has done, and apart from a few jeremiads on the meagre amount of strength which nature has put into his right arm, he has become quite bearable . . . He works hard and adopts so readily the suitable style and method that he is more and more successful and more and more easily so.'

Indeed it would be a remarkable exhibition that brought together the oil sketches Bonington made during this tour; sketches which were all highly prized at the 1829 Family sale: *Landscape with mountains* (National Gallery of Scotland); this Fitzwilliam picture; the several views of gothic

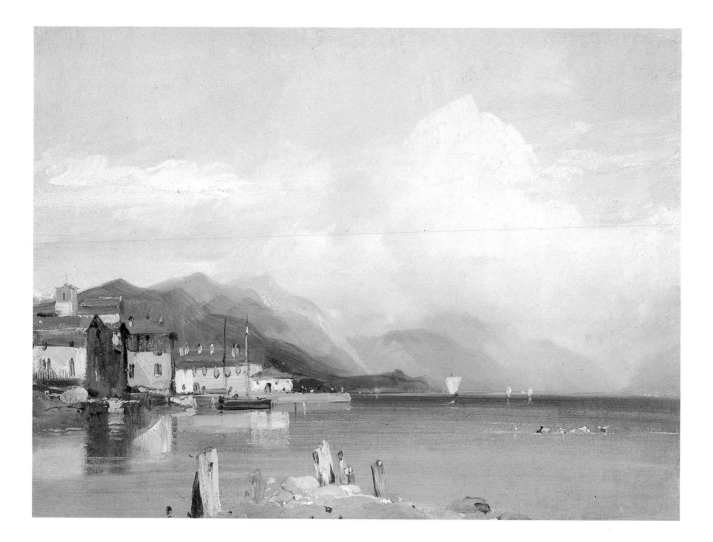

Venice in that cool limpid sunshine of late spring, and then others of the Ligurian coast, one of which had also been treasured by Samuel Rogers.

Bonington and Rivet spent four weeks in Venice and then travelled across the Appenines stopping at Ferrara, and Bologna; they reached Florence on 24 May and stayed a week, which included a visit to Pisa; they then turned towards home, via Lerici, La Spezzia, Genoa, Alessandria and Turin. They were back in Paris on 20 June. Rivet had written:

> 'Bonington has said nothing since we left the lagoons. He regrets Venice, though she treated him so badly with her rain and incessant storms, and he left the place with a presentiment that he would never see it again.'

Quotations are taken from:
J.R. Hale (editor), *The Italian Journey of Samuel Rogers,* Faber & Faber, 1956, p. 169.

A. Dubuisson and C.E. Hughes, *Bonington,* John Lane The Bodley Head, 1924, pp. 69–74.

Richard Parkes Bonington (1802–1828)
Italian Lake Scene, 1826
Oil on millboard, $25 \cdot 1 \times 33$ cm

Provenance: Samuel Rogers, bequeathed by him to his nephew, William Sharpe; by descent to Prof. E.S. Pearson, who presented it to Cranborne Chase School, 1962.

Exhibited: Cosmoramic Rooms, London, 1834, no. 48, *Italian Lake Scene,* lent by Miss Rogers; Castle Museum and Art Gallery, Nottingham, 1965, no. 272; Musée de Cherbourg, 1966, no. 51; Haus der Kunst, Munich, *Zwei Jahrhunderte Englische Malerei,* 1979–80, no. 235.

Bought for £40,000 (the Governors of Cranborne Chase School) by the Fitzwilliam Museum, with the help of a contribution of £10,000 from the NACF.

John Howard Visiting a Lazaretto by George Romney

Victoria Slowe

'. . . His cartoons, some of which have unfortunately perished, were examples of the sublime and terrible, at that time perfectly new in English art . . . As Romney was gifted with peculiar powers for historical and ideal painting, so his heart and soul were engaged in the pursuit of it, whenever he could extricate himself from the importunate business of portrait painting.'

Thus John Flaxman RA, contributing an appreciation of his friend and fellow artist to William Hayley's *The Life of George Romney, Esq.,* published in 1809. Yet, as Sir Ellis Waterhouse has pointed out, (*Painting in Britain 1530 to 1790,* 1953), 'there is little to show for this save a mass of drawings for high-flown compositions, mostly in the Fitzwilliam Museum at Cambridge'.

Now, thanks to the generosity of the NACF, one of these 'drawings for high-flown compositions', together with a related sketchbook, has been purchased by Abbot Hall Art Gallery, Kendal, which already has a fine and representative collection of that infinitely better known aspect of Romney's career, his portraits.

The subject of the newly acquired drawing is *John Howard visiting a Lazaretto,* a theme which occupied Romney's attention, both intellectually and pictorially, for over a decade from 1780. In that year, William Hayley[1] cajoled Romney into executing a design, subsequently engraved by Bartolozzi, to accompany his Ode in honour of Howard, the prison philanthropist and reformer. According to Hayley, his poem inspired in Romney a great desire to paint a series of pictures 'to express his veneration for the character of Howard, and to display the variety of relief, that his signal benevolence afforded to the sufferings of the wretched'.

Despite Hayley's best efforts, Howard, who shunned publicity, resolutely refused to sit for his portrait. He proved willing, however, to recount to Romney, details of several dramatic and suitably anguished incidents which he had observed during the many visits which culminated in his monumental survey, *The State of the Prisons in England and Wales,* published in 1777. Romney subsequently drafted a number of rough sketches and continued – with encouragement – to mull over the possibilities of a radical theme which appealed not only to his own political ideals – or, at least, to those nurtured in him by his circle: Tom Paine, William Hayley, the Rev. John Warner and William Blake – but which also seemed admirably suited to the republican tenets and image-building of the then avant-garde aesthetic movement which we now term Neo-Classicism.

The slow gestation of Romney's thoughts on the interpretation of his chosen theme received a stimulus in 1789, with the publication of John Howard's *The Principal Lazarettos of Europe,* which drew attention to the utterly appalling conditions in which prisoners were held throughout Europe. Howard's pioneering work achieved public recognition. And then, early in 1790, John Howard died, a martyr to his cause, of gaol fever, at Kherson, in South Russia.

As far as Romney was concerned, the catalyst was administered that summer of 1790, when he accompanied Hayley to Paris, where their mutual and somewhat revolutionary friend, the Rev. John Warner, had recently become domestic chaplain to the young and newly appointed English ambassador, Lord Gower.[2] In Paris, the natural idealism of the three friends was heightened by the still recent – and, perhaps more importantly, still bloodless – Revolution.

Hayley records the visit as 'a time when that scene of astonishing vicissitudes presented to the friends of peace, of freedom and of the arts, a spectacle of cheerful curiosity, and of hope so magnificent in promises of good to mankind, that philanthropy could not fail to exult in the recent prospect, unconscious that the splendid vision was destined to sink in the most execrable horrors of barbarity and blood'.

Romney's fellow Cumbrian, William Wordsworth, describes that same mood – rather more succinctly and far

1. In 1968, with generous help from the NACF, Abbot Hall Art Gallery acquired *The Four Friends,* George Romney's group portrait, painted in 1796, of himself with his great friend William Hayley, Hayley's son, Thomas, and William Mayer.

2. Earl Gower was the son of the Marquis of Stafford, a notable patron who had commissioned the magnificent dancing group of his children, *The Gower Family,* from Romney in 1776: this masterpiece was acquired by Abbot Hall Art Gallery with substantial help from the NACF in 1974.

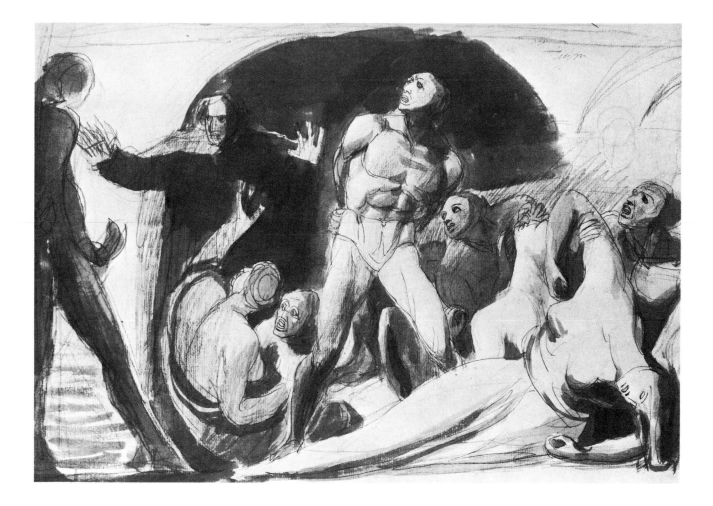

less pompously – in his lines:

> Bliss was it in that dawn to be alive,
> But to be young was very heaven!

And perhaps it is that second line which most accurately reflects Romney's state of mind. When he had first visited Paris in 1764, some twenty-six years earlier, with his schoolfriend, the lawyer Thomas Greene, he had been full of ambition to succeed as a history painter. Indeed, he had already achieved a popular success with *The Death of General Wolfe,*[3] exhibited at the Society of Arts in 1763. This painting had been awarded the second premium for historical painting at the annual exhibition but was subsequently – and some thought inexplicably – demoted, although Romney was given a special prize of 25 guineas.

The Death of General Wolfe, who had been killed at the moment of victory at Quebec in 1759, was a somewhat revolutionary subject for a history painting in 1763: the subject was a modern one – as yet unrecorded by any historian – and the figures were dressed in the costume of the day, rather than classical garb.[4] Now, in Revolutionary Paris, in 1790 – a bare generation later – such an interpretation was the norm.

Hayley records his and Romney's admiration of three works by David: *The Death of Socrates, Paris and Helen* and *The Oath of the Horatii.* It appears that Romney was mightily impressed by the contemporary French painters who were busily transmuting current events into historical allegory. Their paintings were strikingly relevant, giving the Revolution a truly heroic stature. Romney strengthened his resolve to succeed as a history painter. He must have

3. A very telling oil sketch for George Romney's *The Death of General Wolfe* was acquired by Abbot Hall Art Gallery, with help from the NACF, in 1982. The finished painting, exhibited at the Society of Arts in 1763, once hung in Governor Verelst's Council Chamber in Calcutta, but has since disappeared. See Arthur B. Chamberlain, *George Romney,* Methuen & Co., 1910, pp. 42–48, for full account.

4. Benjamin West's famous painting, *The Death of Wolfe,* (now in the National Gallery of Canada, Ottawa), was not painted until 1770. West emulated Romney in portraying the 'hero of Quebec expiring at the moment of his triumph and thus attaining immortality in a double sense. Such a death provided a "classic" theme of universal validity.' (Hugh Honour, *Neo-Classicism,* Pelican, 1968.)

wondered whether the years since 1763 had been totally wasted. His painting of *The Death of General Wolfe* had, after all, been a valid subject.

To Romney, the pioneering work of John Howard seemed a subject of similar importance. The question of a fitting memorial to this philanthropist was discussed at length. Warner renewed his scheme, first mooted in 1786, to erect a public statue in Howard's honour. Hayley began his *Eulogies of Howard, A Vision*. And Romney started sketching more 'scenes of human wretchedness' from Howard's shattering descriptions of captivity, filth, disease and death.

The 'one or two large pictures which', according to his son, the Rev. John Romney (*Memoirs of the Life and Works of George Romney,* 1830), 'Mr. Romney intended to have painted', never materialised. The sketchbook drafts, however, were worked up into tightly resolved cartoons in pen and wash, frequently dramatised with rather frenzied pencil lines. Several of these survive. Three large drawings comparable to that acquired by Abbot Hall Art Gallery and six related sketches were included in the Rev. John Romney's gift to the Fitzwilliam Museum, Cambridge in 1818. Whether the paucity of such drawings reflects the Rev. John Romney's anxiety to shield his father from charges of dangerous and potentially subversive radicalism – as Mrs Patricia Jaffé has cogently argued (see her catalogue for the exhibition *Drawings by George Romney from the Fitzwilliam Museum, Cambridge,* 1977) – or whether George Romney himself decided on discretion in view of the political situation obtaining in England during the Terror and so gave up the project, is uncertain.

The large watercolours on this theme are stark and powerful images, full of an intensity lacking in the decorative sketches of gracefully draped classical females. The Abbot Hall drawing is anguished, full of painful immediacy. Howard, hands dramatically foreshortened and upraised in horror – almost in blessing, in a shocking recall of images of Christ – emerges, deus ex machina, from the dungeon gloom, evoked by a simple arch. The gaoler, to the left, recoils from Howard's terrible, fulminating glare. To the right a dying woman collapses into the arms of her fellow captives, thus completing the outline of the central oval motif. A number of thrusting diagonals – arms, spines, legs, gazes – focuses attention on the heroically-muscled torso of the central figure, contorted as he struggles to free his bonds.

The subject is ostensibly *John Howard visiting a Lazaretto* but the underlying theme is universal: 'Man's inhumanity to man'.

George Romney (1734–1802)
John Howard Visiting a Lazaretto
Pencil, pen and grey wash on paper, 36·2 × 51·2 cm

Bought for £4,800 (Spinks) by Abbot Hall Art Gallery, with the help of a contribution of £1,200 from the NACF.

George Romney (1734–1802)
A Sketchbook containing drawings related to *John Howard Visiting a Lazaretto* and to other items in the collection of Abbot Hall Art Gallery, dated March 1790
Pencil on paper, page size 17·1 × 20·3 cm

Bought for £650 (John Morton Morris) by Abbot Hall Art Gallery, with the help of a contribution of £162 from the NACF.

Epstein's 'Maternity'

Richard Cork

When Epstein exhibited his *Maternity (Unfinished)* at the Allied Artists' 1912 exhibition in the Albert Hall, he immediately became a focus for the disapproval of public and critics alike. Together with Wyndham Lewis's monumental *Kermesse* canvas, displayed in the same show, this over-life-size carving demonstrated that a powerful new force had emerged in British painting and sculpture. Lewis's dionysiac masterpiece, now lost, seems to have been fully aware of the most innovatory European art, and Frank Rutter afterwards recalled that 'here for the first time London saw by an English artist a painting altogether in sympathy with the later developments in Paris'. Epstein's *Maternity* was far quieter and more openly figurative than Lewis's boisterous, semi-abstract composition. But the carving even succeeded in alienating the sympathetic Roger Fry, whose review of the exhibition roundly declared that 'it is terrible that such a talent and such force of character and intellect as Mr. Epstein has should remain ineffectual'.

One reason why Epstein 'shared with Lewis the honours of opprobrious attention' at the show lies in his brazen reliance on the inspiration of so-called primitive art. An earlier *Maternity*, completed in 1908 for the British Medical Association building in the Strand, calmly adhered to the European tradition. But this new carving unequivocally rejects the Western norm, embracing instead alternatives culled from Indian and African sources. The woman's frankly stylised face, protuberant breasts and swaying, erotic stance declare Epstein's allegiance to Hindu sculpture, while the jutting angularity of her arms reveals his growing involvement with African carvings. He was not the only young sculptor in England to discover these enthusiasms: in 1911 his friend Eric Gill joyfully announced that 'the best route to Heaven is via Elephanta, and Elura and Ajanta'. But most of the visitors who scrutinised *Maternity* at the Albert Hall were quite unprepared for this disturbing new interpretation of womanhood.

They would have been affronted above all by the seemingly wanton flaunting of her sexuality. Scandalised attention doubtless centred on the erect nipples thrusting out from her globular breasts, and the ripe pair of buttocks curving so provocatively above the low-slung drapery behind. Never before had a British sculptor dared to present such an inescapably voluptuous image of fertility. Although this serene mother lowers her Asian eyes to contemplate the roundness of her stomach, she exudes the intensely physical allure which brought about her impregnation. However oblivious she may be to everything except the foetus burgeoning within, her body offers itself like a delectable fruit to the spectator. Even the heavy plait descending from her helmet-like head in a sequence of plump folds is eminently graspable. Our fingers itch to run themselves across every swelling, dip and hollow in this woman's enticing flesh. We envy the freedom with which loose strands of garment slide round her breasts, curve over her shoulders and course down the white smoothness of her back.

But *Maternity* is not just a celebration of the ardent feelings Epstein harboured for nubile women in their procreative prime. Although Gill was scarcely exaggerating when he wrote in his diary that Epstein was 'quite mad about sex', this carving also possesses a considerable amount of tenderness and dignified restraint. One of the preliminary drawings shows that he planned to let *Maternity*'s right arm hang at a distance from her body, gesticulating in space while the left arm occupied the place it retains in the carving. But Epstein eventually decided to dispense with this somewhat theatrical gesture. In the statue itself the woman keeps both arms firmly at her sides, as if absorbed by the task of protecting the vulnerable new life rising in her belly. Another drawing outlines his initial plan for the hands, fully encompassing her stomach so that the tips of the middle fingers meet in the centre. But the hands draw back from this confident union in the carving, for Epstein here gives them a more shy and tentative role. Although the fingers of the left hand are still extended across one half of the belly, the other set of fingers is now reluctant to join them. With great subtlety Epstein makes them bend slightly upwards and hover by the side of the stomach, as if unwilling to restrict the baby's movements by encircling the womb completely.

As a result, the carving gains in humanity and gracefulness. However erotic this woman's body may be, she devotes all her love and attention to the well-being of the unborn child. The feet peeping out so modestly from the

strange arch-like opening at the base of her robe indicate that she is standing in a very formal, upright position. No distracting curves are allowed to disrupt the sober sequence of vertical folds in the drapery enclosing her legs. They signify the more chaste side of the figure, and seem determined to give the lower half of the mother a privacy she so conspicuously lacks above her waist.

The robe's flatness and strong upright direction are also the outcome of Epstein's desire to honour the identity of the block he had carved. Only a month before *Maternity* was exhibited, he invited critics and friends to view the completed *Tomb of Oscar Wilde* in his Cheyne Walk studio. One of this sculpture's most arresting characteristics was its sensitivity to the material Epstein had employed. The *Evening Standard*'s reviewer stressed that 'there is nothing to destroy the effect of a rectangular block of stone that has felt itself into expression', and the same is true of *Maternity*. When seen from the sides in particular, the carving discloses Epstein's urge to retain the image of the tall Hopton-wood stone slab which had confronted him at the outset.

A similar motive may well lie behind his decision to exhibit the figure in an unfinished state. For its rough-hewn areas gave viewers a startlingly raw idea of the passionate physical engagement which informed Epstein's chiselling of the stone. He never explained why *Maternity* was left incomplete: an ambiguously defined garment on the right of the pigtail, and the oddly dislocated thumb on the left hand suggest that he encountered difficulties which proved impossible to resolve. But looking at this figure today, with its eloquent evidence of Epstein's struggle so honestly exposed, we suspect that he was right to leave it unfinished. The principle of direct carving, which gave early modernist sculpture so much of its power and vitality, is implemented here with formidable conviction. Epstein's cutting is resourceful enough to master the delicacy of the skin-fold above her right breast as well as the vigorously handled sweep of the robe beneath her buttocks. The whole figure is a testament to the wide range of expressive possibilities opened up by Epstein's pioneering audacity.

In this respect the theme of maternity could hardly have been more appropriate. For this flawed yet deeply impressive carving appears poised for the birth not only of a child, but also of the revolutionary spirit which would provide twentieth-century sculpture with some of its most enduring achievements.

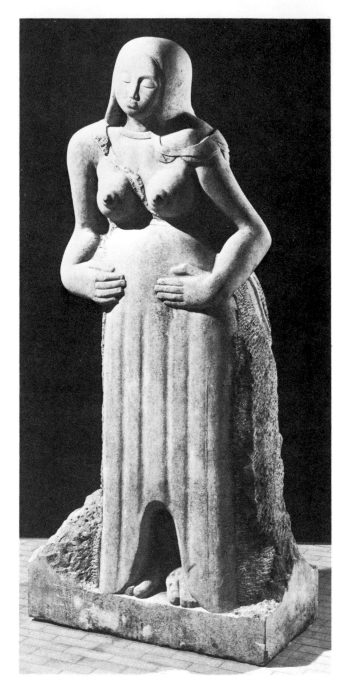

Sir Jacob Epstein (1880–1959)
Maternity 1910–1911
Hopton-wood stone, height 208·2 cm

Bought for £49,000 by the Leeds City Art Gallery (Henry Moore Centre for the Study of Sculpture), with the help of a contribution of £5,000 from the NACF.

Two Views of the Castle of Königstein by Bernardo Bellotto

J. Byam Shaw

Members who visited the Burlington House Antiques Fair in London in October had the opportunity of seeing there, in the NACF stand, the two views of Königstein Castle by Bellotto which have been acquired, with considerable help from the Fund, for the City Art Gallery of Manchester.[1] Though there are many of his fascinating views of Dresden, Vienna and Warsaw in the principal galleries of those cities, his work is not well known in England. Only one small painting, an imaginary composition in the later manner of his uncle Antonio Canal – whom he imitated very closely at the beginning of his career – is attributed to him in our National Gallery; though his name is sometimes attached elsewhere, with less justification, to inferior pieces of the Canaletto school; and he himself has caused some confusion by including the familiar diminutive of his uncle's name (Canaletto) in his own signatures. But though he is poorly represented in London, there are now fine examples of his work in other British collections or galleries: besides two more distant views of Königstein belonging to Lord Derby, there is the *View of Verona* which the NACF helped to save for the National Trust at Powis Castle; and another view of Verona is now on loan to the National Gallery of Scotland. The two large and splendid views of this Saxon castle on the Elbe near Dresden, which are the subject of the present note,[2] can now be added to this short list; and that they were acquired for one of our most flourishing provincial galleries is in accordance with the policy of the NACF.

1. The story of the acquisition, over the period of two years allowed for payment, was told in the NACF *Annual Review* for 1983. This corrected in one respect the caption under an illustration in NACF *News* for September this year: these paintings were never at Knowsley, though Lord Derby owns two other (more distant) views of Königstein by Bellotto. One further correction has been given to me by Mr Francis Russell: in Christie's Sale Catalogue of March 7, 1778, where our two pictures appear (as 'Canaletti', lots 79, 80), the manuscript abbreviation of the vendor's name cannot be taken for that of 'Lady Burlington' (there was no Lady Burlington in 1778), but is almost certainly that of Lady Brown, widow of Sir Robert Brown Bt. It is not known how these Bellottos came to England, still in the artist's lifetime; but Lady Brown had acquired other good Italian pictures.

2. Generally agreed to be the prime versions; for replicas, see the valuable monograph by Kozakiewicz (English ed., 1972).

They were painted in Dresden, probably in the later 1750s for the Elector of Saxony, who was also King of Poland. Bellotto had left Venice in 1746 or '47, soon after his uncle had departed for a long stay in England; and the fact that he took his wife and child with him suggests that he too meant to stay long abroad, if not for good. The Seven-Years War had broken out; the rich tourists would no longer find it easy to come to Venice; and the fashion for view-painting was spreading. And why only Venetian views? Bellotto had already displayed his precocious talents in views of Florence, Verona, Milan, Turin, all painted in the years 1742–46; and whether he was invited to Dresden by the Elector or went on his own initiative, it is not surprising that he was welcomed. With the industry that was characteristic of him, he set himself to paint that city and the neighbouring castles along the Elbe; by 1747 he had already painted the large *View of Dresden from the R. bank of the river* (still in the Dresden Gallery), signing it in full with *detto Canaletto* added, of which there are at least four other autograph versions, all with the minutest detail in the architecture and only small variations in the figures; and in 1748, when he was still only 27 or 28 years old, he was appointed Court Painter to the Elector, Frederick Augustus II. He never returned to Italy. When he, like the Saxon Elector, had to abandon Dresden in 1759 because of the war, he found favour at the court of Vienna; and then, after a disappointing attempt to settle again in Dresden without the Elector's patronage, he migrated to Warsaw in 1767 for the remainder of his life, finding there another enlightened patron in Stanislaus Augustus Poniatowski, who had been elected King of Poland in 1764 after the death of the Saxon Elector.

These two great views of the castle of Königstein are far removed in style from the familiar Venetian *veduta* of Canaletto, not only in respect of the architecture. The colour-scheme is Bellotto's own, developed early in his career: cool grey, near-black, pinkish brown, apple-green, and a very effective extensive use of white. Notice how the lighting, with strong cast shadows somewhat arbitrarily imposed, relieves the uniformities and precise perspectives of the buildings. What might be thought an almost photographic effect is counteracted by the bold handling of paint

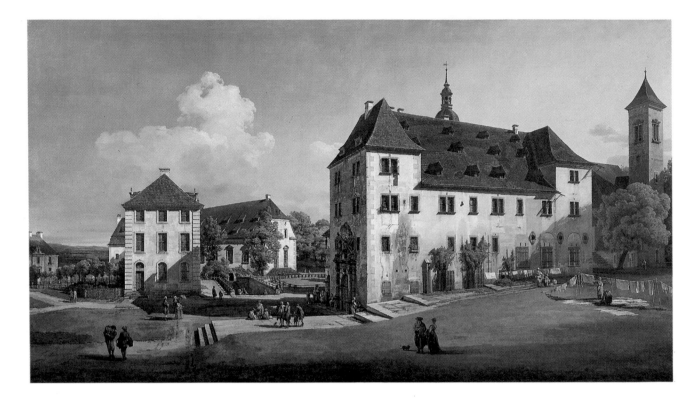

– look at the rendering of the white garden-wall running straight across the foreground of the view of *The Courtyard of the Castle from the West* (the one with the long low building with all the chimneys in the R, middle distance); its rough surface so well suggested, the line broken on the R. by a heavy shadow that leads the eye to the group of figures. And how natural these figures are: in this picture, the old woman, the dog and the boy, the Governor of the castle (perhaps) in the L. corner, the soldiers changing guard, and the gardeners at work; in the other (*The Magdalenburg from the South*) the women hanging out washing, the gentry strolling in the sunshine, the beggars and the countryfolk; painted still in the early Canaletto style, but more varied, more individualised than Antonio's figures, at least in his later more conventional manner.[3] But such things can only be properly appreciated in front of the pictures themselves; I hope they may attract many visitors to the City Art Gallery in Manchester.

3. Large historical pictures, as well as street scenes, were painted by Bellotto in Warsaw at the end of his career, when he was in the service of Stanislaus Augustus, who had succeeded the Saxon Elector as Polish King in 1764. In these the display of figure-painting is astonishing – hundreds of figures, many of them miniature portraits. Twenty-nine of the Warsaw paintings were exhibited at the Whitechapel Gallery in 1957; and it is interesting that these paintings were much used by the architects in the re-building of the ruined city after the last war. Several were included in a good representative group of Bellottos in the exhibition *I Vedutisti Veneziani del Settecento* at the Doge's Palace, Venice, in 1967.

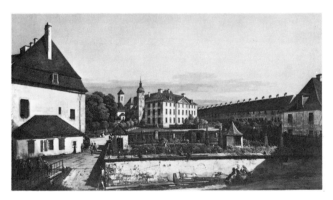

Top: Bernardo Bellotto, *A View of the Castle of Königstein from the South.*

Bottom: Bernardo Bellotto, *A View of the Castle of Königstein from the West.*

Bernardo Bellotto (1720–1780)
View of the Castle of Konigstein from the South, c.1756–8
Oil on canvas, 132·1 × 236.2 cm
One of a pair of paintings acquired over two years (see: *Review,* 1983, no. 3004)

Bought for £256,299 (David Carritt Ltd) by the Manchester City Art Gallery, with the help of a contribution of £30,000 from the NACF.

Four Italian Baroque Parade Chairs

Helena Hayward

English travellers in Italy, from the early days of Thomas Coryat, were impressed by the grand furnishings of the palaces they visited. John Evelyn vividly recorded in 1644 his impressions of the Tribuna in Florence where he was amazed by the ebony cabinets set with semi-precious stones and the magnificent tables of *pietre dure*. Further light on this aspect of British taste is shed by the set of four superb Italian giltwood parade chairs dating from the late seventeenth century recently acquired by Manchester City Art Gallery with the generous help of the NACF.

By tradition these outstanding pieces were given by the Grand Duke Cosimo III of Tuscany to the well-known numismatist and antiquary, Sir Andrew Fountaine (1676–1753) of Narford Hall, Norfolk. Sir Andrew had been knighted in 1699 by William III, and in 1701, at the age of 25, was sent by the king on a mission to the Elector of Hanover. He used this chance also to travel south to Munich and on to Italy where his life-long interest in collecting developed. In 1714 he went abroad again, this time remaining some three years in Rome and Florence and thus he was able to found his famous collection of maiolica and to acquire pictures and works of art for Narford which he had inherited in 1706. In Rome he was painted by Carlo Maratta and this portrait returned with him to furnish his house. In Florence, a bronze medal, showing Sir Andrew in profile on one side and a figure symbolising his interest in numismatics on the other, was made in 1715 by Antonio Francesco Selvi. His connoisseurship brought him the friendship of Cosimo III and a Mss notebook of 1754 entitled *Noblemen's Seats and Parks* (folios 26–28) describes the Dining Parlour at Narford which then contained 'a Picture of the Great Duke of Tuscany giving (sic) to Sr Andrew by the Duke himself as also a large Picture representing the Great Duke and Sr Andrew together in the Tuscan Library'. This friendship is mentioned again, following an old Mss note, in the introduction to the 'Catalogue of the Celebrated Fountaine Collection of Majolica, etc' sold by Christie's on 16 June and following days, 1884. The grandeur of the giltwood chairs said to have been given by Cosimo III to his friend would certainly have suited the Duke's tastes and way of life since he was celebrated for the pomp and splendour of his court and for the lavish enter-

tainment which he offered. Furthermore, their magnificence would have made them an appropriate gift to a man devoted to Italy and Italian art and particularly concerned at that time with the embellishment of his country house. With their boldly scrolling arms, carved with an abandon which disregarded practical needs or economy of material and their flowing front legs and stretchers formed of animated leafy volutes, they represent the last phase of Baroque exuberance. Made perhaps in Venice, they follow the cult of opulent fantasy set by the great sculptor-carvers such as Andrea Brustolon, Domenico Parodi and Anton Maria Maragliano. They were intended to impress the visitor by their sculptural splendour and they would admirably have set off Sir Andrew Fountaine's display of works of art.

While family tradition supports the attractive connection of the chairs with Sir Andrew Fountaine, there is some documentary evidence, albeit inconclusive, which suggests that they did not come to Narford until the 1830s. The 1848 catalogue of the Stowe sale describes the State Drawing-Room as containing 'several very superb specimens from the Doge's Palace at Venice' (H.R. Forster: The Stowe Catalogue, The Fifth Day's Sale, Saturday, 19 August). These items had been bought by the Duke of Buckingham from Messrs Town and Emanuel who were said to have purchased an entire ship-load of furniture taken from the neglected Doge's Palace and brought to England by a Milan dealer named Gasparoni. The catalogue goes on to state that 'Specimens of the same furniture are to be found at Wilton . . . at Burleigh . . . at Narford Hall; and at various other mansions in England'. Should the Manchester chairs have been part of the Gasparoni shipload and purchased for Narford from Town and Emanuel, their Venetian provenance is thus assured.

Fortunately, the original gilding on the chairs survives although there is, inevitably, wear. So, also, do the original loose covers of crimson silk velvet, complete with fringes and the original linen cover below and webbing. The seat covers are secured at each front leg by hooks and eyes while the covers on the back, of slip-over type, are tied by tapes, leaving the linen beneath just visible. This system was perfectly satisfactory as the chairs stood permanently against

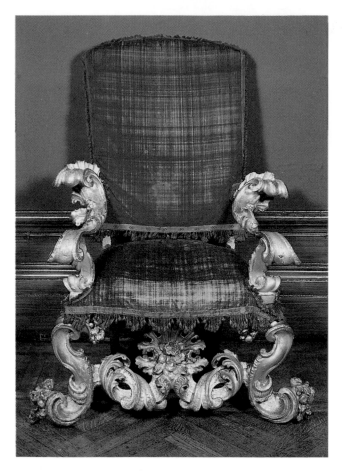 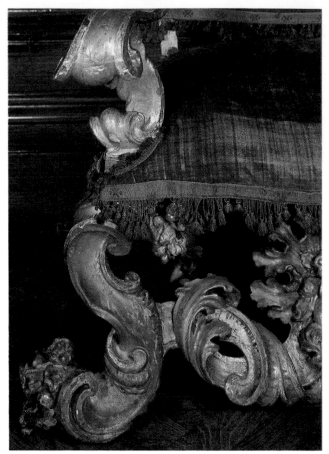

Left: Italian baroque parade chair.

Right: Detail showing the two-colour gilding.

the walls of a gallery or main reception room. The position in which they were placed and their intended immobility accounts also for the plain and abrupt treatment of the back legs which are straight and square and could not, in effect, be seen.

They stand to-day, as they originally would have done, against the walls of the great room at Manchester City Art Gallery devoted largely to Italian painting and sculpture where their confident presence enhances the collection. Fortunately Manchester already possesses a good collection of Italian porcelain and some maiolica. Furthermore, they also have on loan a fine Renaissance *pietre dure* table top richly inlaid with lapis lazuli and other semi-precious stones of the type universally admired, while the Gallery purchased, in 1982, a very nice pair of Venetian mid-

eighteenth century giltwood armchairs. The acquisition, therefore, of the seventeenth century parade chairs admirably suits the growing collection of Italian works of art while the chairs are in an ambiance of which their first English owner would have approved.

Four Italian Baroque Parade Chairs
Venetian, late seventeenth century
Carved and gilded wood, upholstered and with the original loose covers in crimson silk velvet; height 139 cm, width 93·9 cm

Provenance: believed to have formed part of the furnishings assembled in the eighteenth century by Sir Andrew Fountaine for Narford Hall.

Bought for £15,000 (William Redford) by the Manchester City Art Gallery, with the help of a contribution of £10,000 from the NACF.

Two Paintings by Spencer Gore

Richard Shone

Gilman and Gore. Their names are inseparable in any account of English painting before the First War, as followers of Sickert, as leading members of the Camden Town Group and as two highly individual voices from a period which saw the rise of innumerable impressive talents. In a short space of time they both achieved positions of authority among their fellow painters – Gilman through his rigorous dogmatism and forthright manner, Gore through the unforgettable amiability of his nature and the fairness of his dealings within a community jostled by group loyalties, new movements and vociferous person-alities. Gore formed a vital, sometimes healing, link between the older, seasoned figure of Sickert (who never tired of praising him) and younger, very different characters such as Wyndham Lewis. Both painters, alas, died com-paratively young, Gore in 1914 aged 35 from pneumonia caught while painting in Richmond Park, Gilman from 'Spanish' influenza, the day after his forty-third birthday.

Gilman's best work has been reasonably well represented in English public collections. In Gore's case, this is less true and two recent purchases – *Spring in North London, 2 Houghton Place* by the Whitworth Art Gallery, Manchester, and *Letchworth Station* by the National Railway Museum, are particularly welcome. Both these paintings date from 1912, a crucial year in Gore's development in which he produced some of his most memorable work.

Gore's celebrated series of theatre interiors (nearly all painted from drawings made in a half-crown seat at the Alhambra, Leicester Square) virtually came to an end in early 1912. In January of that year he had married and there enters into his work a more domestic note over the follow-ing two years. In the latter months of 1912 the Gores borrowed Gilman's bright new red brick house in Wilbury Road, Letchworth and it was there, among the fast dis-appearing fields, that Gore's identification with the modern movement took startling and successful form.

Spring in North London is still a recognisable Camden Town Group painting and, rarer than might be thought, actually depicts that district. Gore is the master of NW1 with its hazy sunshine over back gardens or the dome of the Camden Theatre, its serried, swan-necked lamp posts and stucco porches, bare trees triumphantly sturdy amid the smoky fumes from nearby Euston Station, Gore's easel shaking perhaps as the trains ground past. It was to a flat at 2 Houghton Place that Gore moved soon after his marriage and it is to April or May 1912 that *Spring in North London* belongs. From his previous studio, Gore looked out over the trees of Mornington Crescent to the Underground Station. His new address afforded a more confined subject of long walled gardens, the blank backs of terraced houses and a glimpse of Eversholt Street. Gore is still essentially an impressionist here, attentive to the quality of the light, still profoundly perceptual in approach. Visual incident amused him – the watchful cat, for example, or the pair of chimney-pots making do as garden ornaments at either end of the threadbare flowerbed. It is the sort of thing that delights us in Vuillard.

With *Letchworth Station*, however, Gore has moved appreciably in a conceptual direction. The colour strikes first. It is more arbitrary; the half-tones and judicious mauves and greens of Camden Town have been abandoned for a startling brilliance of hue. In keeping with this primacy of colour, the drawing is more schematic – the tiny figures are coloured silhouettes, the railway lines reduced to an exact geometry on a tangerine ground. He takes a modern-ist's delight in the unexpected scene, contrasting landscape with 'new town', the rough grass and distant country with the bright posters and clean-cut lines of the station buildings. In the waiting passengers (which Gore studied individually in the margins of a squared-up drawing of the composition) we see a sample of 'garden city' population – predominantly women whose long skirts and large hats seem curiously at odds with their surroundings.

Why did Gore go to so unexpected a place as Letchworth for three or four months? Certainly he needed a rest from his numerous activities in London, and probably influential was the fact that Mrs Gore was expecting their first child (born in Letchworth in October). Harold Gilman was in Sweden and his house, Number 100 Wilbury Road, was vacant. It is likely that Gore came to Letchworth in a mood of confidence which is reflected in the paintings he accom-plished there. A new subject inspired new ways of dealing with it and the *Station* is among Gore's best.

Gilman's house was built about 1908 or '09 and next door

Top: Spencer Gore, *Spring in North London, 2 Houghton Place.*
Bottom: Spencer Gore, *Letchworth Station.*

views was doubtless attracted to the democratic ideals Letchworth initially embodied. Thus the picture (and its companion canvases) is an interesting historical document, showing Letchworth and the station in the early years (the station was enlarged in 1913, the following year). Its important place in the painter's development was underlined by Gore when he sent it to be shown at Roger Fry's *Second Post Impressionist Exhibition* at the Grafton Galleries (no 133 and illustrated in the catalogue) which opened in October 1912. It disappeared from the collection of Hugh Blaker and fortunately was found some years later in a London street market.

United by their high viewpoint and enjoyment of visual incident, these two new acquisitions, so different in other respects, are happy additions to two contrasted public collections.

Spencer Frederick Gore (1878–1914)
Spring in North London, 2 Houghton Place, 1912
Signed and dated lower right
Oil on canvas, 50.8 × 40.7 cm

Exhibited: Spencer Frederick Gore; Anthony d'Offay Gallery, 1983.

Bought for £13,500 (Anthony d'Offay) by the Whitworth Art Gallery, University of Manchester, with the help of a contribution of £3,000 from the NACF.

Spencer Frederick Gore (1878–1914)
Letchworth Station 1912
Oil on canvas, 62.0 × 72.5 cm

Exhibitions: Second Post Impressionist Exhibition, Grafton Gallery, 1912-13; *Spencer Frederick Gore,* Anthony d'Offay Gallery, 1983

Bought for £33,120 (Anthony d'Offay) by the Science Museum on behalf of their outstation, the National Railway Museum, with the held of a contribution of £5,000 from the NACF.

Provenance: Hugh Blaker; Peter Cochrane.

Exhibited: Grafton Galleries *Second Post-Impressionist Exhibition* 1912–13 (133, reproduced); Whitworth Art Gallery *Twentieth Century Art* 1914 (418); The Minories, Colchester *Spencer Gore 1878–1914* 1970 (toured Ashmolean Museum, Oxford and Graves Art Gallery, Sheffield) (50); Yale Center for British Art *The Camden Town Group* 1980 (66, reproduced); Anthony d'Offay Gallery *Spencer Frederick Gore 1878–1914* 1983 no 26.

Reference: Wendy Baron *The Camden Town Group* Scolar Press, London 1979 no 114 (reproduced).

(at 102) another Camden Towner, William Ratcliffe (1870-1955), came to live in 1912. It had been built by Barry Parker, one of the architects involved in the planning and building of England's first Garden City, begun in 1903-04. Gilman, with his advanced social and political

The Oxburgh Altarpiece

John Maddison

The chapel at Oxburgh Hall in Norfolk was completed in 1838 at a time when the fortunes of this ancient Catholic house, built by Sir Edmund Bedingfeld in 1482, had taken an upward turn. Sir Henry, Sixth Baronet (1800–1862), was passionately interested in the history of his family and in heraldry. It was he who secured a licence to bear the arms of Paston in addition to his own and successfully established his claim as co-heir to the ancient barony of Grandison. Much of his considerable means were, moreover, devoted to the restoration and partial rebuilding of the hall; the late Georgian modifications of his grandfather were modified afresh and the architect J.C. Buckler made Oxburgh more Gothic than it had ever been, with new oriels, mullioned casements and twisted chimneys. The apartments were decorated by J.D. Crace with rich and brilliantly coloured wallpapers designed by Pugin, while Sir Henry filled every room with dark oak furniture, carved overmantels, fragments of old Gothic woodwork and heraldic devices.

The chapel, which was built of re-used bricks from demolished cottages, has sometimes been associated with Pugin himself. It is a simple building, whose interest lies in its furnishings. Its windows are filled with fragments of medieval and Renaissance glass. The family pew and altar rails are made of good quality sixteenth century oak stall-work from Germany or the Low Countries, and in a later side chapel the Sixth Baronet's impressive Carrara marble effigy lies behind railings on a panelled tomb chest of brown veined alabaster. But the artistic and liturgical focus of the building is without doubt the great carved and painted altarpiece that was acquired in 1982 by the National Trust with the aid of grants from the National Art-Collections Fund, the National Heritage Memorial Fund and the Victoria and Albert Museum.

It is the most important work of art purchased by the Bedingfelds in the nineteenth century and, like so much else at Oxburgh, is a composite piece. One of the many charming watercolours of Oxburgh interiors painted by Matilda Bedingfeld in the early 1850s shows the present altar table and the semi-octagonal tabernacle surmounted by a tall pinnacled aedicule flanked by red curtains. At some time, probably before the death of the Sixth Baronet in 1862, the upper parts of this construction were removed

and replaced by a splendid Flemish retable.

Whereas the tabernacle work and carved scenes of the altar front are a nineteenth century marriage of fifteenth century elements, the retable is all of a piece. The central section contains a carved and gilded passion cycle which is continued on the painted doors. The carved figures and their settings were completely overpainted in the nineteenth century but the medieval polychrome survives underneath. The Crucifixion occupies the central compartment and is surrounded by the meandering tree of Jesse whose recumbent figure which once occupied the lower central compartment is the only notable absentee from the sculpted scenes. Flanking the Crucifixion are the Road to Calvary and the Deposition, while the tabernacles of the lower register house scenes centred round Pilate and, it is thought, Caiaphas. The painted wings, when open, show, in their upper sections, the Agony in the Garden, Christ taken and Simon Peter striking off the ear of the High Priest's Servant, Christ mocked, the Entombment, Resurrection and Descent into Hell; the lower sections of the wings have four small scenes from the Life of St James of Compostella. When closed, the backs of the doors show the Fathers of the Church standing before a wall. The altarpiece must once have stood on a contemporary predella with at least three further carved scenes. Instead this space is now occupied by the Sacrament Tabernacle of the old altar and two painted scenes of the life of St Catharine whose style is closely related to that of the painted doors but whose original disposition and function are not easily deduced. Stylistically it is clear that the altarpiece is the product of an Antwerp workshop and that it was made between 1520 and 1530. The distinctive hand stamp of Antwerp appears on all the carved figure groups. This feature, together with the handling and composition of its painted scenes, links the Oxburgh altarpiece quite closely with another in the Musées Royaux d'Art et d'Histoire in Brussels which came originally from Oplinter in Brabant. The carved scenes of the Oplinter altarpiece do not possess the taut manneristic postures of the Oxburgh reliefs and it has been suggested that a partial inscription, MOREA, on the garment of one of the figures, identifies the sculptor as Robert Moreau of Antwerp. If that is so it may be that the cryptic partial

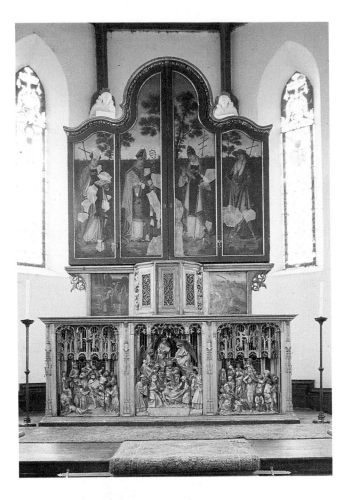

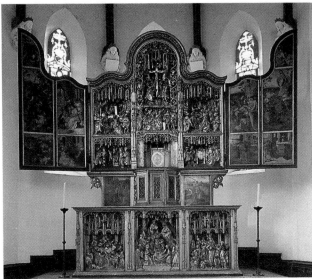

inscription YOLRWOPIN on the hem of St Joseph of Aramathea in the Oxburgh Deposition makes an even more oblique reference to the painter of the panels; but such inscriptions are often random arrangements of letters.

Taken as a whole the Oxburgh retable is an interesting document of the last phase in the production of Gothic altarpieces. In the carved scenes much of the energy of the late Gothic survives, and classical details in armour and costume are the only evidence of Renaissance influence. The profile of the whole structure and the character of the painted scenes shows how, in the Antwerp workshops of the 1520s, the Gothic spirit was subdued by the mixture of partly understood Italian conventions and classical architectural detail.

It is, on the other hand, very unlikely that such questions of art historical criticism had any influence on the Bedingfelds' decision to purchase the object. For them it was a magnificent piece of liturgical furniture and a devotional work of art which powerfully evoked the rich tradition of sixteenth century Catholic Europe. As such it is an object of great poignancy for an old recusant house, and it is a source of considerable satisfaction to know that it can now remain at Oxburgh in perpetuity.

Mrs Kim Wood and Dr Christa Grössinger were generous in providing information for this article.

The Oxburgh Altarpiece
Oxburgh Hall Chapel, Norfolk
Composite Altarpiece made up of a carved triptych showing scenes of the Passion and from the life of St James of Compostella, enclosed by painted wings which act as doors, resting on a carved and gilded altar-table and tabernacle, 1500–1520.

Bought for £130,000 by the National Trust with the help of a contribution of £10,000 from the NACF.

Acquisitions

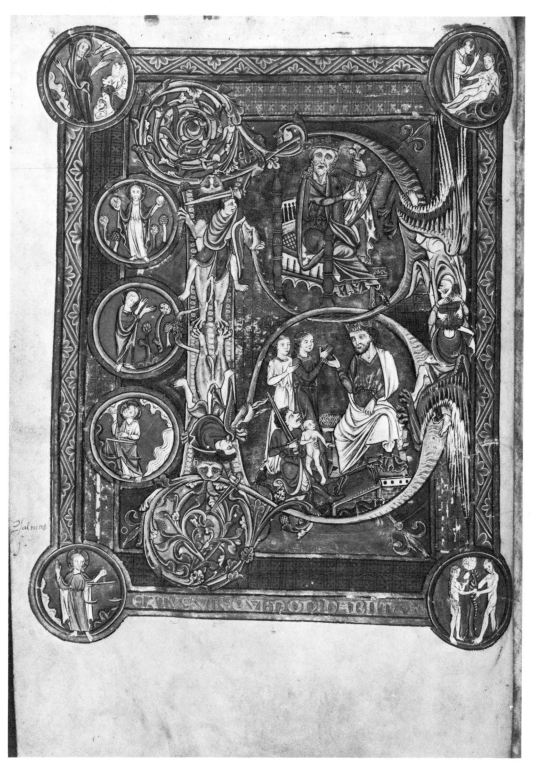

The Rutland Psalter, Beatus page (f.8b). See page 95.

The case-histories which follow include all the items with which the NACF was associated in 1983, whether they were purchased with the aid of grants (summarised on p. 168) or presented or bequeathed through the NACF (summarised on p. 170). This Review brings the total number of cases in our records since the Fund was founded in 1903 to 3077. However, as one case frequently includes many individual items (see, for example, nos. 3045 and 3064 below), the number of specific works of art which we have helped to place in museums and galleries is very much higher.

The Executive Committee wishes to express its thanks to all members for their support, to those who have made special gifts, and to the scholars who have advised on acquisitions.

The Editor would like to thank all those who have supplied information or photographs for this Review.

London

BRITISH LIBRARY

3026 The Rutland Psalter

see page 95

BRITISH MUSEUM

3027 Carl Wilhelm Kolbe

Two Etchings

see page 98

NATIONAL GALLERY

3028 Hendrick Terbrugghen

The Concert

see page 101

PASSMORE EDWARDS MUSEUM

3029 Sir Godfrey Kneller

The Harvey Family

see page 102

3030

Royal Institute of British Architects

3030 The Goodchild-Cockerell Album
1833–1859

96 pages, 53·4 × 38·1 cm

This fascinating document which has been acquired by the British Architectural Library appears on superficial examination to be a form of scrapbook, filled with page after page of miscellaneous material – sketches, highly finished drawings, tracings, cuttings from periodicals and engraved illustrations, even a few early photographs – relating to the career of the architect C.R. Cockerell. In fact it might be said to be unique. Subtitled 'Reminiscences of My Twenty-six Years Association with the late Professor C.R. Cockerell Esq', it is the record of a daily association between a major architect, Charles Robert Cockerell (1788–1863) and his assistant, John Eastty Goodchild (1811–1899). In the whole of the 19th century no comparable document, recording a long period of association, has been compiled for any other architect. It is an important source for Cockerell's life and work, as is demonstrated by the extensive use made of it by David Watkin in his study of the architect published in 1974, and it is now united with the bulk of Cockerell's designs, which form part of the drawings collection at the RIBA, and his diaries which are on loan to them from Cockerell's descendants. The album comes from the celebrated architectural collection of the late Sir Albert Richardson which was sold recently at Christie's. At first sight, owing to the very poor condition – Goodchild used thin, fragile paper which has crumbled badly at the edges – it seemed as if this compilation, of purely documentary interest, might not fetch too large a sum, but more careful examination convinced the British Architectural Library that there was a real danger of the book being broken up for the sake of the fine, highly finished drawings which it contains. Happily this danger has been averted, and at a price far below the break-up value of the album.

Reference: *The Life and Work of C.R. Cockerell,* by David Watkin, Zwemmer, 1974.

Provenance: The Goodchild Family; Sir Albert Richardson, his sale Christie's, 30 November 1983, lot 101.

Bought for £5,332 (Christie's) with the help of a contribution of £1,000 from the NACF.

VICTORIA AND ALBERT MUSEUM

3031 David Le Marchand

Corpus Christi

see page 106

VICTORIA AND ALBERT MUSEUM

3032 Pierre Simon Jaillot

Crucifixion Group

see page 106

Scotland

ABERDEEN

3033 John Phillip RA (1817-1867)

Baptism in Scotland

Signed 'J Phillip' lower left and dated 1850
Oil on canvas, 104 × 145 cm

As he is such an important 19th century Scottish genre painter it is hardly surprising that the NACF has been called upon within the space of a year to contribute towards the purchase of a second painting by John Phillip for a Scottish museum (see: NACF *Review,* 1983 no. 2971; the report includes an account of the artist's life and career). Last year's acquisition was one of the celebrated 'Spanish' subjects which earned for this artist the nickname 'Spanish Phillip', bought by Dundee; this year Aberdeen, appropriately as this was Phillip's birthplace, has secured an ambitious work with a Scottish theme, *Baptism in Scotland,* which he exhibited at the Royal Academy in 1850, the year before he made his first trip to Spain. The baptism is being performed in 'a humble interior of the cottage class', to quote from the 'Review of the Royal Academy' which appeared in the *Art Journal:* 'The figures are numerous, the principal impersonations being placed near the window. These are the father and mother with the infant and on the other side the officiating minister; and from this focus the composition opens on each side into complementary groups, embracing a great variety of appropriate character'. The reviewer ends with an entirely favourable verdict: 'It is indeed a produc-

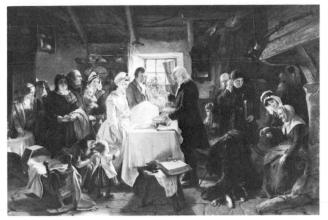

3033

tion which confers the highest credit on the painter, and will go far to establish his fame.' Aberdeen Art Gallery already owns a beautiful study in chalk for the group singled out for comment by the *Art Journal,* of the parents holding the infant, as well as other Scottish genre paintings by Phillip, notably *A Scotch Fair* (exhibited at the RA in 1848) and *A Highlander's Home* (dating from 1855).

Phillip was a seductive colourist, and this talent was to come into its full flowering in the paintings of Spanish life, but it is the more remarkable in the Scottish paintings where the low-key subjects like this scene of poor members of the rural community in a humble interior are suffused with a glowing clear northern light. The subject matter acknowledges the debt that Phillip owed to Wilkie, but the colour comes surely from his admiration for Etty.

Provenance: Painted for James Eden, Fairlaun, Lancashire, 1850; Baron Albert Grant, 1887; Sir John Pender, 1887; J. Pierpoint Morgan, 1913.

Reference: Bryan's Dictionary of Painters and Engravers Vol IV, p. 109; *Art Journal,* 'Review of the Royal Academy Exhibition'; 1850.

Exhibited: Royal Academy 1850, no. 541; Paris, International Exhibition, 1867; Manchester, Royal Jubilee Exhibition, 1887, no. 606; Glasgow, 1888, no. 272, and 1911, no. 221.

Bought for £31,500 (Fine Art Society) by Aberdeen Art Gallery and Museums with the help of a contribution of £5,000 from the NACF (Scottish Fund with the Ramsay Dyce Bequest).

ABERDEEN

3034 John Quinton Pringle

The Curing Station, Whalsay

see page 108

3037

DUNDEE

3035 Alexander Carse

The Village Ba' Game

see page 108

EDINBURGH

3036 Franciszek Smuglevicz

James Byres and Family

see page 111

GLASGOW

3037 John Luke, Jr

A Silver Quaich

Diameter: 19 cm
Struck with the maker's mark and dated 1704

This is a handsome example of a traditional Scottish type of cup or 'cuach', the nearest equivalent to which is the French *ecuelle*. The engraved decoration is characteristic, the lines indicating the stave form and binding of the early wooden examples, and the pattern of rose and tulip heads being derived from Dutch metalwork. The maker, John Luke, Jr, who was admitted to the Glasgow Incorporation of Hammermen in 1699, was a member of a prominent family of silversmiths who worked in Glasgow from the late seventeenth until well into the eighteenth century. In recent years the Glasgow Art Gallery and Museum has been extending its collection of local plate, and the quaich is of a type previously unrepresented.

Bought for £4,500 (How (of Edinburgh)) by Glasgow Art Gallery and Museum with the help of a contribution of £1,000 from the NACF (Scottish Fund).

PAISLEY

3038 John Russell RA (1745-1806)

Portrait of Alexander Wentworth, 2nd Baron Macdonald (1773–1824), dated 1796

Pastel, 102·3 × 78·8 cm

This impressive example of the work of the eighteenth-century portraitist, John Russell, depicting the twenty-three year old Alexander Macdonald of Armadale, Skye, seen against an extensive landscape in the manner of Gainsborough, is free of the over-sweet quality which mars much of this artist's work. One of the finest late eighteenth-

3038

century portraits in the Paisley Art Gallery, this picture has been on loan there since 1964, and had it not been possible to keep it in Scotland it would have been a great loss. The sitter, who became Member of Parliament for Saltash in 1798, was the son of Sir Alexander Macdonald, Chief of Clan Macdonald, who was created Baron Macdonald in the Irish Peerage in 1776. He lived at Armadale on the Isle of Skye, and was host to Dr Johnson in 1773. This disastrous visit was described in some detail by Boswell in *The Journal of a Tour of the Hebrides,* where, among many complaints of the discomfort and the surly manners of their host, he remarked on the 'good garden and a number of trees of age and size'. Macdonald took great exception to Johnson's excessive interest in his kinswoman, Flora Macdonald, who was the chief object of the visit to Skye.

John Russell, the son of a book and print dealer of

Guildford in Surrey, was apprenticed to the pastellist, Francis Cotes. He exhibited annually at the Royal Academy from 1769 until his death. He was elected ARA in 1772, and RA in 1788; from 1790 he styled himself 'Crayon Painter to the King and Prince of Wales'. He was an amateur astronomer and published engravings of his detailed studies of the moon in 1797. Much of his later life was spent in Yorkshire, and he died in Hull.

Bought for £3,560 (Trustees of the late Lord Macdonald Testamentary Trust) by the Paisley Museum and Art Galleries with the help of a contribution of £780 from the NACF (Scottish Fund).

Wales

CARDIFF

3039 Claude Lorrain

Landscape with St Philip Baptising the Eunuch
see page 117

SWANSEA

3040 Allan Gwynne-Jones (1892-1982)

Emmy as a Bridesmaid

Oil on canvas, 39·3 × 29·1 cm
Signed lower left with initials 'AJG' and dated 1956

The Glynn Vivian Art Gallery at Swansea has followed up the showing in 1982 of the important retrospective exhibition of the work of Allan Gwynne-Jones with the acquisition of one of the most admired exhibits, the portrait of the artist's daughter, Emily, painted in 1956. Since Gwynne-Jones habitually worked in a reticent and understated style and on a modest scale, most of his paintings have inevitably found their way into private collections where their essential qualities can be appreciated. *Emmy as a Bridesmaid* was painted just two years after the artist had received long-overdue public recognition when his exquisite still-life, *Peaches in a Basket,* dating from 1948, was bought for the Nation by the Trustees of the Chantrey Bequest for the princely sum of £35 – almost the cheapest painting ever purchased by them – and presented to the Tate Gallery. In that same year, Gwynne-Jones also published his *Introduction to Still-Life,* thus, as it might be said, 'declaring his interest', and it is on his works in this genre, as well as the penetrating and exactly observed portraits, that his reputation stands. In 1980, in a rare example of direct patronage, on the advice of the artist John Ward, a member of the committee, and Gwynne-Jones's old friend, the NACF

3040

bought from the artist and presented to the Ashmolean Museum a delicious still-life of a teapot and fruit on a table.

The obvious complement to the portraiture and the still-life painting is the study of landscape, which Gwynne-Jones explored with the eye of a countryman rather than a dramatist. The Glynn Vivian Art Gallery already owns one of these pictures, *August Morning, Suffolk,* so this portrait, which has the additional attraction of being the artist's own daughter, and therefore a subject picture rather than a commissioned work, makes a useful extension to their representation of his work.

Exhibited: Glynn Vivian Art Gallery, Swansea, *Alan Gwynne-Jones,* 1982.
Royal Academy, London, 1982.

Bought for £5,000 (Mrs Beanland) by the Glynn Vivian Art Gallery, Swansea, with the help of a contribution of £1,250 from the NACF.

3041 Henry Gastineau (1791-1876)

Copper Works, near Swansea, Glamorganshire

Watercolour, 30·5 × 20·3 cm
Not signed or dated, but inscribed on the reverse 'Copper Works near Swansea, Glamorganshire by Henry Gastineau'

Gastineau was a friend of Turner, Cox and Copley Fielding. He began his career as an engraver, and experimented briefly with oil-painting, but soon found his true metier as

a watercolour painter. He has chosen to paint the copper works by moonlight so that the fullest effects of fire and smoke can be exploited in this romantic representation of an industrial scene. During the eighteenth and nineteenth centuries copper mining and smelting were crucially important to Welsh industry, and to Swansea in particular which grew into a busy metalworking centre and port. Little physical evidence remains of the copper industry today, and visual records are valuable evidence of the historical development of the town. The transformation of the Welsh landscape caused by the opening up of the mines and the installation of the engines and mills and blast furnaces with chimneys pouring dramatic clouds of smoke high into the air provoked a widespread response in the landscape painters of the day. 'Picturesque' tours of Wales undertaken by, for instance, John 'Warwick' Smith, J.C. Ibbetson or Paul Sandby, resulted in representations of the deep crater formed by the Parys copper mine, the cavern-like interior of the Cyfartha ironworks dominated by its great wheels, and these copper-smelting works near Swansea which filled the sky with a rain of glowing sparks, among the more conventional romantic landscapes and topographical views. Joseph Wright of Derby was fascinated by the dramatic light effects produced by furnaces working at night which he saw as counterparts to the

Roman fireworks or the erupting volcanoes which he had painted in Italy. Turner, too, loved the impression of force and drama, akin to the effects of the fury of nature, from heat, steam and smoke. Industrial installations had not encroached too far over the landscape and could still be regarded as picturesque. Artistic revulsion against the 'dark satanic mills' did not manifest itself fully until the middle of the nineteenth century, but from this date artists could no longer see the subject as fit for heroic or romantic treatment and the industrial landscape in the late nineteenth century is seen with dour realism.

Bought for £440 (Richmond Gallery, Swansea) by the Maritime and Industrial Museum, Swansea with the help of a contribution of £220 from the NACF.

England

BATH

3042 A Schantz Fortepiano

see page 120

BEDFORD

3043 Sir Edward Burne-Jones

Childe Roland
see page 122

BOLTON

3044 Henry Edridge (1769-1821)

Buildings by a Canal, Caen

Pencil, pen and brown ink, and watercolour, 45·1 × 35·6 cm
1817–21

Born in London, Edridge entered the Royal Academy School in 1784 and began to exhibit the miniature portraits for which he is perhaps best known in 1795. He attended Dr Monro's 'academy' at 8 Adelphi Terrace and, together with Girtin and other pupils of Munro, became a member of the Sketching Society, a group devoted to the currently fashionable concept of 'historic landscape' which survived until the middle of the nineteenth century. At the end of the Napoleonic wars he was one of the first British artists to cross the Channel for sketching tours. He made an excursion to Paris and Normandy in 1817 and again two years later, exhibiting his foreign views at the Academy from 1819 to 1821. The present drawing dates from this period.

The Bolton Museum has a fine collection of English watercolours, but although this included a portrait drawing by Edridge his landscapes were not previously represented.

Provenance: William Spooner.

Exhibited: On loan to the Courtauld Institute Galleries, 1968–79.

Reference: Martin Hardie, *Watercolour Painting in Britain,* III, 1968, p. 000, pl. 2.

Bought for £4,500 (Spink) by Bolton Museum and Art Gallery with the help of a contribution of £1,125 from the NACF.

BRISTOL

3045 Lazarus Collection of Drinking Glasses

see page 125

BRISTOL

3046 Humphry Repton

Red Book for Abbots Leigh

see page 129

CAMBRIDGE

3047 Richard Parkes Bonington

Italian Lake Scene

see page 132

CAMBRIDGE

3048 Ludovico Cardi, called Il Cigoli (1559-1613)

Study of the Head and Shoulders of a Young Man

Oil on paper laid down on canvas, 44·3 × 36·4 cm

Ludovico Cardi was born near Florence at Castelvecchio di Cigoli, from whence he derived the name by which he is usually known. He had a diversity of talents, being described as 'painter, sculptor, architect, poet and musician'. He was a pupil first of Alessandro Allori, painter of the fine portrait of a young man, once in the Rothschild Collection which was bought with the help of the NACF by the Ashmolean last year (see: *Review,* 1983, no. 3014), and later of Santi di Tito. Cigoli was the most individual and original of the Florentine followers of Santi di Tito, and his career, which was partly spent in Rome, spans the transition between Mannerism and Baroque. Cigoli might be described as the Florentine Annibale Caracci, indeed, one or two of his pictures have been confused with Annibale's, but his name is far less well known, partly because his work is so rare in public collections in this country. This very beautiful, rapidly executed oil-sketch of a young man, obviously taken from the life, has all the immediacy of a drawing with the scale and grandeur of a painting. The subject has been identified as a study for the head of an angel in the upper

part of Cigoli's *St Heraclius carrying the Cross* dating from 1594 which is in the church of San Marco in Florence.

This sketch was exhibited in London in the summer of 1983 along with a sheet of studies for figures from the same picture. Other drawings for this work from the Uffizi were shown in Florence in 1980; drawings from his Roman period, also from the Uffizi, had featured in an exhibition in the previous year, but only a few drawings by this important Florentine artist are to be found in this country, half a dozen in the British Museum, four in the Ashmolean, and he was until now represented in the Fitzwilliam Museum only by a single drawing. Two important paintings by Cigoli are, however in English country houses open to the public, one, an altarpiece in the chapel at Burghley House and the other, an *Adoration of the Kings* – Ellis Waterhouse suggests that this is 'perhaps his masterpiece' – at Stourhead. The *Adoration* demonstrates most powerfully Cigoli's masterly use of colour, which is also apparent in this sketch, and can be traced to the influence of Barocci, whose own oil-sketches of single heads it so much resembles.

Bought for £7,500 (Colnaghi) with the help of a contribution of £5,625 from the NACF.

Knatchbull. With the dispersal of the Provender pack Hilton also started his own pack at Selling in Kent, of which his hound 'Glory' was the great ornament.

Ben Marshall has come in recent years to be very highly regarded – and very highly priced – as a sporting artist, a genre of painting which is very liable to cliché and generalisation. His pictures bear evidence of minute observation into the distinguishing characteristics of both men and beasts, and his feeling for landscape and weather conditions is remarkably sensitive. Marshall spent much of his career working, appropriately enough, at Newmarket, exhibiting occasionally at the Royal Academy from 1800–1819.

Reference: The Sporting Magazine, vol. X (1822), p. 217 Aubrey Noakes, *Ben Marshall,* Lewis Publishers, 1978, no. 166, p. 48.

Provenance: The picture descended to the Great great grand-daughters of the sitter, and Mrs J.A. Southby of Wilbraham Place, a life-member of the NACF, most generously donated her share in the picture to the Canterbury Museum.

Bought for £6,500 with the help of a contribution of £1,625 from the NACF.

CANTERBURY

3049 Ben Marshall (1767-1835)

Thomas Hilton Esq., with his hound 'Old Glory', (Lees Court in the background)

Signed lower left, 'B. Marshall p.' and dated 1822
Oil on canvas, 90·8 × 71·2 cm

Thomas Hilton (1750–1826) was known as 'Glory' Hilton, a reference to his favourite hound shown with him in this picture, which was etched by William Smith for the *Sporting Magazine,* and appeared as the frontispiece to the August issue in 1822 (vol. X, p. 217). The illustration is captioned 'Thomas Hilton Esq., the Father of Foxhunters in Kent'. The 'celebrated sportsman' who was said to have been 'at the zenith of his glory, during the real splendour of the Provender Hunt' is described as 'this good-tempered, kind-hearted, hospitable, entertaining gentleman, tho' 74 years of age, mounts and dismounts with the agility of youth, was never known out of spirits, or had the headache – for which blessing he thanks the health-enlivening chase'. Lees Court, the seat of the Earls of Sondes, is to be seen in the background of the picture, possibly because some connection existed between the Provender Hunt, which was managed by Sir Edward Knatchbull, and Lord Sondes' own pack, which he hunted for a few seasons at the time when the Provender pack was being disposed of by Lady

3049

3050 Dame Laura Knight, DBE, RA (1877-1970)

Hop-picking Granny – a portrait of Granny Knowles, c.1938
Oil on canvas, 62·2 × 48·9 cm

Hop-picking No. I., c.1946

Oil on canvas, 74·9 × 62·2 cm
Both signed 'Laura Knight' lower right.

Laura Johnson was brought up in Nottingham, a member of a lace-making family with an interest in the lace industry in France, where the young Laura was thus able to spend long periods when she first began to study art. Her mother was a teacher of drawing who had great ambitions for her artistically gifted daughter. Laura attended the School of Art in Nottingham. In 1903 she married Harold Knight, a fellow-student of outstanding promise who was to be completely overshadowed by his wife, thus acquiring the name by which she was to be known as an artist.

Laura Knight is remembered for her interest in circus people, in gypsies and in the ballet. She loved all Bohemian types, and was fascinated by the uncompromising realism of their attitude to lives lived always on the edge of poverty. The Kentish hop-pickers were a natural choice of subject; these 'motley folk' were described by Edmund Blunden in a poem as 'Gypsies with jewelled fingers', and they descended on the hop-fields each summer from the East End of London in a holiday spirit. The unmistakeable hop-pickers' sheds can still be seen on the edge of some of the hop-fields, though few are now used for their original purpose as much of the work is carried out by machine. Kent has been for centuries, and still is, the principal hop-growing area in England, so these pictures are particularly appropriate to a Kentish museum, where their historical interest in providing a record of this vanishing annual event is as significant as their artistic value in adding strength to the British twentieth century collection at Canterbury.

Laura Knight had an unusually successful career, she became an Associate of the Royal Academy in 1929, at that date an almost unprecedented distinction for a woman. Indeed, her election was reported in the Press, erroneously, as being the first of a woman since 1769. She was made a Dame Commander of the British Empire, and she lived to see a full retrospective exhibition of her work, which included both these pictures, at the Royal Academy in 1965. She wrote then: 'I'm no great artist, but taking the exhibition as a whole, I believe it to be a bit impressive'.

Exhibited: Royal Institute of Fine Art, Glasgow, 1961 (Hop Picking No. 1); Worthing Art Gallery, *Dame Laura Knight,* 1963; Royal Academy, London, *Dame Laura Knight,* 1965, nos. 62 and 72.

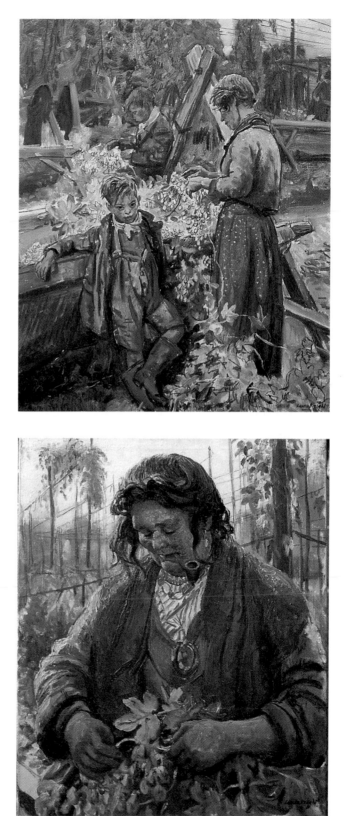

Bought for £4,475 (Dennis Ewen, Salisbury) with the help of a contribution of £1,118 from the NACF.

CHELTENHAM

3051 Sir Gordon Russell (1892-1980)

Print Cabinet and Stand

Made of bog oak, burr elm and laburnum veneers on bog oak
Height: 115 cm, width: 109 cm
Designed in 1924 and made in 1925. Bears a workshop label identifying the craftsman who made the cabinet, E. Turner and T. Lee of Russell and Sons Ltd, Broadway, Gloucestershire

Gordon Russell's family lived in Broadway from 1904, when his father acquired the Lygon Arms Hotel. He was educated at Chipping Campden Grammar School. He was without formal training in art or architecture but his practical knowledge came from working from an early age in the furniture construction and repair shop set up by his father to serve the Lygon Arms, and his aesthetic awareness was fostered by close proximity to C.R. Ashbee's Guild of Handicraft – established since 1903 at Chipping Campden – and Ernest Gimson's workshop at Sapperton. Gordon Russell explored the possibilities of the Cotswold styles to their limits in uniting the most refined cabinet-making with the 'vernacular' vocabulary of simple joinery and bold panels and stretchers ornamented with chamfering. The form of this cabinet recalls Ashbee, but the ornamental

veneering has a sophistication quite foreign to the earlier craft style.

This fine cabinet was made in the year that Russell exhibited at the Paris 'Art Deco' exhibition a cabinet of walnut inlaid on the doors with flowers in ebony, yew and box, an immaculate display of skill which won for him a gold medal. In spite of this, the designer himself always expressed a preference for this more severe piece. Cheltenham has appropriately become the centre for an important collection devoted to the work of the Cotswold School artists and craftsmen. The Russell cabinet will be seen in the context of work from the same cultural background by Ashbee, Voysey – a spectacular collection bought in 1981 with NACF help (see: *Review,* 1981, no. 2912) – Gimson and the Barnsleys. Owing to the great generosity of the Russell family the cabinet will also be joining an important group of Gordon Russell's work, including the 'marriage' bed, made in 1920, to be housed in a special 'Gordon Russell Room' which the Art Gallery has set aside for the purpose.

Exhibited: Gordon Russell Exhibition, the Design Centre, May–September, 1981; *Aspects of Victorian and Edwardian Decorative Art,* Fischer Fine Art, October–November, 1982.

Reference: Gordon Russell, by Ken and Kate Baynes, The Design Council, 1981, p. 45.

Bought for £5,510 (Fischer Fine Art in association with Dan Klein) by the Cheltenham Art Gallery and Museum with the help of a contribution of £1,377 from the NACF.

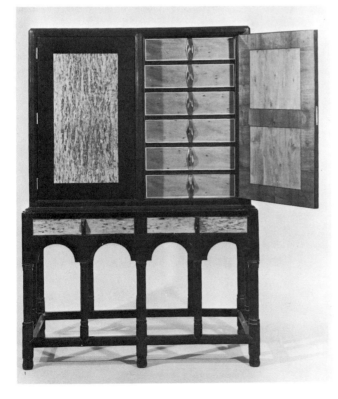

DEVIZES

3052 John Piper (b.1903)

A Stained-Glass Cartoon

Gouache, 96·5 × 122 cm

This is the final cartoon for a window, designed by John Piper and made by Patrick Reyntiens, which was installed in 1982 in the new gallery of the Devizes Museum. Piper, whose 80th birthday last year was celebrated by a major exhibition at the Tate Gallery, has been a member of the Wiltshire Archaeological and Natural History Society, which administers the Museum, for nearly fifty years, and his feeling for the Wiltshire landscape is expressed in many of his works. The window includes many well-known local archaeological monuments, including the stone avenue at Avebury, Barbury Castle hill fort, the Ridgeway,

3054

'Devils Den' (the chambered tomb at Preshute), and the Cherhill White Horse, together with the great 'Stonehenge Urn', the amber necklace from 'Golden Barrow' at Upton Lovell, and other items in the Devizes Museum's collection. The tuberous thistle (*cirsicum tubevosum*), which is indigenous to Wiltshire, is depicted in the lower left corner.

Reference: Antiquity, March 1983.

Bought for £1,000 (the artist) by the Devizes Museum with the help of a contribution of £250 from the NACF.

DONCASTER

3053 Humphry Repton

Red Book for Ouston

see page 129

DURHAM

3054 Nine Pieces of Persian Pottery

Dating from the twelfth and thirteenth centuries, these elaborately decorated bowls and jars are the latest of the long series of works of art which have come to the Fund for distribution to museums since 1909 from the collection of the late Henry Van den Bergh. (For the last case, see our 1983 *Review,* no. 3016). The ceramics have been presented by the Trustees of Mrs Elizabeth Roskill, Henry Van den Bergh's daughter, and have been given to the Gulbenkian Museum of Oriental Art at the University of Durham. Built with the aid of a grant from the Calouste Gulbenkian Foundation, and opened in 1960, the Museum is the only one in the country to be devoted exclusively to the arts and archaeology of the East.

EGHAM

3055 Mainly by John Hassell (d.1825)

A Collection of Views of Egham and Englefield Green

Thirty-seven drawings in all – thirty-one by John Hassell, pencil and watercolour, all signed, inscribed and dated 1822 or 1824; also two tinted drawings of St Agnes Cottage and a house at Staines Bridge (1821); three watercolours of Egham by Edward Hassell (d.1852) (1828 and 1830); and a sepia drawing of Englefield Green. Various sizes

The Egham Museum concentrates entirely on items of local significance; in 1974 the Fund presented it with a Bilston enamel box inscribed *A Trifle from Egham* (our *Report,* no. 2539), and in 1980 we helped to buy a drawing by Rowlandson of *A Fishing-Party at Runnymede (Report,* no. 2849). The present group of drawings, though not of high artistic calibre, is nonetheless of great topographical interest, giving a fairly comprehensive picture of the area in the 1820s. Many of the principal features of Egham are represented – the village street, the Catherine Wheel Inn, the Poor House, the Work House, the New Church, etc, together with the main local houses – Potnall Park, Milton Park, Foster House and others, the house and grounds of

Virginia Water, and the principal houses in Englefield Green.

John Hassell, who executed most of the drawings, and his son Edward, who was responsible for three, were prolific topographical draughtsmen; it is estimated that they painted over 2,000 views in the Surrey area alone. Examples of their work are in the British Museum, and John Hassell was responsible for an important work of topography called *Aqua Pictura, 1813*.

Provenance: Anon sale, Sotheby's, 7 July 1983, lot 35.

Bought for £1,896 (Sotheby's) by the Egham Museum with the help of a contribution of £474 from the NACF.

HASTINGS

3056 A Ludwigsburg Milk Jug

White porcelain with painted decoration by Andreas Philipp Oettner. Marked with the Ludwigsburg mark on the base. Height: 22 cm
*c.*1760

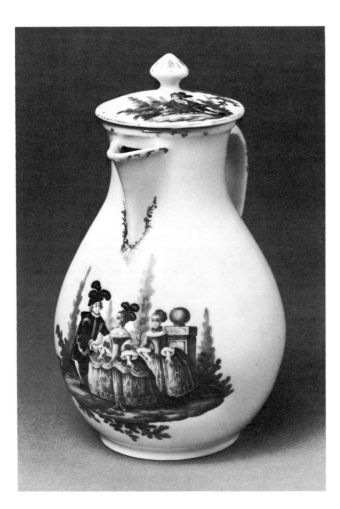

An early example of Ludwigsburg porcelain, the jug is decorated with scenes from contemporary ballet by Andreas Philipp Oettner, who was employed at the factory from 1758 to 1762. The dancers represented are possibly Vestris and Sallé, who had been brought to the Württenburg court after their success in Paris. Representations of Maria Sallé are very rare. A sugar bowl from the same service is known (see Horst Reber, 'Der Porcellanmakr Andreas Philipp Oettner', *Keramos,* vol. 63, 1974).

The Hastings Museum and Art Gallery has a comprehensive collection of English, European and Oriental ceramics, but the Ludwigsburg factory was not previously represented. The NACF last helped to add to the collection in 1981 (see our *Annual Report,* no. 2924).

Bought for £2,000 (Kate Foster Ltd) by the Hastings Museum and Art Gallery with the help of a contribution of £500 from the NACF.

HOVE

3057 Richard Henry Nibbs (c.1815-1893)

The Cosens Collection of Views of Sussex

281 drawings in pencil and watercolour, inscribed and dated, mounted and bound in three volumes

This extensive collection, of obvious topographical interest, was formed by F.W. Cosens, a member of the Sussex Archaeological Society from 1862 to 1889. He was also a noted collector of Dickensiana and a friend of the artist George Cruikshank. His armorial bookplate appears in the three volumes in which the drawings are bound.

R.H. Nibbs was a musician who later became a full-time artist, concentrating on marine and Sussex antiquarian subjects. In 1851 he published a well-known volume of etchings of Sussex churches (republished by M.A. Lowther, 1872), and a further volume of etchings, *Antiquities of Sussex,* appeared in 1874. He exhibited over forty works at the Royal Academy during his career, and died in Brighton.

The present collection of drawings range from comparatively finished watercolour views to slight pencil sketches. It appears to include sixty of the original drawings for the 1851 etchings of Sussex churches, and twenty-eight of those for the *Antiquities of Sussex.* The other drawings are mainly unpublished views, covering the whole county. There are about thirty-five of the Brighton and Hove area, including two good views of Benfield House, which was demolished a century ago, and many details of old domestic buildings, including Michelham Priory, Old and New Place, Pulborough, and St Mary's House, Bramber.

For an earlier but comparable collection of Sussex topographical drawings, acquired comparatively recently with

3057

NACF help, see our 1975 *Annual Report*, no. 2585.

Bought for £2,250 (Mr Michael Norman) by the Hove Museum of Art with the aid of a contribution of £562 from the NACF.

KENDAL

3058 George Romney

John Howard Visiting a Lazaretto
see page 134

LEEDS

3059 Sir Jacob Epstein

Maternity
see page 137

LIVERPOOL

3060 Nicolas Poussin

The Ashes of Phocion
see page 117

LUTON

3061 The 'Grove' Candlestick

Enamelled and gilded copper folding pricket candlestick, Limoges, France, late thirteenth century. Excavated at the site of Grove Priory, near Bedford
Height: 18 cm

The candlestick, made of gilded copper and decorated with

champlevé enamels in white, red and blue, has three legs, terminating with zoomorphic heads which rotate on the rivet attaching them to the stem and seems to be exceptional among the rare survivals of this type in being complete. The bifurcated prongs which spring from the drip-pan are intact on the 'Grove' candlestick whereas one is missing from many of the other survivors.

This type of pricket candlestick (ie with a point rising from the drip-pan to pierce the base of the candle and hold it in place) has the tripod feet constructed so that they can fold together for ease of packing; it is known as a *chandelier de voyage* or travelling candlestick. Made at Limoges in France, this medieval enamelled candlestick is a significant addition to the small number that survive from the late thirteenth century. Although they were probably quite commonplace there are thought to be less than a dozen of these folding candlesticks in the whole of Europe; not one

of them has a secure provenance as this one has, nor is it usual to find them so complete. Small, spindly and delicate, not only the metal itself, but even more the gilding and the enamels are all vulnerable to the wear and tear of time. In fact the condition of the Grove candlestick is remarkably good for an excavated object.

In *L'Oeuvre de Limoges,* published in 1892, Rupin illustrates a folding candlestick of this type from the Treasury of Roc-Amadour (fig. 591) and cites two more, then in the Ducretal Collection. There are two in the Victoria and Albert Museum, one of which resembles the 'Grove' candlestick very closely (M.355 – 1956, Hildburgh Bequest), and another closely comparable example from the Flannery Collection was sold recently at Sotheby's (15 November 1983, lot 42). The 'Grove' candlestick is uniquely valuable in having an association with a find place about which a considerable amount is already known, but it is also useful in establishing – or confirming – the status of the original users. Grove was not only at one time a nunnery of high social standing, but when it reverted to manorial use in 1289 it became a Royal residence, being given by Edward I to his daughter, Margaret of Woodstock. Indeed, the enamelled armorial devices which ornament the tripod of the candlestick have been tentatively associated with her, but final assessment of the significance of the heraldry has to await the completion of the conservation since enamel colours can change when buried in the ground. The Limoges enamellers went to great lengths to render the armorial colours correctly, and if accurately interpreted, the heraldic ornament can yield very precise information.

Bought for £15,000 (Church Commissioners) with the help of a contribution of £3,000 from the NACF.

MANCHESTER

3062 Bernardo Bellotto

View of the Castle of Königstein
see page 139

3063 Four Italian Baroque Parade Chairs

see page 141

No se puede mirar.

3064

3064

3064 Francisco Goya Y Lucientes (1746-1828)

Sixty-nine etchings from the Tomás Harris collection, various sizes

The greater part of this celebrated collection of almost all the published editions of Goya's prints was formed in the last decade of his life by the late Tomás Harris and was accepted in lieu of duty on his estate by HM Treasury. In accordance with his wish, it was transferred in 1979 to the British Museum, where it became one of the most important acquisitions to be made since the War. The collection was made the subject of an exhibition which also included the rest of the Goya material from the Prints and Drawings Department, and the catalogue includes an account of the Tomás Harris collection with a complete list of all the prints now in the Museum's collection.

Duplicates from the Harris collection were specifically excluded from the gift to the British Museum, and a choice group of these has been made available for purchase to the City of Manchester Art Galleries. They are as follows:

3066

Los Caprichos, thirty-seven plates from a set of eighty from the first edition of 1799, fine impressions of Goya's famous satires on the splendours and miseries of life in eighteenth-century Spain.

Los Desastres de Guerra, twenty-six plates from an edition of eighty, published in 1863, long after the death of the artist. No earlier edition was permitted by the Spanish authorities of this devastating indictment of the violence and folly of war. To conform with the taste of this later date the plates were printed with much of the ink left on the surface to provide a tone, which quite alters the effect intended by Goya, whose intentions can be judged from the set of proof impressions in the British Museum.

Los Proverbios, four plates from the edition published by Lienart for *L'Art* in 1877, including 'Fool's Folly' the famous surrealist image of four flying bulls.

La Tauromaquia, two plates from the first edition of 1828, fine examples from the set of thirty-three plates depicting dramatic moments in the encounters between man and the wild and dangerous bulls.

Manchester now joins London, Oxford and Edinburgh in owning an important group of the graphic work of this artist who is rightly regarded as one of the greatest of printmakers.

Bought for £13,400 (Tomás Harris Estate) by the Manchester City Art Gallery with the help of a contribution of £3,000 from the NACF.

3065 Spencer Gore

Spring in North London

see page 143

3066 Rembrandt van Ryn (1606-1669)

Landscape with a Cottage and Haybarn

Etching with drypoint, with full margins, 12·9 × 32·1 cm
Signed and dated *Rembrandt f. 1641*

As a print maker Rembrandt only turned to landscape in the middle of his career, dated examples ranging from 1641 to 1652. Nearly all were composed in the studio, although their themes were taken from Amsterdam and its immediate vicinity. In the present etching, one of the most attractive and characteristic of the earlier landscape prints, the mansion of Kostverloven on the River Amstel, which was already a picturesque ruin in Rembrandt's day and was sketched by many artists, appears on the right, while the skyline on the left is made up of various Amsterdam buildings. There are a number of related drawings (see Christopher White, *Rembrandt as an Etcher,* 1969).

Last year the Friends of the Whitworth Art Gallery celebrated their fiftieth anniversary by helping to purchase an important new work for each of the main departments, and the Rembrandt etching was the acquisition made for the prints collection. It fills an important gap since the Whitworth, although it already owned twenty-eight Rembrandt prints, had no example of his landscapes. It also makes a valuable addition to a group of seventeenth-century Dutch landscape prints by other artists – Ruisdael, Swanevelt, Waterloo, etc – and an interesting comparison with a fine collection of landscape prints from the English etching revival, notably by Seymour Haden, which often depend so heavily on this particular type of Rembrandt print.

Reference: Bartsch 225.

Bought for £19,793 (Christopher Mendez) by the Whitworth Art Gallery, University of Manchester, with the help of a contribution of £4,500 from the NACF.

NATIONAL TRUST: OXBURGH HALL
3068 The Oxburgh Altarpiece
see page 145

NATIONAL TRUST: COTEHELE HOUSE, CORNWALL
3067 John Chessell Buckler (1793-1894)
Cotehele House, the South Front

Watercolour, 23 × 35·5 cm
Signed and dated 1821

Cotehele House is one of the least altered mediaeval houses in this country. It was built on the foundations of an earlier house, and added to over a long period between 1485–1627. It was presented to the National Trust in 1947.

Like his father, John C. Buckler was a noted topographical artist, his talents in this direction having been stimulated by an architectural training. The view of Cotehele House was made while he was engaged on a series of drawings of Oxford (now in the Bodleian Library). It is interesting to note that he was the architect responsible for the alterations to the Chapel at Oxburgh Hall in Norfolk, see: Maddison p. 145

This attractive drawing, which appeared at a local auction last May, is of particular interest since it shows not only the south elevation which was considerably altered in 1865 when a widowed Countess of Mount Edgcombe went to live at Cotehele. This is the only known record of this feature, all the early engravings of the house showing the other elevations. The drawing joins a view by Buckler of the interior of the Hall at Cotehele which the Trust acquired some years ago.

Provenance: Anon sale, Bearnes of Torquay, 25 May 1983, lot 12.

Bought for £240 (Bearnes) by the NACF and presented to the National Trust for display at Cotehele House, Cornwall.

NORWICH
3069 Two Pieces of Norwich Silver

Cylindrical beaker, c.1680, by Robert Osborne, height: 10·8 cm
Norwich mark, maker's mark and monogram 'RO'
Counter-box and cover, c.1680, by Thomas Havers, height: 5·1 cm
Maker's mark of Thomas Havers

3069 3069

These two pieces of engraved silver made in Norwich add hitherto unrepresented items to the unrivalled collection of local silver which has been amassed by the Castle Museum, and to which the NACF has already helped to add the important Elizabethan 'Cobbold' flagon (see: *Report,* 1980, no. 2867). Both the cylindrical beaker and the counter-box, designed to contain silver gaming counters, date from the late seventeenth century and are decorated with simple, bold engraved ornament. The counter-box bears the mark of Thomas Havers, goldsmith, who was appointed Sheriff of Norwich in 1701 and Mayor in 1708. The beaker was made by Robert Osborne; the work of this silversmith is very rare, only one other piece, a spoon, with his idiosyncratic version of the Norwich mark, and a variant of the maker's mark used on the beaker, is in the Museum. No plate was assayed in Norwich after 1700; according to O.M. Jackson the earliest fully marked and authenticated plate dates from 1565 (see: *English Goldsmiths and their Marks,* revised ed. 1948), but this relatively short span of activity saw the production of some very fine gold and silver plate.

Bought for £2,925 (Brand Inglis) by the Castle Museum, Norwich, with the help of a contribution of £731 from the NACF.

3070 A Collection of Watercolours, Drawings and Prints of Norfolk Antiquities

English, the watercolours and drawings c.1843–1851, the prints mostly 1800–1850, contained in a bound scrapbook (32 × 24 cm) and a portfolio of over 200 loose leaves (30 × 23·5 cm)

Of great interest to students of Norfolk archaeology, topography, architecture and art, the collection is a characteristic product of a period which saw intense ecclesiological activity, epitomised by the foundation of the Cambridge Camden Society in 1839. It was formed by the Rev Strickland Charles Edward Neville-Rolfe, vicar of the isolated parish of Heacham in north-west Norfolk. About 1840 he found himself with sufficient income and leisure to start a private museum of antiquities and specimens of natural history, focusing particularly on objects of local interest. Aiming to supplement his copy of Francis Blomefield's unfinished *Essay Towards a Topographical History of the County of Norfolk* (five volumes published between 1739 and 1773; Blomefield himself completed most of the third volume before his death in 1759), he commissioned drawings and watercolours of churches, church furnishings and other items of note within the county. According to Mrs V.A. Berry in her history of the Neville-Rolfe family, a 'specially large carriage was constructed in which to carry the artists . . . and their gear, and many a pleasant expedition was made'.

Part of the collection exists in a scrapbook containing watercolours, monochrome wash and line drawings, engravings and maps etc, documenting a wide variety of ecclesiological subjects: exterior and interior views of churches, architectural details, fonts, bench-ends, tracery, heraldic glass, monumental brasses, and the like. There are also drawings of secular buildings, prehistoric finds and other miscellaneous subjects, as well as the plans for Beechamwell Parsonage. The artists responsible include H. Ninham, F.C. Lukis, Elizabeth Reeve, and members of the Neville-Rolfe family.

The rest of the collection occupies a large portfolio of over 200 leaves. This material is similar in character but has a larger proportion of fine watercolour drawings and is entirely concerned with Norwich. Among the subjects are many copies of stained glass in the city churches and Guildhall, together with records of bosses and other carved stones (especially from St Helen's), roof and screen paintings (notably the St Peter Mancroft screen on the eve of its destruction), and features of the Cathedral (including the

3070

unrestored Bishop Despenser retable). C.J.W. Winter and H. Ninham are the artists mainly concerned.

The collection was inherited by Mrs V.A. Berry and Mr A.E. Gunther from their grandfather, Eustace Neville-Rolfe, of Heacham Hall, Norfolk, and has been presented by them in his memory to the University of East Anglia at Norwich through the NACF. The University is a centre for East Anglian studies.

Reference: A. and R.T. Gunther, *Rolfe Family Records,* II, 1914; A.E. Gunther, *Rolfe Family Records,* I–III, 1962; Veronica Berry, *The Rolfe Papers: The Chronicle of a Norfolk*

SALISBURY

3071 George Beare

Miss Fort of Alderbury House

see page 102

3072 Ten Persian Ceramics

These ten items – five bowls, a cup, a small dish, a plate and a jug, all Persian, dating from the ninth to the thirteenth centuries, together with three Syrian Tiles, possibly Damascus ware, c.1600 – have been acquired from the distinguished collection of Persian ceramics of the late Dr John Macnaughton Whittaker, FRS, FRSE, formerly Vice-Chancellor of the University of Sheffield, which has been on loan to the Graves Art Gallery for over a decade. The pieces have been carefully selected to complement items already in the Gallery's possession, and make this one of the choicest and most comprehensive collections of Islamic ware in the country.

Bought for £7,500 (Dr Whitaker) by the Graves Art Gallery, Sheffield, with the help of a contribution of £1,875 from the NACF.

TAUNTON

3073 An Edward the Confessor Penny

Silver. Diameter: 2 cm
Ilchester mint. Reverse legend: AEGELPI ON GIVEL

With the possible exception of the British Museum, the Somerset County Museum has the most important collection in the country of Anglo-Saxon and Norman pennies of the Somerset mints. This Ilchester penny, however, is an exceptionally rare coin, which was not previously repre-

3074

sented. It has no known history, having only recently come to light.

From the late eleventh century English pennies were of uniform weight and fineness, hence the use of the term 'sterlings' from a Middle English word meaning something stable or firm. From the twelfth century, because they were one of the few remaining silver coinages in the West, they had wide circulation on the Continent.

Bought for £600 (A.H. Baldwin & Sons) by the Somerset County Museum, Taunton, with the aid of a contribution of £300 from the NACF.

WATFORD

3074 Sir Hubert von Herkomer (1849–1914)

Portrait of Anna Herkomer

Oil on canvas, 50·8 × 61 cm
Signed lower left with initials, and inscribed *Painted for our dear children Aug 1876*

Painted when Herkomer was twenty-seven, in the year after he had exhibited *The Last Muster,* his first great success at the Royal Academy, this portrait shows his first wife soon after the birth of their second child, a daughter named Elsa. Herkomer, himself Bavarian by birth, married Anna Weise, a German some years older than he, in 1873. Very soon after the marriage she was prostrated by an attack of inflamation of the lungs which developed into

consumption. J. Saxon Mills, Herkomer's biographer, wrote: 'The marriage seems to have been impulsively contracted and his wife's continued illness, which ended in fatal consumption in 1882, made Hubert's first wedded life a decade of trial and trouble'. (*Life and Letters of Sir Hubert Herkomer*, 1923.)

In spite of this initial set-back Herkomer had an immensely successful and productive career, some of the rewards of which he applied to the building of 'Lululand', at Bushy which enjoyed the distinction of being the only house in England to be designed by the celebrated American architect, H.H. Richardson, who provided the designs for the elevations in return for his portrait by the artist. 'Lululand' was named after Herkomer's second wife, Lulu Griffiths, who had been a member of the household since 1874 when she came as nurse to Anna Herkomer. Lulu and Hubert Herkomer were married in 1884; Lulu Herkomer died only a year later and no full-scale portrait of her is recorded. In 1888 Herkomer married for the third time, Margaret Griffiths, the sister of his second wife, who had taken charge of Siegfried and Elsa, Anna's children. Herkomer painted a portrait of Margaret in 1893, but it is a conventional 'society' image and like the majority of Herkomer's portraits, rather dull.

The early portrait of Anna is exceptional in showing a depth of insight into the character and painful disability of the sitter. Very few oils were painted at this early date; until Herkomer began to paint commissioned portraits regularly in the 1880s he worked mainly in watercolours, exhibiting only about one oil-painting each year. The portrait of Anna was not exhibited – it is not even recorded by A. Lys Baldry, Herkomer's first biographer (1901) – and the artist himself remarked that it was painted for his own private pleasure: '. . . Through painting my dear wife's portrait and that of my beautiful Siegfried, I have at last some pictures for myself in the house. These have just been finished . . .' (25 September 1876). The portrait of 'my beautiful Siegfried' is already at Watford, so the portrait of Anna is reunited with an old companion, and joins an interesting group of other Herkomer family material which has been assembled at the Museum, sited only minutes away from where Herkomer lived at Bushey.

Reference: J. Saxon Mills, *Life and Letters of Sir Hubert Herkomer*, 1923, p. 97.

Bought for £1,850 (David Messum, who identified the picture as a portrait of Lulu Herkomer) by the Watford Museum, with the help of a contribution of £462 from the NACF.

WOLVERHAMPTON
3075 Joseph Highmore
The Family of Lancelot Lee
see page 102

WORTHING
3076 Keith Vaughan (1912-1977)
The Trial (after Kafka)
Oil on cardboard, 70·8 × 99·7 cm
Signed 'Vaughan' bottom right and dated 1950

This is the first painting by Keith Vaughan which the NACF has helped to buy, so it is appropriate that it should be one of the most powerful and melodramatic examples from the important group of eight interiors with figures which he painted between 1948 and 1951. Like many of Vaughan's paintings, the '*Trial*' is figurative in the most literal sense of the word, in that it is dominated by boldly simplified, monolithic figures, composed without the distraction of minutely observed detail. Although on occasion his work came close to total abstraction, notably in the landscape paintings, the suggestion of a recognisable, if nightmarish, location is always present.

Vaughan belongs to the generation of English painters born only a few years after Graham Sutherland, the outstanding romantic representational English painter of this century whose importance has increasingly come to be recognised as a renewed interest in the representational tradition gains ground. The so-called 'Neo-Romantics' or 'Realists' have recently been allotted a label and a corporate identity which has brought into focus the work of the group of artists, including John Minton, John Craxton and Michael Ayrton – and many others who might be surprised to find themselves in each other's company – who represent the force behind the great surge of post-war energy and inspiration.

The Trial was begun in 1949; it was exhibited at Leeds soon after its completion in 1950, and again in New York two years later, but was substantially reworked in 1959 before being shown at the Whitechapel Art Gallery in the Vaughan *Retrospective* in 1962. Comparison with a photograph of the original version shows how the artist has striven towards the monumental simplicity of his final solution by the elimination of any detail even faintly suggestive of individual identity; for instance the roughly delineated features, the hair and the ear of the figure on the right have all been removed.

The mid-twentieth century is still not very well represented in public collections outside London, with notable exceptions in Leeds and at the Ferens Art Gallery in Hull,

3076

perhaps because the selection of nearly contemporary work is so difficult to make without the helpful backing of the 'judgment of history', but the passage of thirty years has enabled certain artists, and particularly individual works, to find their place of importance to the development of the art of the present day.

Exhibited: Leeds, *Fifteen Contemporary British Painters,* 1950–1; Durlacher, 1952; Whitechapel Art Gallery, *Keith Vaughan Retrospective,* 1962; Rutland Gallery, London, *Some Significant British Artists,* 1974; Geffrye Museum, London, *Keith Vaughan,* 1981; Messrs Agnew, London, *The Realist Tradition,* 1983.

Bought for £4,400 (Messrs Agnew) by the Worthing Museum and Art Gallery, with the help of a contribution of £2,200 from the NACF.

YORK

3077 Spencer Gore

Letchworth Station

see page 143

Summary of Grants given by the Fund in 1983

In 1983 the NACF made grants totalling £316,449. Of this sum £79,488 went to London Museums and Galleries and £236,961 to those outside London.

The grants we make come partly from donations and members' annual subscriptions, and partly from the generous legacies which have been left to the NACF over the years. The income and expenditure of these legacies are separately included in the accounts of the NACF.

COLLECTION	CONTRIBUTION	WORK OF ART	PAGE NUMBER
London			
British Library	£50,000	*The Rutland Psalter*	95
British Museum	£613	*Two Etchings* – Carl Wilhelm Kolbe	98
National Gallery	£10,000	*The Concert* – Hendrick Terbrugghen	100
Passmore Edwards Museum	£2,875	*The Harvey Family* – Sir Godfrey Kneller	102
Royal Institute of British Architects	£1,000	*The Goodchild-Cockerell Album*	148
Victoria and Albert Museum	£5,000	*Corpus Christi* – David Le Marchand	106
	£10,000	*Crucifixion Group* – Pierre Simon Jaillot	106
Outside London			
Scotland			
Aberdeen: Art Gallery and Museums	£5,000	*Baptism in Scotland* – John Phillip	149
	£3,400	*Curing Station, Whalsay, Shetland, 1921* – John Quinton Pringle	109
Dundee: Museums and Art Galleries	£1,750	*The Village Ba' Game* – Alexander Carse	109
Edinburgh: Scottish National Portrait Gallery	£4,375	*Portrait of James Byres and Family* – Franciszek Smuglevicz	
Glasgow: Museum and Art Gallery	£1,000	*A Silver Quaich*	150
Paisley: Museum and Art Gallery	£780	*Portrait of Alexander Wentworth, 2nd Baron Macdonald* – John Russell	150
Wales			
Cardiff: National Museum of Wales	£40,000	*Landscape with St Philip Baptising the Eunuch* – Claude Lorrain	116
Swansea: The Glynn Vivian Art Gallery and Museum	£1,375	*Emmy as a Bridesmaid* – Allan Gwynne-Jones	151
Swansea: The Maritime and Industrial Museum	£220	*Copper Works, near Swansea* – Henry Gastineau	152

England

Manchester: Whitworth Art Gallery	£3,000	*Spring in North London, 2 Houghton Place* – Spencer Gore	143
	£4,500	*Landscape with a Cottage and Haybarn* – Rembrandt van Ryn	161
National Trust: Cotehele House, Cornwall	£240	*Cotehele House, The South Front* – John Buckler	162
National Trust: Oxburgh Hall	£10,000	*The Oxburgh Altarpiece*	145
Norwich: Castle Museum	£731	*Two Pieces of Norwich Silver*	162
Salisbury: Salisbury and South Wiltshire Museum	£1,500	*Portrait of Miss Fort of Alderbury House* – George Beare	102
Sheffield: The Graves Art Gallery	£1,875	*Persian Ceramics*	164
Taunton: Somerset County Museum	£300	*An Edward the Confessor Silver Penny*	164
Watford: Museum	£462	*Portrait of Anna Herkomer* – Sir Hubert von Herkomer	165
Wolverhampton: Art Gallery and Museums	£5,625	*The Family of Lancelot Lee* – Joseph Highmore	102
Worthing: Museum and Art Gallery	£2,200	*The Trial (after Kafka)* – Keith Vaughan	165
York: National Railway Museum	£5,000	*Letchworth Station* – Spencer Gore	143

Summary of Works of Art presented through the Fund in 1983

In addition to making grants towards the purchase of works of art, the Fund every year distributes items which are given or bequeathed to it for presentation to Museums and Galleries.

COLLECTION	WORK OF ART	DONOR
Durham: The Oriental Museum	*Collection of Nine Pieces of Persian Pottery*	Bequeathed by the late Henry Van den Bergh
Norwich: University of East Anglia	*A Collection of Watercolours, Drawings and Prints of Norfolk Antiquities*	Presented by Mrs Veronica Berry and Mr A.E. Gunther in memory of Eustace Neville Rolfe

Published for the National Art-Collections Fund
by Trefoil Books,
7 Royal Parade,
Dawes Road,
London SW6

Set in Monophoto Bembo by Chambers Wallace, London
and printed and bound by Purnell & Sons Ltd., Paulton

Abridged Report

of the Eightieth Annual General Meeting
held at the Mansion House, London EC4, on Wednesday, 25th May, 1983,
the Chairman, Lord Normanby, presiding

The Lord Mayor opened the meeting with a short speech of welcome. He noted with pleasure that one of the Fund's most recent grants had gone to the Museum of London for some pieces of South Sea Company plate, and recalled that the portrait of George Dance, the architect of the Mansion House, which hangs in the building, had been presented through the NACF in the 1930s. He wished the Fund a very successful meeting on its 80th Anniversary. After being thanked by the Chairman for kindly allowing the meeting to be held in the Mansion House, he then left for another engagement.

The Chairman began by reminding his audience of some general points of NACF policy. It was, he felt, a wise course not to initiate purchases but to confine the Fund's role to supporting museums in their own choice of acquisitions. The Fund did not hesitate to associate itself with representations to government regarding taxation on works of art if it felt these were helpful to its fundamental aim of retaining the best of the national heritage in this country. It had never, however, been chauvinistic, and was deeply conscious of the keen appreciation of British art and culture which existed in the United States, and of the help it had often received from Americans. This link had recently been strengthened by the special arrangement, sanctioned by the Inland Revenue Service of the United States, whereby gifts to the NACF attracted the same tax concessions as those to museums in the States.

The Fund had recently taken part in talks with the government about the imposition of VAT on 'in lieu' works of art, and he was happy to say that this had now been dropped. Lifting VAT on the sale of objects which had been on view to the public would do much to stop works of art being torn from their original or traditional settings. The retention of such works – as for example in the recent case of Kedleston – was of the utmost importance. Indeed there was a growing consensus of opinion that museums did not necessarily provide the right environment for looking at paintings, and more thought should be given to the possibility of moving some from overcrowded museums to empty National Trust houses – an experiment that had already been successfully tried at Beningbrough, where pictures

had been lent by the National Portrait Gallery. The cost of insurance and custody which such schemes involved was small compared to that of building extensions to museums. The public had shown that it welcomed the opportunity to see beautiful things in beautiful surroundings, and this comparatively recent development should be encouraged.

The Chairman referred with gratitude to the attention and care which the current Minister for the Arts, Mr Paul Channon, had brought to the problems of his office; in its dealings with him the Fund had always found him showing complete fairness all round.

He then turned to a matter which was beginning to arouse great concern and which, as Chairman of the NACF, he felt it was his duty to speak, namely the immense financial resources which were now available to the Getty Trust for the purchase of major works of art on an international scale. Fears were widespread that this would have serious repercussions, especially in the United Kingdom, which was still one of the main sources for such treasures. Present regulations governing the export of works of art were generally acknowledged to be fair and reasonable; to impose a blanket restriction would damage the value of objects to their owners, and harm both the art trade and foreign museums. But what should be the reaction when offers were made from abroad for several major pictures at a Getty-enhanced value? He knew of a recent example where an owner had been offered $\pounds5\frac{1}{2}$ million by a dealer on behalf of a museum in America for a picture which had been valued by the authorities in this country at $\pounds3\frac{1}{2}$ million – nor was $\pounds5\frac{1}{2}$ million the upper limit of the offer. It would be impossible for the National Heritage Memorial Fund, the NACF, or any museum in the country, to cope with a number of such cases coming together. The powers which the British government had at its command should not be underrated, and might have to be invoked if artificially inflated prices were used to invalidate the present arrangements.

The Chairman welcomed the news that a substantial part of the Getty Trust's resources was to be devoted to supporting conservation and the history of art, and he found it reassuring that it had appointed as its new Director Mr John Walsh who, as Director of the Boston Museum of Fine Art,

was a museum official of great experience and knowledge. It was to be hoped that he would stress to his board the need for extreme circumspection in pursuing an acquisitions policy in this country.

The Chairman now turned to the Report and Accounts. In 1982 the Fund had made and promised grants totalling £378,621, of which some £85,000 had gone to London museums and galleries and £292,000 to those in the provinces. He drew special attention to certain outstanding acquisitions: 'The Triumph of Pan' by Poussin, which had gone to the National Gallery; the great Saenredam of the interior of St Bavo, Haarlem, bought by the National Gallery of Scotland; Stubbs's 'Gimcrack' and the two magnificent Canalettos which the Fitzwilliam and the Bowes Museum had acquired respectively, each as the result of heroic public appeals. He also mentioned the outstandingly generous gift which had been made through the NACF by Dr Esmond de Beer to the Dunedin Art Gallery and the Otago Museum in New Zealand, including paintings by Claude and Monet and a very large number of drawings, prints and *objets d'art*.

With regard to the accounts, it was encouraging that the Fund's capital had increased by some £1¼ million during the past year. Administration costs had been cut back, as promised, and the subscription had not been raised. The move to the new offices in John Islip Street had been completed satisfactorily, and the celebrations to mark the Fund's 80th Anniversary were well under way, thanks to the co-operation of the Representatives and the Directors of museums and galleries throughout the country, who had all drawn attention to their acquisitions made with the help of the NACF. A splendid concert had been held at the Barbican in April in the presence of HRH The Princess Margaret, and Her Majesty The Queen had allowed a reception to be held at St James's Palace in June, and would graciously attend it herself. All in all it had been a most successful year, with some splendid legacies, a higher membership than ever before, and many acquisitions of the first rank.

The Chairman now asked if there were any questions from the floor, and, none being forthcoming, proposed the adoption of the 1982 Report and Accounts. He then introduced Mr Philippe de Montebello, the Director of the Metropolitan Museum of Art, New York, who had flown over specially to give the address at this 80th Anniversary meeting.

Mr de Montebello admitted that he had not prepared a careful speech, but at best he would live up to the reputation of Americans for being informal. He had been asked to say something about the Metropolitan Museum. In comparison with the Getty Trust it was a pauper; indeed had it been able to buy the Algardi bust now at Manchester or the Warwick Vase at Glasgow, for both of which export licences had been withheld, the price would have represented more than half its total funds, covering no less than eighteen curatorial departments. The Museum was a semi-private institution and its single largest source of income was an endowment fund, the annual revenue from which now stood at about 6½ million dollars. Next came the grant from the City of New York, which owned the land and building and contributed 5½ million dollars per annum, plus the cost of lighting and heating. Another major source of revenue was admission fees, totalling about 4½–5 million dollars. Entry to the museum was free, 'but we do coerce'; a figure of 4 dollars a head was suggested and about 2.40 on average received. Senior citizens and children got in free; so did members, of whom there were 94,000. Much lower was the revenue from the museum shops which, contrary to general belief, were not profitable, bringing in less than 1 million dollars a year.

In fact all the revenues combined fell short of the income required for running the Museum by about 2½ million dollars. A third of the galleries were closed due to lack of warders, and for the last three years there had been a jobs freeze; when curatorial posts fell vacant they were not being filled. In short austerity was the order of the day.

Nor was the purchasing situation much brighter. The income from the Rogers Fund, established in the early part of the century, was about 1.2 to 1.4 million dollars per annum, but this was static and woefully inadequate. Curiously enough in New York it was easier to find money for new buildings or amenities than for purchasing works of art. The Metropolitan had a very strong board of Trustees, and the American tax laws, to which reference had already been made, were undoubtedly advantageous. A certain amount of money was raised by the Museum's 'de-accessioning' policy, by which it disposed of duplicates of works of secondary importance. Exchanges with other museums were also occasionally a source of acquisitions. But it was simply no longer possible to buy the supreme masterpieces that the Metropolitan, with the aid of generous benefactors, had been able to secure in the past.

In fact the Metropolitan today was not primarily an acquiring body but an educational institution, and the main emphasis for the future lay on exhibitions and teaching programmes. Most American museums had of course been founded in the late 19th century as instruments of popular instruction, and this view of them had prevailed, especially abroad, where it was widely believed that they were exceptionally enterprising in the educational field. In fact Mr de Montebello was struck by how much better education was handled by British, French and German museums than by those in the States. The reason, he believed, was that in America they had made the mistake of committing the general public to educational departments, 'whereas you in

Europe still entrust it to the curatorial passion'. Good examples were the new wing of the V & A, with its long labels and explanations, and the exhibitions at the National Gallery, which treated the public seriously and made them really look at the pictures. In America curators tended to feel that they were losing something if they transmitted their information, and it would be of great benefit to the public if they could be persuaded to share it more. Significantly, the only department in the Metropolitan which had gone in for long labels was run by an Englishman, the Curator of Paintings, although the same practice was now being adopted for the archaeological collections.

Before leaving the subject, Mr de Montebello wanted to mention the Metropolitan's current exhibition of treasures from the Vatican. The Museum had been much criticised for moving these great works of art, not only by the Italian press but by a number of people in the art world. But this was to suggest that the ultimate home for a work of art was a museum, from which it should never be moved. He welcomed the Chairman's remarks about museums not necessarily providing the best environment for works of art. Many curators would agree with him. Museums inevitably represented a different *milieu* from those for which its treasures were created, and exhibitions, by varying the context in which works of art were seen, were a reminder that they had 'a life of their own'. Curators who refused to let them travel were 'not really acting as custodians' but as 'gaolers'. All museums were involved in the exhibition process, and the lack of co-operation over loans was symptomatic of a general lack of communication in the museum world. More should be done to establish fellowships to enable young deputy keepers and curatorial assistants to travel and spend six months or a year in other museums. The Metropolitan already had a reciprocal arrangement of this kind with Germany, and Mr de Montebello would have liked to see one with England.

This brought him to his conclusion. Museums had so much at stake as guardians of the patrimony of mankind that inevitably decisions they took individually affected the whole community of museums around the world. The 'configuration of museums' that existed today was 'a historical fact', and it should be respected. No one had the right to upset the *status quo* to 'try to remake history'.

Mr de Montebello then seconded the adoption of the Report and Accounts. The Chairman thanked him for his most interesting and far-sighted talk, and the motion was unanimously carried.

The Chairman now moved to the next item on the agenda, the confirmation of Lord Faringdon as a new member of the Executive Committee. Sir Ellis Waterhouse proposed this motion, which was formally seconded and adopted. The Chairman then asked Sir David Piper, the Director of the Ashmolean Museum, to address the meeting and propose the re-election of the five retiring members of the Committee. The Ashmolean this year celebrated its tercentenary, which made the 80-year-old NACF seem a mere stripling.

Sir David Piper said he had originally felt rather presumptuous following a speaker who was the head of one of the greatest museums in the world, but the piteous tale of woe his audience had heard, though it had not entirely convinced him, had slightly lessened the feeling. He himself represented an institution in 'a medium-sized provincial city', one that had benefited much from NACF generosity and which, though it might not have grown to 'maxi-Met' proportions (indeed a colleague of Mr de Montebello had once described it as a 'mini-museum'), did at least have antiquity. The Prince of Wales had just visited the Ashmolean to mark its opening 300 years ago by the Duke of York, later James II, and on the following day a wreath was to be laid on the grave of the founder, Elias Ashmole, at St Mary's Church, Lambeth, in the presence of the Queen Mother.

Yet while the Ashmolean claimed to be the oldest institution of its kind open to the public, like all museums it faced the problem of remaining open – one 'rooted tediously in money'. University museums were more or less departments of their parent universities, which in turn depended for their life-blood on central government acting through the University Grants Committee. Museums had to bid for their allocation against all the other university departments, and in a recession, when universities faced heavy cuts, they tended to come off worst. In fact the Ashmolean had lost the whole portion of its annual grant for purchases. It had had to close on Mondays, 'a most melancholy way of celebrating our centenary', and on all sides staff vacancies went unfilled. But at last the University's finances seemed to be looking up. The Ashmolean had just been told to hold further retrenchments in abeyance, and even to submit bids for restoring certain posts. True, at the same time came a warning that the full overall cut might yet have to be made, and no measures should be taken which would prevent it from being met – 'which makes it rather difficult'. But there did seem to be 'a patch of blue in the financial sky'.

Throughout this difficult period the University had been scrupulously fair to the Ashmolean, which had suffered no worse than anyone else, but unless things continued to improve the pressure on the University not to sustain the balance would undoubtedly increase. The reason was obvious. Whereas the University's primary functions were academic, the Museum also had a public function and it was quite unrealistic to expect the University, when faced with swingeing cuts, to spare it at the expense of teaching and

research departments. Although it was difficult to assess the cost of the Ashmolean's services to the public, they probably amounted to about a fifth or even a quarter of its annual expenditure, not including money spent on acquisitions. This money of course now came from the 50 per cent V & A grant, or was manna from heaven, 'heaven being another name for the NACF'.

It might have been expected that the public would meet or at any rate contribute towards the Museum's running costs, but its representatives did not oblige and were unlikely to do so in the present economic climate. In any case they had 'such useful fall-back positions'. Local authorities could say, indeed had said, that as the Ashmolean was of national and international consequence the central exchequer must support it, while government said that, being a local institution, it should be the ratepayers' responsibility. 'I believe that is known as a Catch 22 situation. It is certainly an on-going situation.'

At Cambridge the town did provide a very modest subsidy towards the Fitzwilliam, but at Oxford neither city nor county provided anything.

There were other methods of raising the wind, and some of Sir David's junior colleagues had been 'righteously, almost mutinously indignant at his failure to produce funds from outside sources to prevent Monday closing. But it was a fact of life that while sponsorship could be found for exhibitions, purchases, or even new buildings. it was very difficult to raise large sums of money for 'unglamorous' running costs.

As for the ever-recurring question of entrance charges, his audience would recall the furore these had caused when they were imposed some years ago. The principle of free museums, like that of free public libraries, was one of the great inheritances of liberal Victorian optimism, but if the problem was to charge or to close (as it had not been ten years ago), then some very hard thinking was needed. The Ashmolean had thought, but its calculations indicated that even a charge of £1.50 per adult would be unlikely to produce a positive cash-flow within a decade. It had yet to produce a 'begging technique which is as efficient as the entirely voluntary compulsory entrance charges' which the previous speaker had described. Sir David would be seeking 'very cogent advice' about the technique later in the evening. He admitted to a certain relief, however, on hearing that the Metropolitan's shop was not proving 'an absolute goldmine', since he had qualms about the practice, adopted in many national museums, of turning prime exhibition galleries near the entrance into shops, especially if there was not the space to compensate further back.

He had inflicted this 'litany of woe' on his audience only because so many people wondered why university museums were unable to offer the kind of amenities that were now taken for granted – lifts, rest-rooms, cafeterias, education services and so on. Unfortunately university museums had not shared in the great boom that the national museums had enjoyed in the 'sixties. Since he had left the National Portrait Gallery for the Fitzwilliam in 1967, it had literally doubled its staff – an expansion due partly but not wholly to 'that new phenomenon in the museums firmament', Roy Strong. In the same period the National Maritime Museum had almost trebled its staff, while major extensions had been added to the National Gallery, the Tate and the British Museum, all at government expense. Such expansion did not happen at either Oxford or Cambridge. At Cambridge an exhausting fund-raising exercise had produced a small extension, and Sir David was proud of having given the Fitzwilliam electric light; but by the time he had reached Oxford 'we were in the advance guard of the recession and survival has been our watchword'. All, however, was not lost. The Museums and Galleries Commission was well aware of the anomalous nature of university museum funding, and the subject had even emerged in the debate in the House of Commons on the Heritage Bill. It was to be hoped that when the dust had settled after the General Election it would not be lost to sight.

Soon after moving from a national to a university institution, he had decided that the only ultimate solution was a subsidy direct from the Exchequer other than the general grant from the University Grants Committee. The great university museums had responsibilities far beyond their local higher academic function, to the general public and indeed to visitors from all over the world. They were integral not only to the pursuit of knowledge but to 'the general cause of life-enhancement, to sheer delight and pleasure'.

One reason why the Ashmolean had to keep open was to honour the undertaking made when it accepted help from the NACF. The Fund had helped with two of its most splendid recent acquisitions, Allori's elegant and mysterious portrait of a young man and the colossal Chinese Bodhisattva. It was a great pleasure to convey greetings from the Ashmolean's 300th Anniversary to the Fund's 80th, and to propose the re-election to the Executive Committee of Lord Normanby, Mr James Byam Shaw, Lord Gibson, Mr St John Gore and Professor Francis Haskell. All were 'good and honest men, men of experience, learning, wisdom and taste who had worked well for the Fund'. They should be given the opportunity to continue their good work.

The motion was formally seconded and carried, and the Chairman then presented the Hornby Cup. It was always difficult to choose a winner when so many people were active on the Fund's behalf, but the Cup was being presented this year to Mrs T. F. Hewer, who had done invaluable work over many years as Representative for Avon.

Mrs Hewer thanked the Chairman on behalf of her county; they were all very honoured to receive the Cup, though she was sure they had been 'chugging along too slowly'. Yet things had changed since she was first made a Representative. For a long time she had never been asked to do anything, and when she applied for instructions the answer had been: 'One day you will be told what to do'. Now there was much better communication throughout the society. She herself had been a member since she was seventeen, when her parents had urged her to join 'because it was very important'. She had found it brought her 'increasing pleasure'.

As a county Representative she had tried to maintain a steady stream of small events which gave local members a sense of involvement; it was easy to think that the interesting things only happened in London. The Committee was anxious to see a large body of people across the country caring for the aims of the NACF, and it was the Representatives' job to make this a reality.

She had been asked to propose a vote of thanks to the two guest speakers, and was delighted to do so. For most NACF members museum-going was naturally an important part of their lives, and it had been a real pleasure to hear two of the world's greatest museums discussed by their Directors. Despite the troubles her audience had heard of, the speakers had also managed to make it one of the most amusing meetings she could remember. Last but not least, she was sure everyone was grateful to the Lord Mayor for allowing the Fund to hold the meeting in such splendid surroundings in their 80th Anniversary year.

Mrs Hewer's vote of thanks was carried with acclamation and the meeting was concluded.

OTRAS LEYES POR EL PUEBLO.
(*Autres lois pour le peuple*)

Francisco Goya y Lucientes, *Los Proverbios*.

Honorary Life Members

The election to Honorary Life-Membership, the highest honour the Committee can bestow, is in consideration of outstanding benefactions or service to the Fund.

L.M. Angus-Butterworth, Esq, FRGS, FSA(SCOT)

Professor Bernard Ashmole, CBE, MC, FBA, Hon. ARIBA

Roland Cookson, Esq, CBE

A.E. Gunther, Esq

Mrs Buschka Manenti

Lady Vansittart

Corporate Members

Benefactors

The Peter Moores Foundation (£4,000)

*Christie, Manson & Woods Ltd (£2,000)

Sotheby & Co (£1,200)

John Lewis Ltd (£1,000)

National Westminster Bank plc (£1,000)

Shell UK Ltd (£1,000)

Unilever plc (£1,000)

Donors

Manchester City Art Gallery (£500)

Herbert Smith & Co (£500)

Rank Xerox (UK) Ltd (£500)

Companies, Livery Companies, Trusts and Societies

Akroyd & Smithers Ltd (£25)

Arthur Anderson & Co Foundation (£100)

Anderson & Garland (£25)

Antique Collector (£25)

Barclays Merchant Bank Ltd (£100)

Baring Foundation (£2,750)

Bat Industries plc (£250)

Baxter, H. C. & Sons (£25)

Bridgeman Art Library Ltd (£25)

British Petroleum Oil Ltd (£350)

Cazenove & Co (£125)

Central & Sherwood Ltd (£50)

Frere Cholmeley (£100)

Colefax & Fowler (£25)

Coutts & Co (£250)

Dallas, Anthony, & Sons Ltd (£25)

Datsun UK Ltd (£25)

Worshipful Company of Drapers (£450)

Edinburgh Antiques and Fine Arts Society (£25)

Gerrard & National plc (£100)

Grand Tour of Scotland (£25)

Morgan Grenfell & Co Ltd (£250)

GT Management (£100)

Guardian Royal Exchange (£250)

Equity & Law Charitable Trust (£150)

Fielden & Mawson (£25)

Fleming, Robert, & Co (£100)

Gander & White Ltd (£25)

Hill Samuel & Co Ltd (£25)

Hull and East Riding Antiques and Fine Arts Society (£25)

Kleinwort, Benson Ltd (£250)

Landmark Trust (£50)

Littlewoods Organisation Ltd (25)

Mackelvie Trust Board, Auckland (£10)

Worshipful Company of Mercers (£250)

Mincoff Science & Gold (£25)

Montagu Ventures Ltd (£10)

Morris, John G., Ltd (£25)

National Association of Decorative and Fine Art Societies:

 Ashdown Forest (£25)

 Bishop's Stortford (£25)

 Cambridge (£25)

 Canterbury (£25)

 Chelsea and Kensington (£25)

 Chiltern (£25)

 Claremont (£25)

 Croydon (£25)

 Devon (£25)

 Dover and Deal (£75)

 Dukeries (£25)

 East Dorset (£25)

 Godalming (£25)

 Harpenden (£25)

 Henley (£25)

 Itchin Valley (£25)

 Leeds (£10)

 New Forest (£30)

 New Forest Evening (£25)

 North East Cheshire (£25)

 North Kent (£25)

 North Wiltshire (£25)

 Petersfield (£25)

 Ribble and Craven (£25)

 Southport and Formby (£25)

 Test Valley (£25)

 Thanet (£25)

 West Essex (£25)

 West Meon (£25)

 Wirral (£25)

Nottingham Society of Artists (£10)

Ocean Transport & Trading Ltd (£200)

Worshipful Company of Painter Stainers (£25)

Albert Rickett Charitable Trust (£385)

Peterson & Short (£25)

Rowe & Pitman (£75)

Royal Numismatic Society (£25)

Royal Society of British Sculptors (£25)

RTZ Services (£250)

Worshipful Company of Saddlers (£50)

Save & Prosper Group Ltd (£250)

Scharf, K. Ltd (£25)

Schroder Wagg & Co Ltd, J. Henry (£300)

Society of Antiquaries (£25)

Travers Smith Braithwaite & Co (£100)

West Yorkshire Antique Collectors Society (£25)

Witan Investment Co (£350)

Auctioneers, Art and Antique Dealers

Adams, Norman, Ltd (£25)

Asprey & Co Ltd (£25)

Agnew, Thomas, & Sons Ltd (£25)

Bonham, W. & F. C. & Sons (£25)

Bourdon-Smith, J. H., Ltd (£25)

Carritt, David, Ltd (£50)

Christies Contemporary Art (£25)

Christie's South Kensington Ltd (£25)

Colnaghi, P. & D. (£50)

Fine Art Society, London (£25)

 Scotland (£25)

Fine Art Trade Guild (£75)

Green, Richard, (Fine Paintings) (£25)

Heim Gallery Ltd (£50)

Hotspur Ltd (£25)

Humphris, Cyril, Ltd (£25)

Inglis, Brand, Ltd (£25)

Iona Antiques (£25)

Lane Fine Art (£30)

Lefevre Gallery (£25)

*Leger Galleries (£100)

Maas, J. S., & Co (£25)

*Mallett, E., & Sons (Antiques) Ltd (£50)

Marlborough Fine Art (London) Ltd (£25)

Morton Morris & Co (£25)

Newman, M. Ltd (£25)

Parker Gallery (£25)

*Phillips, Ronald, Ltd (£25)

Phillips, S. J., Ltd (£25)

*Phillips Son & Neale, Fine Art Auctioneers (£100)

Pollak, F. A., Ltd (£25)

Reed, Anthony, Gallery Ltd (£25)

Rutland Gallery (£25)

Sabin Galleries Ltd (£25)

Sampson, Alistair, Antiques (£25)

Shield & Allen (£25)

South Molton Antiques Ltd (£25)

Spink & Son Ltd (£25)

*Stacey-Marks, E., Ltd (£25)

Winifred Williams (£50)

Rainer Zietz (£25)

Museums, Galleries, Libraries, Universities, Colleges and Schools

Abbot Hall Art Gallery, Kendal (£10)

Aberdeen: Art Gallery and Industrial Museum (£21)

　　Friends of the Art Gallery and Museums (£20)

Army Museum, Ogilby Trust (£10)

Auckland City Art Gallery (£42)

Bankfield Museum, Halifax (£10)

Barbados Museum and Historical Society (£10)

Bath Museum Service (£25)

Birmingham Museums and Art Gallery (£52.50)

Blackburn Art Gallery (£10)

Bolton Art Gallery (£25)

Bowes Museum, Barnard Castle (£50)

Bradford City Art Gallery and Museum (£50)

Brantwood Trust (Ruskin Museum) (£10)

Bridlington Parks and Recreation Dept (£10)

Bristol: City Art Gallery (£25)

　　Friends of the Art Gallery (£10)

British Council: Fine Arts Dept (£25)

British Library Board (£100)

British Museum (£100)

Bury Central Library (£10)

Cambridge:

　　University (£300)

　　Gonville and Caius College (£25)

　　Jesus College (£25)

　　King's College (£25)

　　St John's College (£35)

　　Trinity College (£100)

Cannon Hall Museum, Barnsley (£10)

Carisbrooke Castle Museum, Isle of Wight (£10)

Carlisle Museum and Art Gallery (£10)

Castle Museum, Nottingham (£10)

Cecil Higgins Art Gallery, Bedford (£50)

Cheltenham Art Gallery and Museums (£100)

Cheshire County Museums (£25)

Clive House Museum, Shrewsbury (£10)

Colchester Museums and Art Galleries, Friends of (£10)

Columbia University Libraries, New York (£10)

Council of Museums in Wales (£25)

Coventry Libraries, Arts and Museums Dept (£10)

Darlington Art Gallery (£10)

Dartmouth Museums, Friends of the Association of (£10)

Derby Museums and Art Gallery (£10)

Doncaster Art Gallery and Museum (£140)

Dudley Leisure and Recreation Dept (£10)

Dundee City Art Gallery (£25)

Durham, University of, Horticultural Offices (£25)

Dyson Perrins Museum Trust, Worcester (£10)

Edinburgh: City Art Centre (£21)

　　University of (£25)

East Anglia, University of, Sainsbury Centre (£25)

Egham Museum (£10)

Eton College (£40)

Ferens Art Gallery, Kingston upon Hull (£10)

Fogg Art Museum, Harvard University, Mass (£10)

Fondation Custodia, Paris (£25)

Frick Art Reference Library, New York (£10)

Geffrye Museum (£25)

Getty Museum, J. Paul, Malibu (£10)

Glasgow: Museums and Art Galleries (£100)

　　University of (£25)

Gloucester City Museum and Art Gallery (£10.50)

Glynn Vivian Art Gallery and Museum, Swansea (£10.50)

Graves Art Gallery, Sheffield (£30)

Gray Art Gallery and Museum, Hartlepool (£10)

Grosvenor Museum, Chester (£25)

Grundy Art Gallery, Blackpool (£10)

Guildford Museum (£10)

Guildhall Art Gallery, London (£10)

Hampshire County Museum Service (£10)

Harris Museum and Art Gallery, Preston (£10)

Harrogate Museums Service (£10)

Harrow School (£25)

Hastings Museum and Art Gallery (£10)

Hereford City Museum (£25)

Holburne of Menstrie Museum, Bath (£10)

Hove Museum of Art (£10)

Huddersfield Libraries and Museums Service (£10)

Hull, University of (£25)

Inverness Museum & Art Gallery (£15)

Ipswich Museum (£10)

Iveagh Bequest, Kenwood (£25)

Jersey Museum (£25)

Jewish Museum (£10)

John George Joicey Museum, Durham (£10)

Johnson Society, Lichfield (£10)

Duncan Jordanstone College of Art (£25)

Kettering Amenity and Recreation Committee (£10)

Kingston upon Hull Museums (£10)

Kirkcaldy Museums and Art Gallery (£10)

Laing Art Gallery, Newcastle upon Tyne (£10)

Lancashire Museum, Preston (£20)

Lancaster City Museum (£25)

Leamington Spa Art Gallery and Museum (£10)

Leicestershire Museums, Art Galleries and Records Service (£175)

Liverpool, University of (£50)

London, University of (£25)

 University Library (£10)

 Courtauld Institute of Art (£25)

Luton Museum and Art Gallery (£10)

Maidstone Museum and Art Gallery (£10)

Manchester: County Treasurer, Manchester Council (£100)

 Whitworth Art Gallery (£150)

Manx Museum, Isle of Man (£10)

 Friends of Manx Museum (£20)

Marylebone Cricket Club (£25)

Merseyside County Council (£10)

The Minories, Colchester (£10)

Moyse's Hall Museum (£10)

Museum of Fine Arts, Boston (£10)

Museum of London (£10)

National Army Museum (£10)

National Gallery (£25)

National Gallery of Victoria, Melbourne (£25)

National Gallery of Wellington, New Zealand (£20)

National Library of Wales (£10)

National Maritime Museum (£10)

National Museum of Wales (£400)

National Portrait Gallery (£100)

National Trust for Scotland (£25)

National Trust, Yorkshire (£10)

Natural History and Archaeological Society, Dorset (£10)

Newport Museum and Art Gallery (£10)

Northampton: Museums and Art Gallery (£10)

Friends of the Museums and Art Gallery (£10)

Norwich: Castle Museum (£50)

 Friends of Norwich Museums (£25)

Oldham Central Library and Art Gallery (£25)

Oxford University:

 Ashmolean Museum

 Dept of Antiquities (£10)

 Dept of Eastern Art (£10)

 Dept of Western Art (£50)

 Heberden Coin Room (£20)

 Pitt Rivers Museum (£10)

 Christ Church (£50)

 Corpus Christi College (£25)

 Lady Margaret Hall (£25)

 New College (£10)

 Queen's College (£25)

 St John's College (£25)

 Somerville College (£25)

 Trinity College (£25)

 Worcester College (£25)

 Faculty of Music, Bate Collection of Historical Instruments (£10)

Paisley Museum and Art Gallery (£10)

Passmore Edwards Museum (£150)

Perth Art Gallery and Museum (£10)

Peterborough City Museum and Art Gallery (£10)

Plymouth City Museum and Art Gallery (£10)

Portsmouth City Museum (£21)

Poole Museum Service (£10)

Reading Museum and Art Gallery (£50)

Rijksmuseum, Amsterdam (£12)

Robert McDougall Art Gallery, Christchurch, New Zealand (£10)

Rochdale Arts and Entertainment Services (£25)

Rotherham Museum and Art Gallery (£15)

Royal Academy of Arts (Llewellyn Fund) (£25)

Royal Albert Memorial Museum, Exeter (£50)

Royal Institute of British Architects (£25)

Royal Institution of Cornwall (£10)

Royal Museum, Canterbury (£10)

Royal Pavilion, Brighton (£25)

Royal Scottish Academy (£10)

Royal Scottish Museum (£250)

Russell-Cotes Art Gallery and Museum, Bournemouth (£15.75)

Salford Art Gallery and Museum (£10)

Salisbury and South Wiltshire Museum (£10)

Scunthorpe Museum and Art Gallery (£10)

Sefton, Metropolitan Borough of (£10)

Sevenoaks District Arts Council (£25)

Shrewsbury School (£25)

Smith Museum and Art Gallery, Stirling, Friends of (£10)

Somerset County Museum (£10)

South Australia, Art Gallery of (£50)

Southampton Museum and Art Gallery (£100)

Southend-on-Sea Art Gallery (£25)

St Anne's School, Windermere (£25)

St Helens Metropolitan Borough Council (£10)

Sterling and Francine Clark Art Institute, Williamstown, Mass (£10)

Stockport Metropolitan Borough Council (£50)

Stoke-on-Trent City Museum and Art Gallery (£10)

Tameside Libraries and Arts (£20)

Tankerness House Museum, Kirkwall, Orkney (£10)

Temple Newsam House, Leeds (£10)

Toledo Museum of Art, Ohio (£10)

Towneley Hall Art Gallery and Museums, Burnley (£10)

Towner Gallery, Eastbourne (£10)

Trevelyan College, Durham (£25)

Ulster Museum, Belfast (£10)

Ulster Museum, Friends of (£25)

Usher Gallery, Lincoln (£60)

Vancouver Public Library (£10)

Victoria and Albert Museum (£250)

Wakefield: Museum and Art Gallery (£10)

 Permanent Art Fund (£10)

Walker Art Gallery, Liverpool (£100)

Warrington Museum and Art Gallery (£20)

Warwick Museum (£10)

Watts Gallery, Compton (£10)

Whitehaven Museum and Art Gallery (£10)

Wigan Museum Service (£10)

William Morris Gallery, Walthamstow (£10)

Williamson Art Gallery and Museum, Birkenhead (£30)

Wiltshire Archaeological and Natural History Society (£25)

Winchester City Museum (£10)

Wisbech and Fenland Museum (£10)

Witwatersrand, University of, South Africa (£10)

Wolverhampton Art Gallery (£20)

Worcester City Museum and Art Gallery (£25)

Worthing Museum and Art Gallery (£10)

Wycombe Chair and Local History Museum (£10)

York: City Art Gallery (£10)
 Friends of the City Art Gallery (£25)

Legacies

Legacies received by the Fund during 1983 amounted to £628,810.83 (before adjustments)

£344,560.06
Mary Lady Conant (cash and securities)

£107,662.63
Miss G.D.W. Farrar (cash and securities)

£65,040.21
G.M. Battersby

£20,000.00
J.N. Bryson

£16,000.00
Mrs L.M. Thomas

£12,000.00
Miss Mary Scouloudi Will Trust

£10,630.00
Aubrey Herbert

£10,000.00
E.A.G. Caroe

£9,321.47
Miss E.R. Quelch

£8,500.00
C.R.S. Noble

£7,800.00
Mrs E. Hart

£3,414.46
Miss M.E.H.J. Gollancz

£3,321.00
Mrs Hilda Richardson Will Trust

£2,000.00
J.H. Francis

£1,412.78
Mrs E.W. Fuller

£1,000.00
Mrs L.M. Bosanquet
M.G. Dreyfus
St G.H. Phillips
The Hon. G.H. Samuel

£885.08
Lt Col A.M. Scott Bequest (Sir J.M. Scott Will Trust)

£696.73
F.W. Pierce

£500.00
Mrs M.F. Waycott

£250.00
Miss A.M. White

£158.21
Miss L.V.P. Leach
C.R.S. Noble

£100.00
Miss S.A. Clarke
Mrs D.F. McLagan
R.C. Matthews
Mrs E.C.H. Roskill

£50.00
Miss N.K. Drown
Mrs J. Shenton

Scottish Fund

Legacy

£5,000.00
J.M.R. Mitchell

Donations

The Committee takes this opportunity of thanking those who pay more than the minimal annual subscription for their additional support. It also wishes to acknowledge with gratitude the following donations to the NACF General Fund, totalling £92,235.29, and to the Scottish Fund, totalling £4,093.58.

£25,000.00
The Wolfson Foundation

£10,000.00
Esmée Fairbairn Charitable Trust

£5,000.00
The Rayne Foundation
Trusthouse Forte

£2,500.00
Thomas Agnew & Sons Ltd

£2,000.00
The Eranda Foundation

£1,900.00
The Astor of Hever Trust

£1,500.00
The Members of Lloyd's and Lloyd's Brokers

£1,000.00
Anonymous (2)
The Coulthurst Trust
D.C. Moncrieff Charitable Trust
The Grocers' Charity
Spooner Charitable Settlement

£800.00
The New Moorgate Trust

£700.00
Sir Jeremiah Colman Gift Trust

£500.00
The Adeby Charitable Trust
Anonymous
Bank of England
Messrs Bolton & Lowe

Lady and Lord Gough Charitable Trust
R.J. Harris Charitable Trust
The Inverforth Charitable Trust
Noswad Charity
Poling Charitable Trust
Provincial Insurance plc

£450.00
Godinton Charitable Trust

£400.00
Gilbert and Eileen Edgar Foundation
The Meyer Family Charitable Trust
Mrs Martin Myers

£350.43
P.H.T.

£350.00
R.S.W. Clarke, Esq
Hampshire County Council
Ofenheim Charitable Trust

£300.000
Francis C. Scott Charitable Trust

£250.00
Lloyds Bank plc
Mrs E.M. Sheldon
South Square Charitable Trust
The late Professor Wormald's Charitable
Settlement

£200.00
Goldsmiths Charitable Donations Fund
Maud Van Norden's Charitable
Foundation

£150.00
The O.J. Colman Charitable Trust
Twenty-Seven Foundation

£125.00
Miss H. Swift

£100.00
Colefax and Fowler Designs Ltd
H.J. Charitable Trust
H.C. Graves Esq (covenant)
Alexander Howden Group Ltd
Julian Layton Charity Trust
Dr Janet E. Leng
Miss D.V. Pares-Wilson
A.D. Shead Esq
Sir Mark and Lady Turner Charitable
Trust
Walker Art Gallery
West Essex DAFAS
Whitbread plc

£91.02
A.A. Hayler

£90.00
Sir Robert and Lady Sainsbury Charitable
Trust

£80.00
C.C. Empson Esq

£75.00
Anonymous
Ashridge DAFAS
St John's College, Oxford

£71.43
The Miller Tiley Charitable Trust (75th
Anniversary Appeal)

£70.00
Chiltern DAFAS

£60.00
Anonymous (cash)
Mrs P.A. Cowen

£56.00
Mrs M.R.H. Wormald

£52.00
Humphrey Whitbread Esq

£50.00
Edgar Astaire & Sons Charitable Trust
The G.T. Ayre Charitable Trust
The Bruce Ball Charitable Trust
Nellie and Verdin Baron
Sir Stanford and Lady Jane Cooper
Charitable Trust
Delphine M. Dickson Trust
Messrs Ernst and Whinney
Glass Sellers Company
Gloucestershire DAFAS
Sir Nicholas and Lady Goodison
Charitable Settlement
Annis M. Heawood
Alexander M. Jacob Charitable Trust
Jermyn Publications Ltd
J. and K. Morton Charitable Trust
Newbury DAFAS
Messrs Quilter Hilton Goodison
Rowsell Trust
Mr and Mrs F.R. Waley

Various other smaller amounts

Area Representatives

£5,201.16
London Projects Committee

£1,255.50
Mrs T.S. Lucas (Yorkshire North)
(includes £1,000 from the Coulthurst
Trust)

£1,255.00
Mrs J. Wall and Mrs P.D.E. Bergqvist
(Buckinghamshire)

£1,140.00
Mrs D. Lloyd-Thomas and Mrs H.
Villiers (Kent)

£618.23
The Hon. Mrs M.C. Brudenell
(Northamptonshire)

£466.52
Mrs D. Colville (Cornwall)

£450.00
Mrs G. Cookson and Mrs R. Morritt
(Co Durham)

£413.79
J.R. Bernasconi Esq (Tyne and Wear)

£320.00
Lady Reid and Sean Hudson Esq
(Cambridge)

£310.00
Mrs T. Peter Naylor and H. Cornish
Torbock Esq (Cumbria)

£270.62
The Countess of Yarborough
(Lincolnshire)

£258.00
Miss Emma Crawshay (Norfolk)

£250.00
Mrs R. Gresty (Gwynedd)
Lady Stevens (Devon)

£218.00
Mrs Humphrey Brooke (Suffolk)

£200.00
The Hon. John Jolliffe (Somerset)

£198.48
H.F.W. Cory Esq (Wiltshire)

£130.00
Mrs J.A. Fielden (Shropshire)

£115.50
Mrs H. Boyle and Mrs M. Roscoe
(Yorkshire West)

£110.00
Mrs T.F. Hewer OBE (Avon)
Lady Holland (Gloucestershire)

£105.00
Captain W.D. Thorburn CBE, VRD, RNR
(Northumberland)

£101.00
Miss D. Abel Smith (Hertfordshire)

£100.00
Mrs G.E. Graham (Surrey)
Norman McKenna Esq, CBE (Dorset)

£73.00
Lady Montgomery Cuninghame
(Berkshire)

Development Fund

£2,796
Specialtours Ltd

£620.10
Arthur Ackermann & Sons Ltd

£300.00
Sir Antony Hornby

Collecting Boxes

£2,596.00
National Gallery

£907.86
Victoria and Albert Museum

£760.27
British Museum

£437.74
National Portrait Gallery

£330.20
Cannon Hall, Barnsley

£154.00
Cecil Higgins Art Gallery

£68.00
City of Birmingham Museum and Art
Gallery

Donations were also received from:

Cheltenham Art Gallery and Museum
Derby Museum and Art Gallery
Doncaster Museum and Art Gallery
Dove Cottage Local Committee
Ipswich Museum
Kingston upon Hull: Ferens Art Gallery
Lancaster County Museums
Lincolnshire Museums
Manchester City Art Gallery
Norfolk Museum Service
Wallace Collection

80th Anniversary Donations

£125.00
L.S. Lebus Esq

£100.00
Cambridge Decorative and Fine Arts
Society

£80.00
Humphrey Whitbread Esq

£50.00
Miss S. Foster

£750.00 (gross amount of covenant)
Bank of Scotland
Clydesdale Bank plc

General Accident Fire and Life Assurance
Corporation plc
Royal Bank of Scotland

£150.00
Edinburgh Antiques and Fine Arts
Society

£100.00
Mr and Mrs Graham Buchanan Dunlop

£90.91 (gross amount of covenant)
J.P. Ferguson Esq

£80.00
Sir Ninian Buchan Hepburn

£54.30
National Museum of Antiquities

£50.00
Dr M.W. Paterson
and various other smaller amounts

Representatives

£304.63
Mrs John Foster (Fife)

£300.00
Mr and Mrs N.R. Hynd (Edinburgh and
Lothian)

Donations totalling £345.50 were
received in memory of:

Mrs K. Gifford-Scott
Dr J.F. Hayward
L. Rickard